W9-ASD-134

WITHDRAWN

WITHDRAWN

Erotic Art

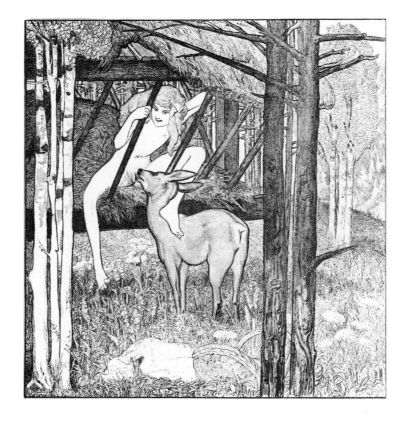

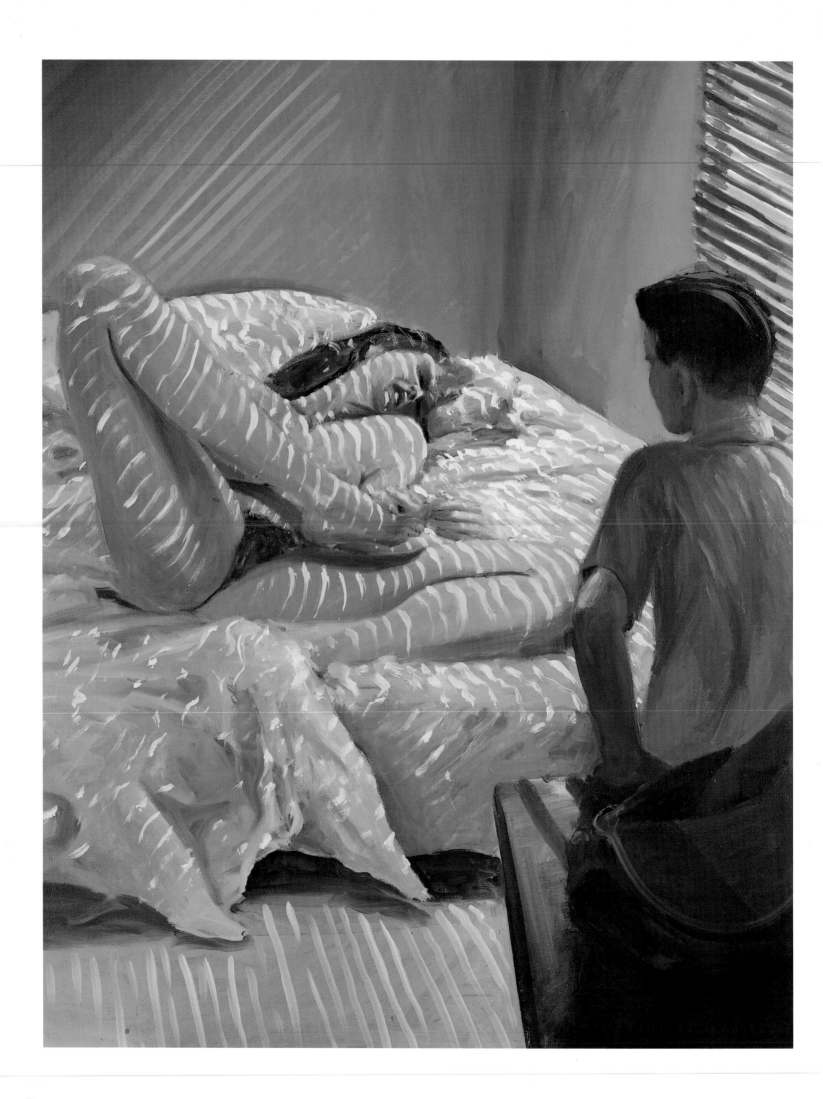

Edited by
Angelika Muthesius
Burkhard Riemschneider

Twentieth-Century Erotic Art

Text by Gilles Néret

Benedikt Taschen

FRONT COVER:
Salvador Dalí
Detail from: *The Great Masturbator,* 1929
See illustration page 181

PAGE 1:
Franz von Bayros
O, what a pretty like-place, 1908
Illustration to "Erzählungen am Toilettentisch"

PAGE 2:
Eric Fischl
Detail from: *Bad Boy,* 1981
See illustration page 173

**This book was printed on 100% chlorine-free bleached
paper in accordance with the TCF standard.**

© 1993 Benedikt Taschen Verlag GmbH
Hohenzollernring 53, D–50672 Köln
© 1992 for the reproductions from artists but for the following:
© Galerie Alvensleben, Munich, for the work of Rudolf Schlichter
© The Francis Bacon Estate
© James Corcoran Gallery, Santa Monica, for the work of Vito Acconci
© Paula Cooper Gallery, New York, for the work of Robert Gober
© CPLY Art Trust, New York, for the work of William N. Copley
© Otto-Dix-Stiftung, Vaduz
© By Dr. Wolfgang & Ingeborg Henze-Ketterer, Wichtrach/Berne
for the work of Ernst Ludwig Kirchner
© Galerie Max Hetzler, Cologne, for the work of Jeff Koons
© 1989 Munich, Edition Spangenberg for the work of Alfred Kubin
© The Estate of Robert Mapplethorpe, New York
© 1992 Matthew Marks Gallery, New York, for the work of Nayland Blake
© Succession Henri Matisse, Paris
© Metro Pictures, New York, for the work of Cindy Sherman
© Munch-Museet, Oslo
© Oelze-Archiv, Rittergut Posteholz, Ellida Schargo von Alten
© Urheberrechtsgemeinschaft Max Pechstein, Hamburg
© Christian Schad by G.A. Richter, Rottach-Egern
© The Tom of Finland Foundation, Los Angeles
© Jeff Wall Studio, Vancouver
© 1992 Andy Warhol Foundation for the Visual Arts/ARS, New York
© Tom Wesselmann/VAGA, New York, 1992 VG Bild-Kunst, Bonn
© 1992 VG Bild-Kunst, Bonn, for the work of Arman, Balthus, Beckmann, Bellmer, Beuys,
Bourgeois, Brancusi, Brauner, Bonnard, de Chirico, Cocteau, Corinth, Dalí, de Kooning,
Delvaux, Dubuffet, Duchamp, van Dongen, Ernst, Fautrier, Fetting, Grosz, Klein, Klossowski,
Kokoschka, Lichtenstein, Lindner, Magritte, Maillol, Masson, Matta, Miró, Mueller, Nauman,
Nitsch, O'Keeffe, Oppenheim, de Saint Phalle, Picabia, Picasso, Pollock, Man Ray, Rivers,
Salle, Wesselmann, Wols
English Translation: Craig Reishus, Munich

Printed in Italy
ISBN 3-8228-9652-7
GB

Contents

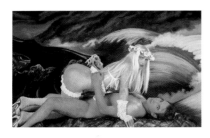

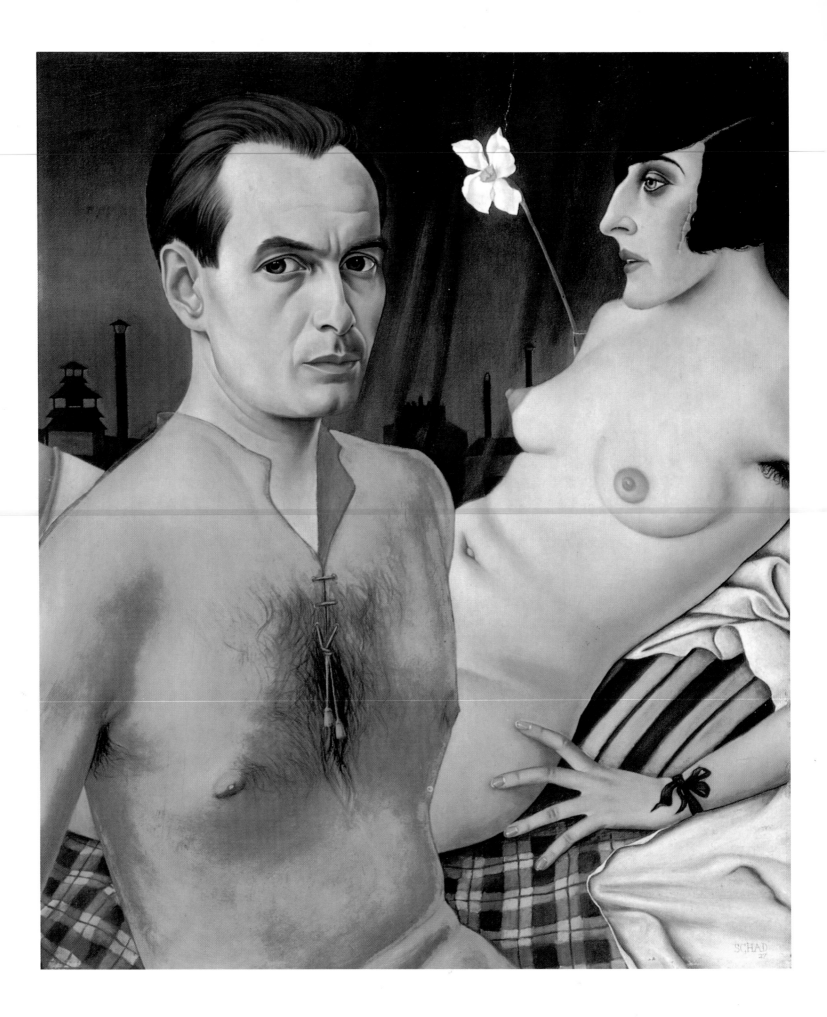

Nudity Veiled

"All art is erotic," Adolf Loos insists. In his controversial essay of 1908, "Ornament and Crime", Loos dares suggest that the world's earliest expression of ornament – the cross – sprang from erotic impulses. Moreover, the premier work of art, that carnally charged outburst through which the first artist proclaimed his transport by rasping marks into a wall, was likewise erotic in genesis. The horizontal line, Loos continues, represents a prostrate female; the vertical line, her penetration by the male.

Naturally, such theories are not for everyone. Charles Baudelaire, in his private journals entitled "My Heart Laid Bare", remarks: "All these sheepheaded bourgeois prigs who endlessly spout words like 'immoral, immorality, morality in art,' or mouth other such idiocies, remind me of that five-franc whore, Louise Villedieu, who once accompanied me through the Louvre – it was her first visit – only to blush most deeply, veil her face, tug continually at my sleeve, and ask me, before sundry immortal statues and paintings, how it were possible that someone be allowed to put such indecencies on public display."

The false shame and prudish taboos sown by Judaeo-Christian civilisation gave rise to a compensating movement in art. The erotic and its closet companion, fetishism, quickly coming of age, conquered the museums. Are we not all fetishists of one sort or another? We are all attracted to hair, lips, eyes, legs, apparel, all have our own preferences. Art – sometimes consciously, sometimes less so – brims with just such predilections. Artists, like everyone else, have their preferences too, obsessions which become the pet motifs that figure so prominently in their work. These endless "shameful" proclivities can be classified according to general thematic clusters or individual preoccupations.

There are painters exclusively possessed by the female pudendum. Gustave Courbet, in a work he revealingly titled *The Origin of the World* (p. 51), painted the female genitals in lingering, worshipful detail. Other artists similarly predisposed – among them Rodin, Kubin, Dix, Grosz, Schiele, Masson, Picasso, Brauner, Magritte, Wols and Wesselmann – fancifully transfigure the genitalia into a landscape, fruit, blossom, animal or monument. Ever since Greek antiquity, the male penis has also had its admirers: from Dürer to Mapplethorpe, from Warhol to Fetting and Cocteau. The devotees of fleshy, full-bosomed women form another column, one running from Rubens and Rembrandt to Maillol and Renoir. Not to be forgotten are the aficionados of the gigantesque, artists such as Lindner, Botero, Lachaise. And then there are those drawn to the

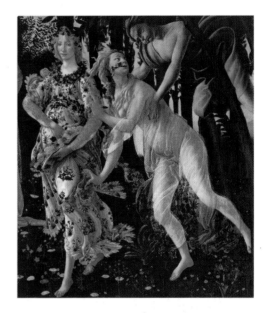

Sandro Botticelli
Detail from: *Spring,* 1477/78
La Primavera
Oil on canvas, 203 x 314 cm
Florence, Uffizi

ILLUSTRATION PAGES 6/7:
Otto Dix
Detail from: *Portrait of the Dancer Anita Berber*
See illustration page 13

Christian Schad
Self-Portrait with Model, 1927
Selbstbildnis mit Modell
Oil on panel, 76 x 71.5 cm
Private collection

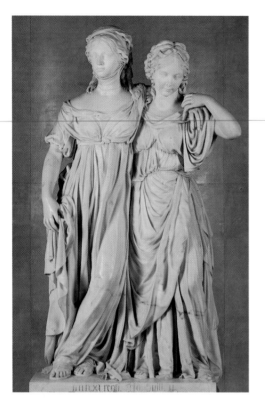

Johann Gottfried Schadow
Crown Princess Luise and Princess Frederike,
1796/97
Die Prinzessinnengruppe
Marble, height: 172 cm
Berlin, Staatliche Museen zu Berlin –
Preußischer Kulturbesitz, Nationalgalerie

cadaverous or gaunt, among them Otto Dix, Grünewald, Schad, Schiele, van Dongen, Gruber and Giacometti.

Goya's rendering of pubic hair was audacious at the time. More recent and daring expressions can be found in the work of Modigliani, van Dongen, Magritte and Delvaux. The fascination with hair runs from Rubens' *The Little Fur* (p. 96), which inspired Leopold Sacher-Masoch's "Venus in Fur", to such bizarre creations as Meret Oppenheim's *Fur-Lined Tea Cup* (p. 99).

Paintings portraying paedophiliac themes can work as a heady stimulant on adults fascinated by boys, as well as those smitten by prepubescent girls. The masters of this mode – each every bit as daring as Balthus – include Caravaggio, Schad, Schiele, Otto Mueller, Heckel and Jeff Koons. Michelangelo, Dalí and Bacon are captivated by the male nude, while Pearlstein, Kahlo and Balthus prefer to frequent Sappho's passion theatre. Pregnant women have their own devoted admirers, a list that reaches from Manuel Deutsch to Gustav Klimt. Fetish followings have also sprung up around tattoos and various items of apparel. Accessories, lingerie, lace gloves and black stockings have inspired the creations of countless artists. One need only recall Toulouse-Lautrec or Degas, Rops, Schad, Man Ray, Foujita, Rouault, Beckmann, Bellmer, Lindner, Jones, Blake, Balthus, Jeff Koons, Kacere.

Does this imply that apart from innovations of technique and strategies of form and colour, the semantics of eroticism have remained shackled in place? Is that same traditional stereotypical pair – the lust-crazed, predatory artist and his devoted, compliant model – still busy at work? Has the male's relationship to the female, sexuality, and art edged forward over the course of the centuries, or is humankind yet labouring – despite the optimism of an Auguste Comte – under the yoke of ignorance, naiveté and religious stupefaction? One cannot help concluding that humankind's two-poled sexual dynamo with all its egalitarian machinations is still very much a thing of the drawing board. And this conclusion is by no means mitigated by the popular belief that humankind has arrived upon the threshold of an all-new and improved era: the Age of Acceptance. "In order that the vulva be outfitted with the right to artistic self-expression," writes Gérard Zwang in his book "The Female Gender", "society must everywhere grant women equal rights, including sexual equality. A fundamental prerequisite therefore is the secularisation of customs and social behaviour – even if it portends no more than a beginning."

But the fact is that artists themselves are still incorrigible machos. They refuse women the right to express their will, to make and carry out decisions, to exercise their initiative. Down through the ages the female has embodied art's foremost aesthetic ideal, a ranking she by and large has attained as sex object – as a blow-up doll subject to the artist's will. Whether she is the maid of La Tour, the princess of Goya, or the odalisque figures of Ingres or Matisse; whether she is the exotic fruit of Gauguin, the landscape by Masson, or the pin-up by Warhol; whether van Eyck portrays her at church, Greuze paints her busy in the kitchen, or Fragonard depicts her nestling in bed; whether she is the salon hostess of Boucher, the bordello madame of Toulouse-Lautrec, or the female sharing the bathroom with Bonnard and Wesselmann – the advent of modernism has hardly elevated her status. Indeed, the modern artist has employed his powers to deface the female, to obliterate beauty's quintessential ideal bit by bit. The modern artist has transformed the female into a geometrical representation,

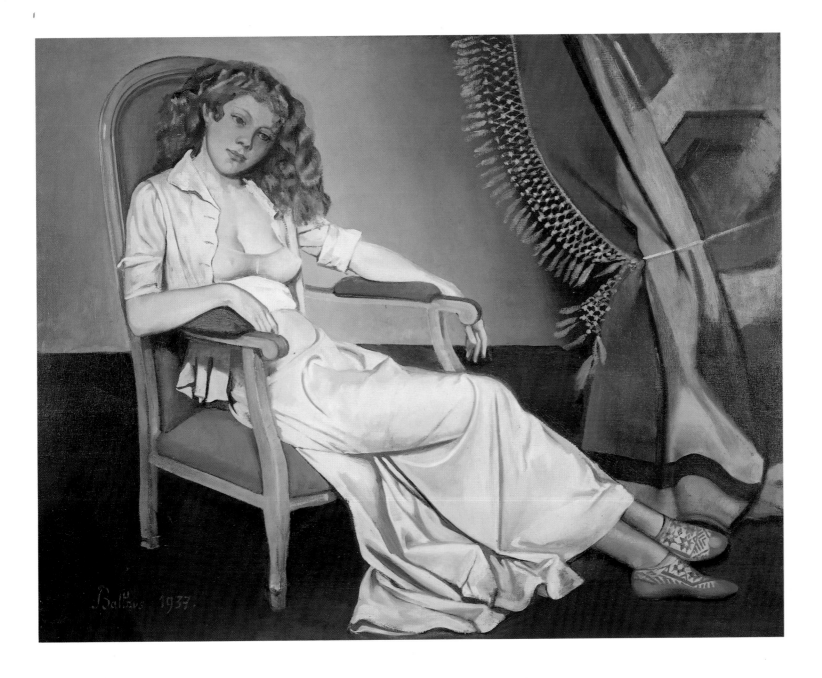

Balthus
The White Skirt, 1936/37
La jupe blanche
Oil on canvas, 130 x 162 cm
Zurich, Courtesy Thomas Ammann

has simplified her, elongated her, roguishly added or subtracted pounds, portrayed her jetting apart in explosion. The artist oscillates back and forth between the attenuated and the obese, the monster and the beast. Only the power of the erotic has spared the female figure from undergoing a total Kafkaesque metamorphosis. Only the erotic has kept her from becoming merely animal, vegetable or mineral. "One has to read this phenomenon as the confession of modern man," writes René Huygue, "who, exactly like archaic peoples, stands uncomprehending before an enigma. Fearful, wary, he is forever being confronted with it anew, for he has thrown overboard all those safeguards the past had equipped him with."

"The man of spirit," Auguste Rodin remarks, "is a stud horse on the make with nature." Malraux speaks of the "incurable conflict" Picasso experienced in his relations with what he termed nature: "Nature must exist, so that man can do her violence!" On another occasion, in the company of Roland Penrose, Picasso declared: "To create a pigeon, one must first wring its neck." Must the modern artist first wring a woman's neck before she is eligible to become a

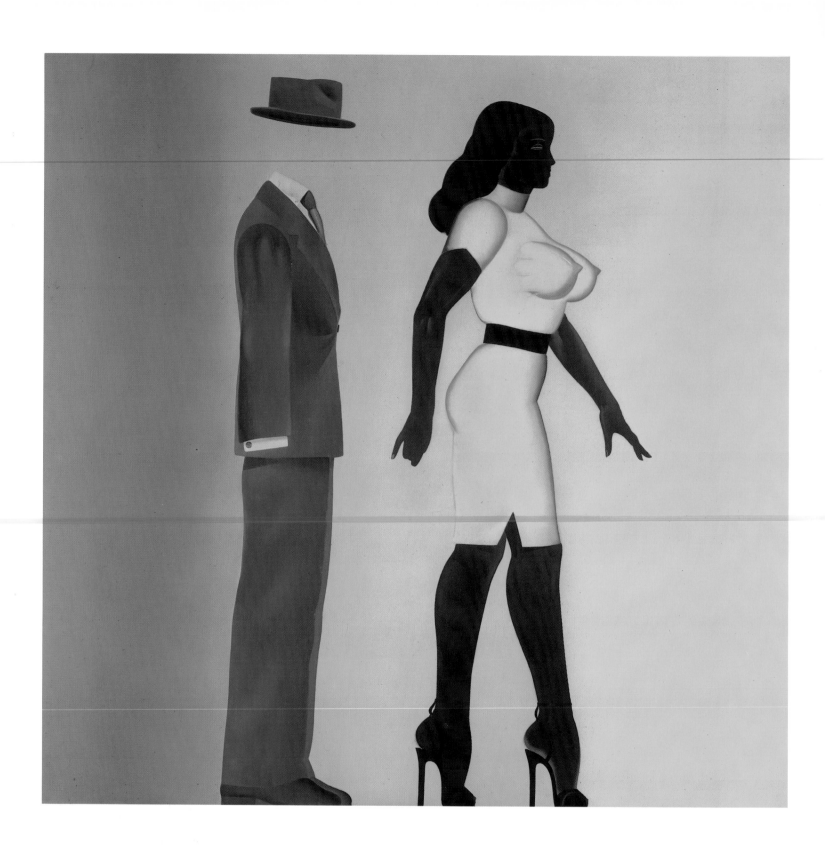

Allen Jones
Maid to Order III, 1971
Oil on canvas, 182.88 x 139.7 cm
London, Waddington Galleries

work of art? No doubt – but solely upon the condition that afterwards she resume her womanly functions, pick up where she left off. Only with a growing sense of horror can one entertain the question: what motivates the artist of genius, that phoenix who burns to experience the never-slackening pleasure of rising up anew from his ashes after giving himself over so utterly to the obliterating power of artistic coitus that every inhibition, every last convention is stripped away? Can it be anything else than his sexual desire, that erotic fuel, the fantasies he distils directly from nature before he sweeps off to attain the summit of desire?

Aristide Maillol
Study for the Torso of Flora, 1911
Etude pour le torse de Flore
Bronze, 66 x 13 x 17 cm
Dijon, Musée des Beaux-Arts

"I want the young girl I depict in a statue to stand
for all young girls, and the woman expecting a child
to symbolise all mothers..." A. M.

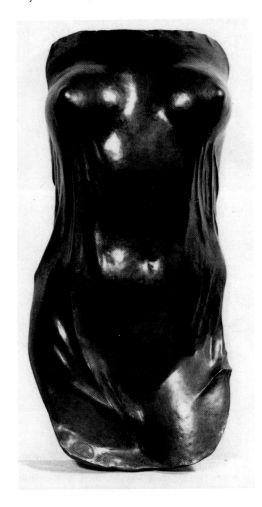

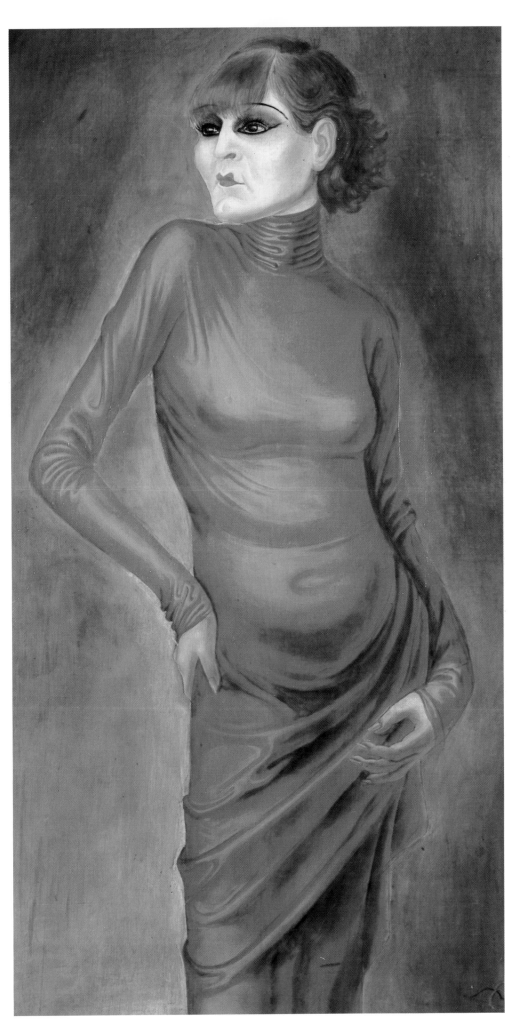

Otto Dix
Portrait of the Dancer Anita Berber, 1925
Bildnis der Tänzerin Anita Berber
Oil and tempera on panel, 120 x 65 cm
Stuttgart, Galerie der Stadt Stuttgart

Clothing plays an essential role. It is almost impossible to overestimate the stabilising function clothing performs by girding the artist's feverish imaginings. Clothing performs a double-edged service: it both spares the body from becoming a wandering exhibitionist spectacle and tantalizes one's curiosity. Striptease weaves a powerful erotic spell. Living naked along the Pongo, tribal bushmen of West Africa are on the most intimate terms with this phenomenon: they refuse to allow their wives to wear clothing. Clothed, their feminine beauty would be so enhanced that the males of neighbouring villages might ravish them away as toothsome trophies. What artists have always cultivated in their work is beyond the imaginable pale of missionaries, men who have traded in their fantasies for the inspirations of holiness. One missionary confesses with awful bitterness and contrition: "By attiring their naked bodies, we have contributed to the natives' moral undoing, created in them an altogether unhealthy curiosity, one which never before existed."

Eroticism cannot exist without taboos. Humankind possesses an extraordinary faculty for inventing taboos. An entire catalogue of them is elaborated by religion, a taboo tailored to every person's desire. Taboos can be gleaned in prodigious number from the Bible. We have learned how to utilise clothing as a way of regulating or controlling desire. The dosage of sex appeal is determined by the clothes we choose to wear. Like the flame of a lamp, the desire in others can be intensified or extinguished. There are two main categories of clothing: work attire, pragmatic, a hindrance to sexual desire; and leisure apparel, attractive, even seductive. How much to reveal, how much to hide away? The answer depends on whether one wants to come across as tastefully demure or convey a more provocative impression – a move which can work as an open invitation for an encounter, and signal one's availability. Therein lies the difference between the labourer, invisible in his work outfit, and the night-club hostess, who, revealing more than she hides, emboldens expectations.

Max Beckmann
Columbine (Carnival Mask, Green, Violet and Pink), 1950
Columbine (Fastnachtsmaske grün, violett und rosa)
Oil on canvas, 135.5 x 100.5 cm
St. Louis (MO), The St. Louis Art Museum, Bequest of Morton D. May

"Surrender yourselves to the ascetic, renounce all worldly things, and by doing so you derive a certain concentration, but you might also dry up. Abandon yourselves into the arms of passion, and you could easily become burned. Art, love and passion are very closely related. Because they all hinge more or less on the realisation of beauty in some form or other, or in its pleasure-taking. And the intoxication is exquisite – it is not true, my love?" M. B.

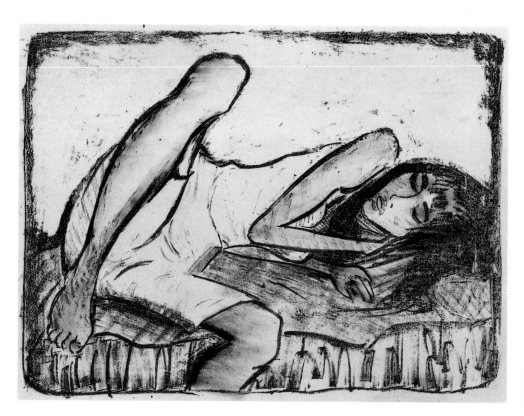

Otto Mueller
Girl Reclining on a Bed, 1919
Mädchen auf der Liege
Lithograph, 32.5 x 44.5 cm
Berlin, Galerie Nierendorf

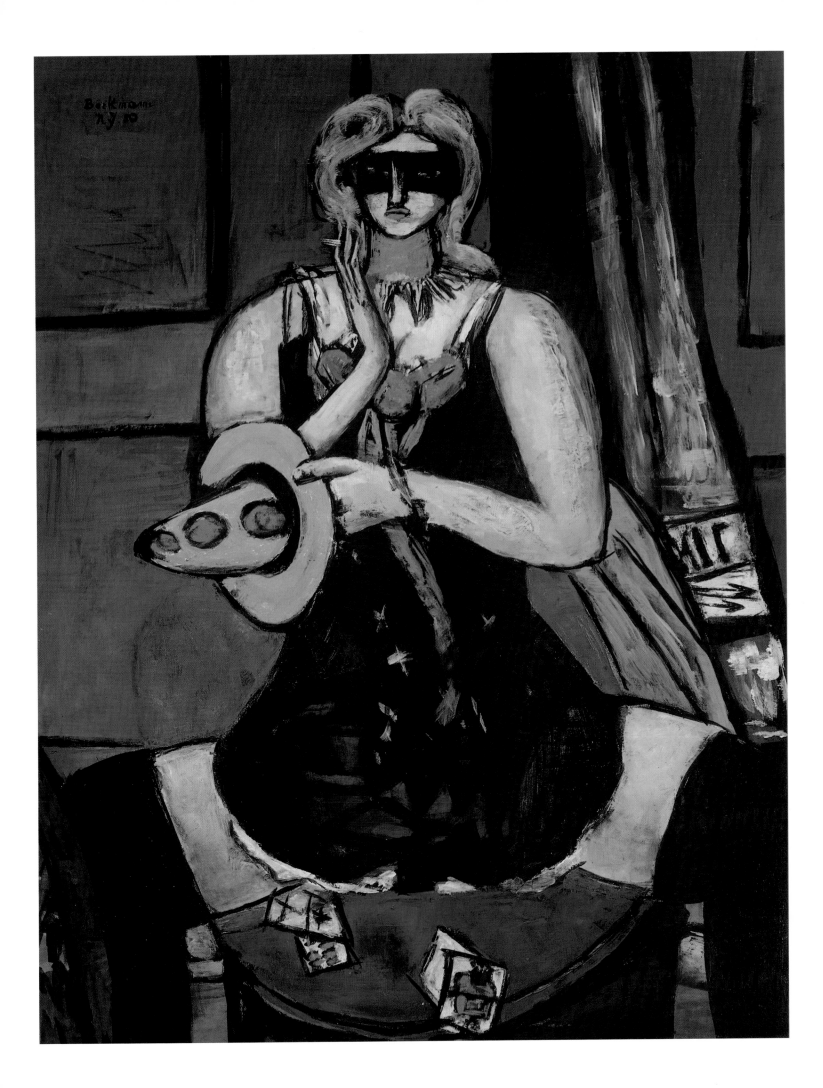

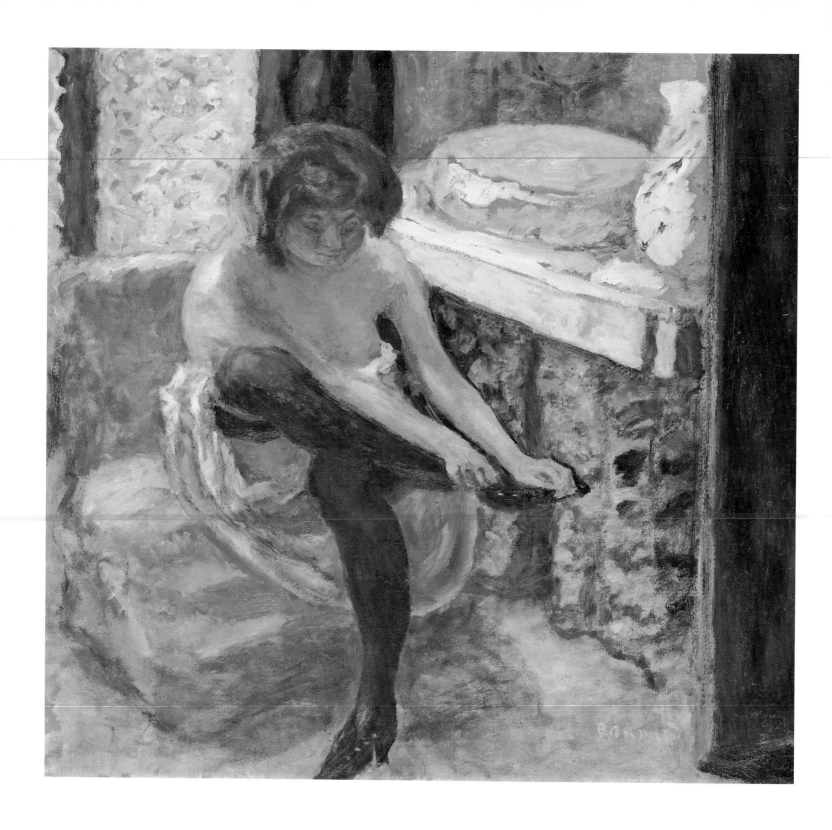

Pierre Bonnard
Woman with Black Stockings, circa 1900
La femme aux bas noirs
Oil on card, 62 x 64 cm
Lucerne, Galerie Rosengart

Otto Dix
Girl with Rose, 1923
Mädchen mit Rose
Watercolour, 61 x 48.5 cm
Private collection

Clothing is the second skin. This truism has always inspired those artists whose accomplished brushes have been capable of replicating the voluptuous effect. Eroticism draws on the collusion of body and garb: sexual fantasies and desires toss off their fetters, attire and bodies commingle, flesh and fabrics meld, and the neck, shoulders, arms and thighs co-exist upon the same plane as silk, satin and synthetic materials. Fabric wrinkles might well be mistaken for wrinkles of skin. It has been said of the seemingly innocent portraits of Ingres and Matisse that the figures appear as if they might step naked from their clothes at any moment, as if their garments might simply vanish, disappear, leaving behind the naked body to exalt in triumph. Whether one considers the mar-

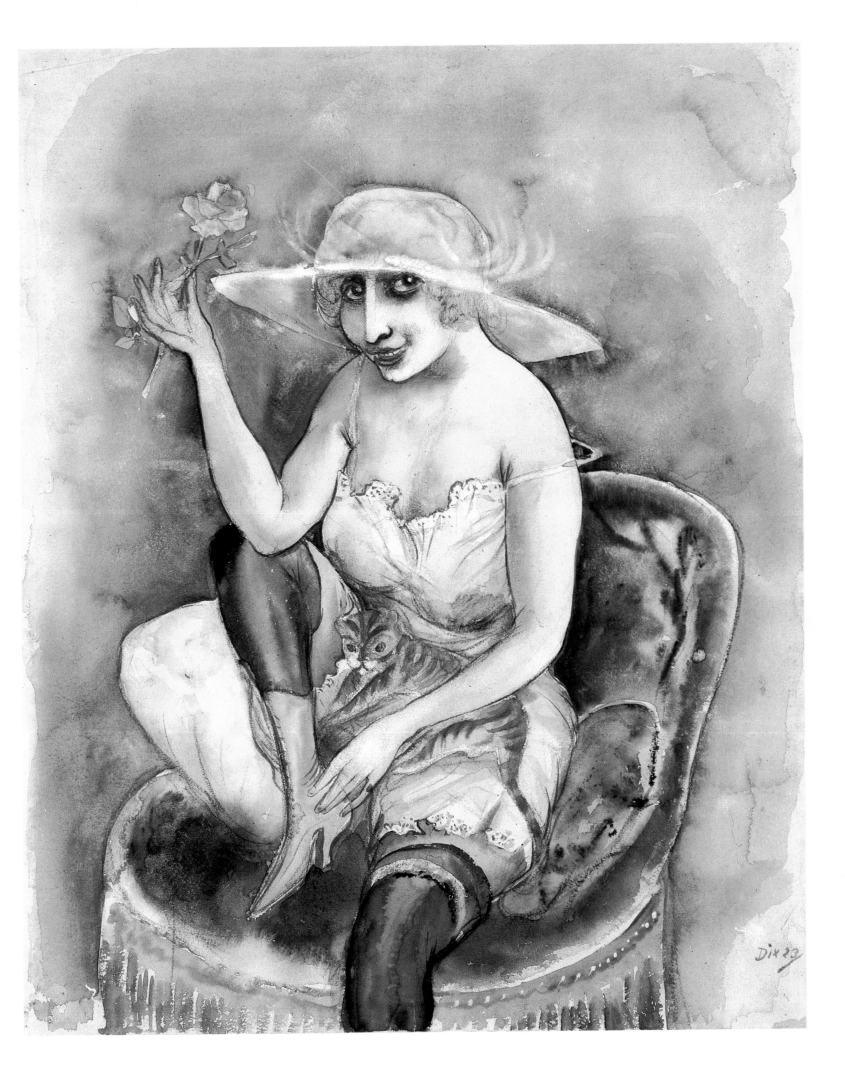

William N. Copley
The Devil in Miss Jones, 1972
Acrylic on canvas, 130 x 97 cm
Antwerp, Lens Fine Art

"I have a very dirty mind. It has brought me neither
success nor failure." W.N.C.

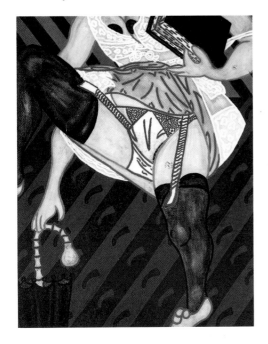

kedly aggressive, Anglo-Saxon approach of Allen Jones (p. 12), the more motherly and Mediterranean version of Aristide Maillol (p. 13), or the somewhat morbid style of Otto Dix (p. 13), one is confronted repeatedly with the same phenomenon: what counts in such work is at once nakedness and formal elaboration. Transformed into voyeurs by these artists, we must contemplate these "obscure objects of desire," images which – depending upon one's tastes – are either magnificent or monstrous. Are these female figures aware of the urges they rouse within us? Or are they satisfied merely to exist? To exist and to torment the unconscious with their siren solicitations? We should beware of arrogance. Perhaps, as in the compositions of Klimt or Manet, the female subjects are indeed innocent of their erotic charms. It is the artists, however, who are never innocent. They know exactly what they are doing when they thrust their works before the public, images which well from the depths of their erotic fantasies, emerge from the white heat of their desires.

Very few painters of accomplishment have left the tradition of art a successful image of the feminine ideal. Years elapse between the artistic careers of Botticelli and Piero della Francesca and those of Veronese and Tintoretto. Ingres arrives much later. His expressions of the eternal feminine – here with an added maw, there with an extra vertebra or two – pursue the female ideal known from classicism. Matisse is very likely the first modern painter in whose work we find female figures who do not solely intimate a personal ideal – as do the servants of Renoir, the dancers of Degas, and the *femmes fatales* of Klimt – but instead lend expression to an age. Viewed in this manner, Matisse's sagely beautiful images, proffering a sort of mirror, are timeless. Like the writings of Proust, his

ILLUSTRATION LEFT:
Lovis Corinth
After the Bath, 1906
Nach dem Bade
Oil on canvas, 80 x 60 cm
Hamburg, Hamburger Kunsthalle

Gerhard Richter
Pi-Mädchen / Wee Girls, 1967
Oil on canvas, 90 x 100 cm
Private collection

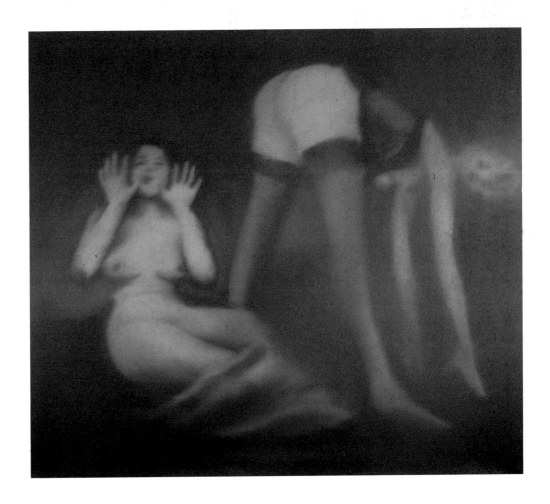

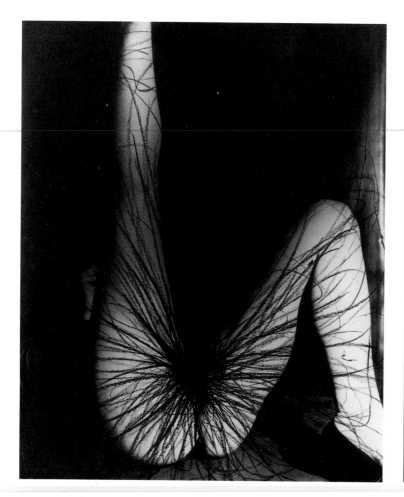

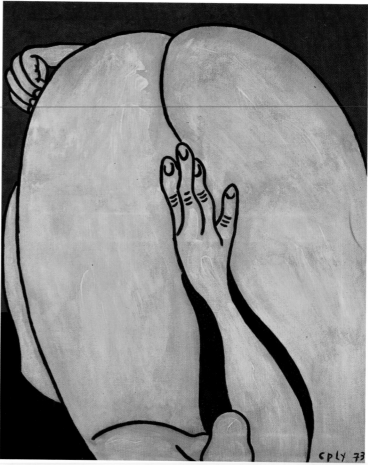

"Painting, I feel, is man's concern with women. Men look; women touch sculptures."　　　W.N.C.

women consummately capture the mood of an age. Since then such artists as Warhol, Wesselmann and Jeff Koons have stepped forward as the articulators of this venerable motif – quirky, individual talents familiarizing us with the modern Eve. These artists powerfully render the spirited evolution of our age, lend expression to its underlying problem: the rise of consumer society and the ensuing spread of recreational culture. Who but Marilyn Monroe or Cicciolina could better embody the new Alice in Wonderland, that pin-up in cellophane (puritanical enough in its way) – an unadulterated occasion for voyeurism, as artificial as she is untouchable as she is impenetrable. Everything unveiled for the eyes, at the striptease joint or at the Playboy Club – but though you can look, you definitely can't touch. With this in mind we can understand Warhol's remarking that the entire world was made of plastic – and that he loved plastic. Louis Aragon once observed in regard to Fernand Léger: "There is more to admire in a coffee grinder than in heaven's entire assembly of angels." We are indebted to Warhol and Koons that art has progressed from the cantankerous puritanical contraptions of the 19th century to hyper-modernity's exaggerated refinements.

The deceitful use of clothing has yet a few more advantages. Not only do clothes hide the body's progressive ageing, but they also conceal the latent physical clumsiness of puberty, the budding breasts of the child–woman, the pubic hair beginning to fleece the genitals. Everyone finds it adorable when children run naked along the beach, but once puberty shades the genitals, grown-up smiles turn to frowns. Because pubic hair reminds us of the animal

world? Does that explain why so many people are ashamed of the hair covering their groins? Strange, for very few animals possess pubic hair. (Neither, incidentally, do many Orientals.) In the West, the pubic hair taboo tends to be broken only at night-spots with special licences; and in Japan, where pubic hair is thought of as an insidious disfigurement, a monstrosity visited upon the native population by outsiders, the taboo is more carefully monitored than ever.

According to Hirschfeld, of every 1000 men, only 350 are attracted to a completely naked woman, some 400 find her most beguiling when she is half-clad, and 250 register their peak attraction only if she is attired from head to foot. Or, to phrase his findings differently: 65 per cent of "normal" men have fetishist tendencies. If the garter belt – actually a fairly recent invention, for it is

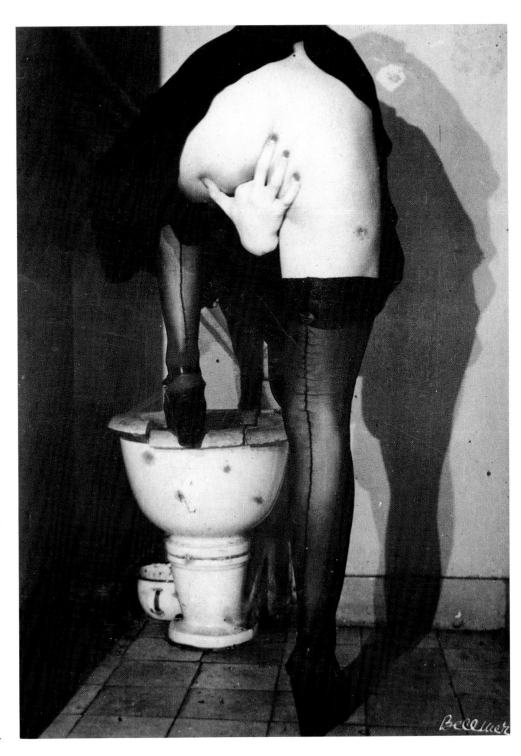

Hans Bellmer
Untitled, 1946
Tinted photograph, 17 x 12 cm

"In all probability no one has to this point seriously enough considered to what extent the image of a desirable woman is dependent on the image of the man who desires her, so that in the end it amounts to a series of phallic projections which progress from one segment of a woman to configure her entire image, whereby the finger, the arm, the leg of the woman, could actually be the man's genitals – that it's the male sex organ in the woman's firm, stockinged leg, the thigh swelling over – or in the pair of rounded buttocks out of which, arching backwards in tension, the column of the vertebrae extends – or in the double breasts, that hang down from the extended neck or freely from the body – so that the phallus is finally the entire woman, sitting with hollow spine, with or without hat, standing erect . . ." H. B.

Richard Lindner
Suburban, 1969
Gouache, 152 x 116 cm
Paris, Galerie Maeght

no older than the Eiffel Tower – still qualifies as the Occident's supreme erotic achievement, it has indeed a long line of noble precursors. One need only recall how Faust, in Goethe's drama, cries out during a fit of emotion: "…bring me the kerchief from her breast, or a garter for my love's delight." In accordance with his last will and testament, Anatole France, the much honoured and revered French author, was buried with a sealed case containing the panties of Madame Armand de Caillavet, the wife of a government official – the pair she had worn upon first surrendering to the writer's advances. Glorious knickers! Along with their illustrious collector they enjoyed the tribute of a state funeral.

In one of his prose poems, Charles Baudelaire, while dreaming of his Columbine, informs us of the fey musings of "Mademoiselle Bistouri", a woman who has fallen in love with a surgeon: "I wish he would come to me, with his bag and wearing his smock, even though it be slightly flecked with blood!" She

says this with that same exhilaration of emotion one might discern in the voice of the sensitive man who bids his actress lover: "Let me see you in that gown again, the one you wore playing your famous role." An erotic illusion, like the feminine lingerie that reveals a world that must remain hidden. An erotic illusion, like the uniform, the nurse outfit and the tie – yes, the everyday tie, idolized by so many women when looped around the neck of a man, for it has the aura of an undergarment in the same sense as a garter.

And then there is the erotic illusion of the fur coat. According to Sigmund Freud, the fur coat derives its fetish power by analogy with the pubic hair. Jewellery, tattoos and shoes can also cast intoxicating erotic spells. And not to be discounted are the mutilated feet of Chinese women, the hunchback who brings good luck, and the one-legged whore with her endless stream of clients.

Konrad Klapheck
The Womaniser, 1974
Der Schürzenjäger
Oil on canvas, 85 x 100 cm
Private collection

"The corset-pink intensifies the erotic mood of the painting, to which also the title, derived from the function of the item, alludes in humorous ambivalence."
Werner Hofmann

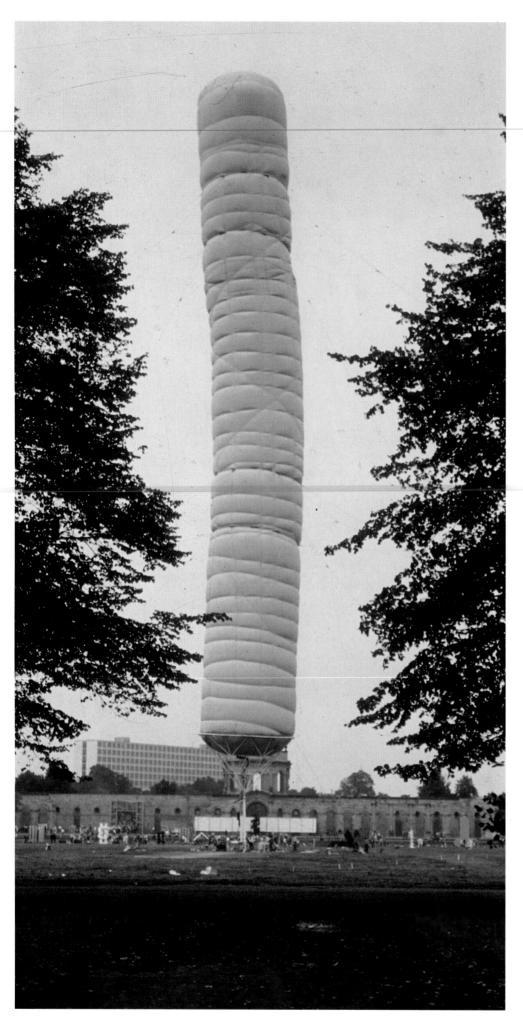

Christo
5,600 Cubic Metre Package, 1968
5,600 Cubicmeter Package
Installation (documenta 4, Cassel 1967/68),
82 x 10 m
© 1968 Christo

Christo
Wrapping a Woman, 1963
Verpackung einer Frau
In-progress photograph
© 1963 Christo

The list of secret desires can be extended endlessly, and by taking the detour of art, we can strike across them all.

"In truth, to believe that there are special objects which arouse sexual desire," writes Jean-Paul Sartre in "L'Enfance d'un Chef", "and that these objects are women because they possess a hole between their legs, is a malicious and wilful error of the Establishment [...] anything can operate as an object of sexual desire, a sewing machine, a test tube, a horse or a shoe." Eroticism in art, from the point of view of the artist, comes about (as Surrealist practice amply showed) by juxtaposing various objects and the human physique in discordant relationships, or in relationships which reinforce a common tenor. In a work dating

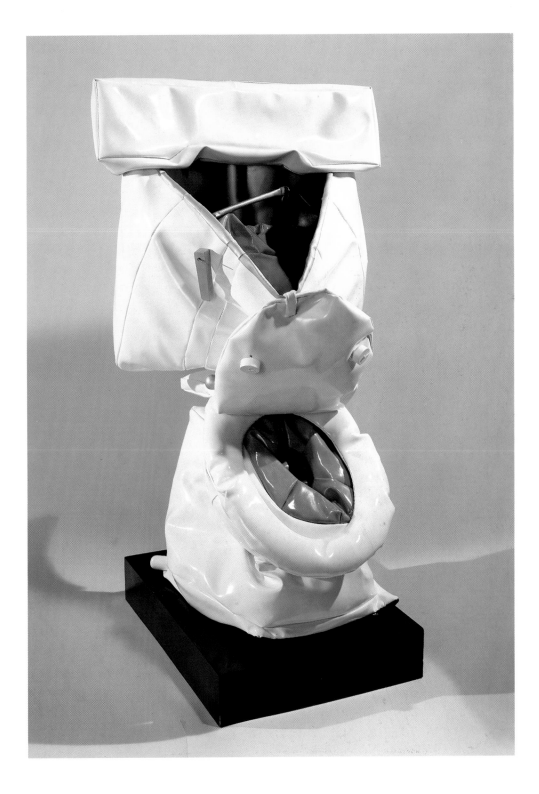

Claes Oldenburg
Soft Toilet, 1966
Vinyl, kapok and wood, painted,
132.08 x 81.28 x 76.2 cm
New York, Collection of Whitney Museum of American Art,
Gift of Mr. and Mrs. Victor W. Gane
in Honor of the 50th Anniversary

Jean Cocteau
Illustration to Jean Genet's "Querelle de Brest"

from 1950 entitled *Carnival Mask, Green, Violet and Pink* (also known as *Columbine*; p. 15), Max Beckmann configures his composition's fetishism by assembling the circus costume of the woman; her accessories; the cards which seem to have slipped out from beneath her dress; the lewd, intentional manner of her pose; and the black hosiery, which exaggerates her splayed thighs. This riddle could carry the title Love, a Game of Chance? A game without a deeper meaning, or instead, one steeped in delicious mystery?

The garter belt in William N. Copley's *The Devil in Miss Jones* (p. 19; the title was borrowed from a famous pornographic film) appears to rise like a curtain above the theatrically suggestive gestures of the painting's headless heroine: the fingers of one hand ply the pages of a book, while the other hand reaches for the handle of an umbrella. The realism of Balthus is often termed magical – aptly. Major poets and writers have ackknowledged their intrigue with his work, among them Rainer Maria Rilke, André Gide, André Breton, Antonin Artaud and Albert Camus. Some, for instance Artaud, are beholden to Balthus for his vital reworking of Surrealism's "embryonic painting". Surrealists of Breton's order admire his furtive, suggestive eroticism. Camus discerns in Balthus the "Bluebeard" of painting. Regardless of the swarm of opinions about the man, one thing is certain: Balthus appears in public only in the company of young girls, his "nieces", as he calls them. They play about his feet like little kittens, exhibiting glimpses of their knickers. Young girls such as these furnish Balthus with his leitmotiv. "We all have a passion," René Char remarks, "for the tenderness of these young wasps, which the bees have named girls, and who wear hidden in their bodices the key to Balthus." Delvaux peoples his vacant world with sleepwalker-like women, in the full bloom of beauty. Balthus prefers the bittersweet perversions of adolescence; in the best of the sado-Baudelairean tradition, his cast includes both victim and torturer.

Lindner is another story altogether. He has no ambition to paint the female. Instead, he paints only her skin, or better yet, her panoply of armour (p. 22). The acknowledged master of images with sinister overtones, he paints canvasses that are at once stereotypical and fraught with complication. His is a world of depraved girls, imperious equestrian riders and, complete with fetish accessories, unequivocally sadistic dominatrices clad in leather. While growing up in Nuremberg, the "City of Toys", Lindner was gripped by the fetishism evoked by the garter belt and stockings worn by Marlene Dietrich in the film "The Blue Angel". The moral and aesthetic roots which nurtured this fetishism defy untangling – it was Germany upon the eve of the Nazi take-over. Later, after emigrating to New York, Lindner was marked by experiences of a radically different nature: he saw his fantasies acted out in daily life. The tension in Lindner's work results from the secret, frustrated desires he brought from Germany to America, and then the experience of seeing these fantasies lived out. The artistic sublimation found in his work presents one answer to the question of what happens when an unquenchable craving encounters its object of desire. If Pop Art sees in Lindner one of its masters, then it does so precisely because it, like Lindner, must brook the contradictory dynamic of our age.

The corset in all its various manifestations has long fascinated artists, eliciting a nearly mischievous delight not only because it functions as a potent erotic symbol, but because, in practical terms, it so forcefully immures its wearer. Revenge for some artists, the urge for power in others? The corset is a perfect

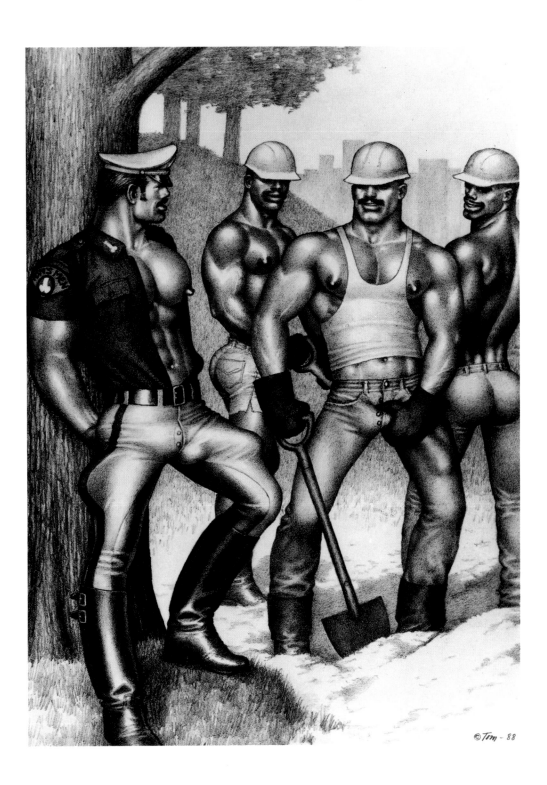

Tom of Finland
Lumberjacks, 1988
Pencil, 39.4 x 29.1 cm
Los Angeles, Courtesy The Tom of Finland
Foundation

strait-jacket. Its function is to rigorously accentuate the breasts and hips, a duty it accomplishes by imprisoning the female so unnaturally that she is forced to feel a friction between her thighs each time she takes a step. We gain a clearer insight into the conditions which generated the work of Freud if we are acquainted with the epoch in which the founder of psychoanalysis performed his investigations. It was an era in which the corset both imprisoned the female body and armoured it against sensuous attack. The corset gave material expression to a ban placed on the male, a societal taboo which it helped enforce through its defensive character. "Lust has the damnable fate of existing only over a duration of time, and is lingeringly and secretly kept alive by the manifold guards lined up to curb it," writes Jacques Laurent.

Mel Ramos
Beaver Shot, 1966
Oil on canvas, 111.7 x 121.9 cm
Fremont, Mr. and Mrs. Stan Schiffer
Collection

28

Thus the crisis of the object goes beyond the self-referential or introspective. That crisis has been one of the prominent themes of the 20th century, a debate precipitated by Picasso when he crossed the seat with the handles of a bicycle and called the progeny the head of a bull. The object, a simple body, becomes a machine, a complex body, and therewith confirms its superiority over the human. In this regard, both Klapheck (p. 23) and Klasen establish nomenclatures that undermine the rote functional values of objects, yet win for them significance through heightened representation. Freud, one might recall, theorized that all objects are capable of becoming libidinal signifiers, especially objects endowed with functions. Like nobody else, Duchamp, creator of *The Coffee Grinder*, *The Chocolate Grinder*, and *The Bride Stripped Bare by Her Bachelors,* is a disciple of "the humour of objects". He places his trust in machines, not only to make plausible his mechanical-cum-cynical interpretation of the phenomenon of love alongside its wealth of philosophic and aesthetic ramifications, but also to make accessible a space in which each object can be found again by the mechanism of the human psyche, a space in which each object functions according to the traditional character assigned to it by the mechanism of desire. Havelock Ellis had already explicated the practical merits of common machines, objects so utilitarian as a bicycle or a sewing machine, in pleasurably satisfying autoerotic urges. Here a well-known remark of Lautréamont's, taken as motto by the Surrealists, returns to mind: "Beautiful as the chance encounter of a

Max Ernst
The Garden of France, 1962
Le jardin de la France
Oil on canvas, 114 x 168 cm
Paris, Musée National d'Art Moderne,
Centre Georges Pompidou

"The Touraine is commonly referred to as the garden of France. Max Ernst lived for years in Huismes by Chinon, on a strip of land between the Indre and Loire rivers, from whence the Département takes its name. Here this district becomes an anthropomorphic landscape, for the artist has so entirely painted over the salon image of a female reclining nude, that only the erogenous zones remain visible. The manner he employs actually goes back to a technique of voyeurism which was once used by the half-mythical groups at the beginning of the American era."
Günter Metken

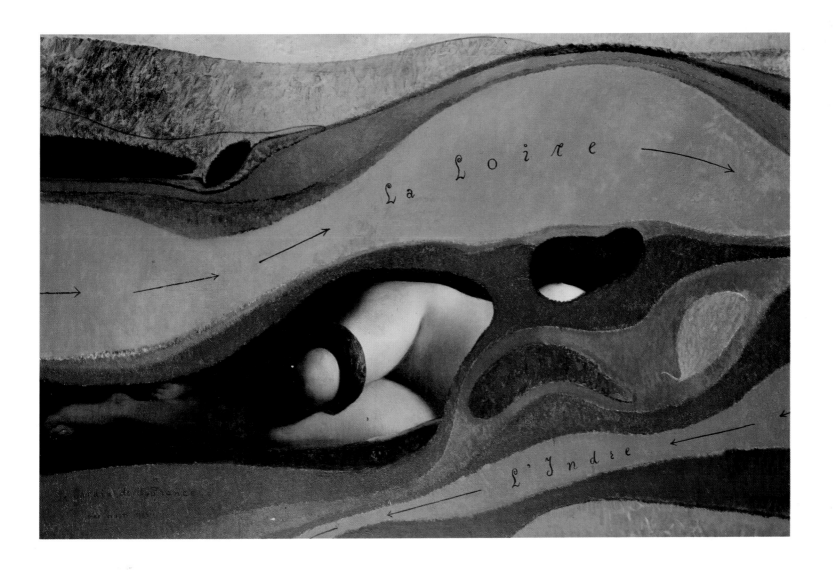

René Magritte
Philosophy in the Boudoir, 1947
La philosophie dans le boudoir
Oil on canvas, 80 x 60 cm
Washington (DC), Private collection

ILLUSTRATION PAGES 32/33:
Robert Gober
*Male and Female Genital Wallpaper and Two
Drains,* 1991
Silkscreen on paper, drains, 20 x 12 x 16.5 cm
New York, Courtesy Paula Cooper Gallery

*"In the second room too, the wallpaper with male/fe-
male genitalia worked impressively in terms of dec-
orative design, as well as concept. In this room the
drains mounted in the walls evoked a string of meta-
phors. The drains made tangible absence, separation.
The holes in the walls called to mind peepholes,
arseholes and vaginas."* Gregg Bondowitz

sewing machine and umbrella upon a dissecting table." This remark set in motion the flurry of activity which attributed symbolic functions to the entire roster of machines.

Is not the female anatomy, the object of every male desire, through the power of creation, or better, artistic re-creation, transformed into that marvellous mechanism it never ceased to be? Whether she is nearly idolized by Picabia, or painted lolling passively by Schiele (p. 53); whether we find her flaunting herself from every angle, as in Gerhard Richter (p. 19), or insinuating disapproval with her hand (a gesture that finally appears more provocative than discouraging), as in William N. Copley (p. 20) and Hans Bellmer (p. 21) – each image ultimately returns to the same fundamental questions of painterly accomplishment and medium. We sense the autobiography of our mechanical age emerging beneath the artists' fingers. "So long as the desire for technical advance rules the world," writes Jacques Vaché with regard to his *Octopus Typewriter,* "one cannot expect the machine to renounce its role as vamp – even though it be unmasked."

In the brave world of erotic art, the male plays a small supporting role – as the solitary figure in Jean Cocteau (p. 26), say, or as one of a group of lads assembled to play some pocket pool, as rendered by Tom of Finland (p. 27). But whenever eroticism wants to strut its stuff, it uses the body of a woman. The model sacrifices her anatomy to the artist's imagination, although she well re-alises that he might carve her up, mutilate her in the manner of Max Ernst (p. 29). Or that he might transmogrify her, peel back the layers of her being until only the erotic segments remain. Perhaps his fantasy will eschew all but her genitals or breasts – which still exist (regardless of how broad the Cheshire Cat in "Alice in Wonderland" may grin), intact and glowing voluptuously from the diaphanous night-gown hanging in Magritte's *Philosophy in the Boudoir.* The woman has left the frame. Freudian professionals raise the issue of castration at this point. The painting pays homage to the Marquis de Sade, a protagonist of the modern age which he could never be to his own. De Sade poured himself uninhibitedly into his writings, and for this he paid most dearly – for the blunt existence of his fantasy desires, and for rendering them in his art.

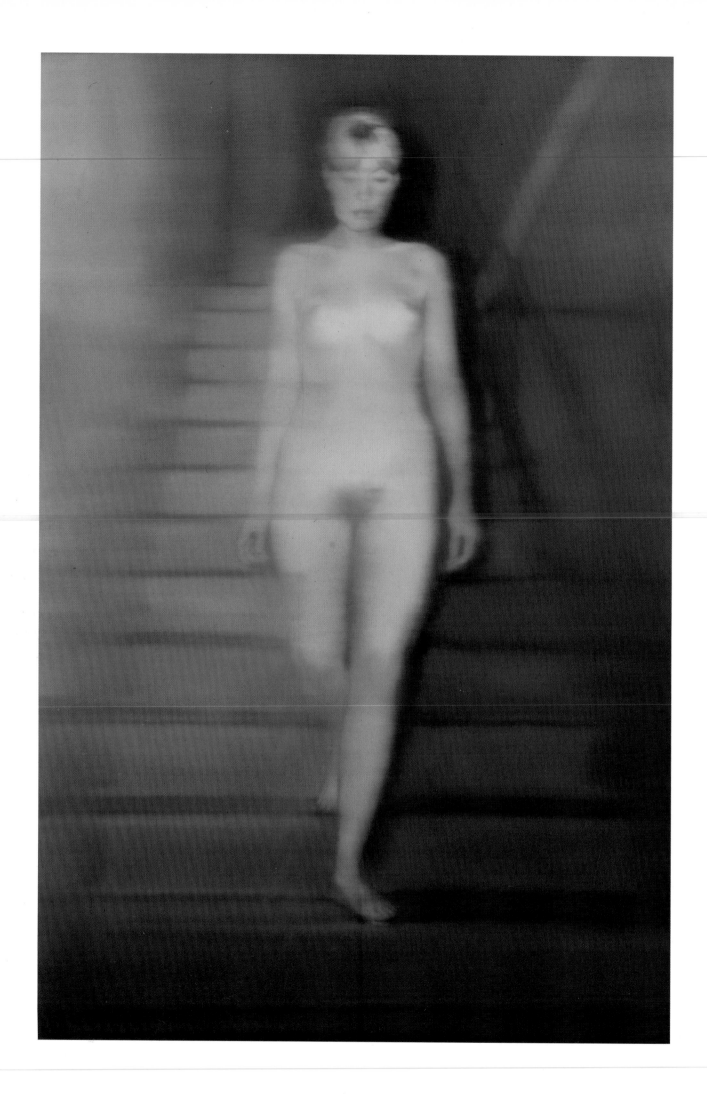

The Nude as Self-Portrait

Every artist is a Narcissus returning to work continually on his own self-portrait, even when he is painting this or that female nude. The gestalt of the creator is woven into the formal elements of every painting, every graphic work, every sculpture. France Borel observes in her book, "The Model", "The artwork feeds on the artist's longings, on his passion for the other, for the model, the nude woman posing before him, and on his narcissistic passion for himself. The creative act is profoundly erotic in nature. Paintings and sculptures are composed of tactile materials, possess erogenous zones. They assume the form of human beings. They are a kind of fetish, operating simultaneously as sexual substitutes and as vehicles for erotic projections. Shaped by the flesh and spirit of their creators, they take on a life of their own, conveying pleasure."

According to legend, we have Gyges of Lydia to thank for the first graphic work. In the market place, he picked up a piece of charcoal to outline his own shadow on a wall. The creative act is surely, among other things, an attempt to gain immortality. And eroticism, by the same token, is a way of thwarting death. With his blood, his semen, his drippings (in Pollock's case), the artist accomplishes his creative work. And indeed, artists prized for their virtuoso renderings of the skin, artists such as Titian, have always stood accused of mixing their blood, their sperm, the vital substances of their beings, in with the pigments of their oils.

Paul Klee addresses this fundamental problem of the artist in his private journals. An artwork is profoundly male and female, Klee claims: female as a formal creation, and male in the spermatic potency of its motif. The vital male element derives its character from the substance of the female element. No artist or human being exists who is solely male or female; everyone is a subtle mixture of both principles. The artwork which is engendered by the interpenetration of the male and female elements, Klee continues, takes as its most essential and immortal theme the nude, which originates in nakedness.

The artist selects his model according to how closely she typifies his own idea of the feminine. "The artwork weaves itself into the skin of its creator," Jean-Paul Sartre writes, "doubles with his flesh." Gustave Flaubert remarks, "I am Madame Bovary." And Nietzsche speaks of the blood of the letter being equal in importance to its spirit. From this double, this metaphorical body, this repository of fantasy desires, the artist derives his vital subject matter. The double is the centrepiece of Western iconography. The artist clothes or disrobes his

Balthus
Reclining Nude, 1977
Nu au repos
Oil on canvas, 200 x 150 cm
Paris, Collection Claude Bernard

ILLUSTRATION OPPOSITE:
Gerhard Richter
Ema – Nude on a Staircase, 1966
Ema – Akt auf einer Treppe
Oil on canvas, 200 x 130 cm
Cologne, Museum Ludwig

"I follow no intention, no system, no set direction. I have no programme, no style, no pet concern. I have absolutely no interest in professional problems, in themes of work, in the various levels leading to acknowledged mastery. I flee from every determination, I have no idea what I want, I am inconsequent, indifferent, passive; I am drawn towards the nebulous and indistinct, the perpetually uncertain." G. R.

double as he chooses, multiplies its formal possibilities, returns to it time and again to rework its representation. He fashions his double from every conceivable medium, placing it in whatever context of associations come to mind. He even peels back the double's flesh to familiarize himself with its musculature, even peels back the muscles, the better to see the skeleton.

Art's every erratic rendering of the anatomy – for instance, the overscaled limbs and added vertebrae of *The Bather of Valpinçon* by Ingres; the almond-shaped faces by Modigliani; the elongated shapes of El Greco; the attenuated forms of Giacometti; the muscle-bound heroic figures by Michelangelo, ornamenting the ceiling of the Sistine Chapel; Toulouse-Lautrec's wilted, red-haired prostitutes; the armoured giantesses of Lindner; the lewd nymphets of Balthus; Wesselmann's cellophane-wrapped pin-ups – all these can be traced back to the artist's relentless attempt to capture his double. Realising that no living model can possibly embody his entire store of erotic desires, the artist has no qualms in transfiguring the anatomy with his brush or chisel. Perhaps he will embellish the lustre of the skin, or harrow it with slashes. He might attenuate or bloat the lines of the figure, might even – as in the cases of Picasso and Magritte – parcel the anatomy into pieces. These two artists went so far as to retain only those portions of the female anatomy which continued to gratify their interests.

Robert Gober creates the anthropomorphic effect characteristic of his work by investing ordinary manufactured objects with an erotic power, a transformation he accomplishes by symbolically associating them with the human anatomy. He too follows the laws of the dissection table. Gober draws attention to familiar objects known from childhood: a washbasin, a tap, a crib, a dress, a shoe, a simple drain, a toilet bowl. The sole difference between Marcel Duchamp's urinal of seventy years ago and Gober's recent toilet bowl and washbasin creations is that instead of purchasing his work from the shelves of a plumber's outlet, Gober makes his objects himself. A tremendous difference! "The obviously aseptic shape of these appliances," remarks the critic Harald Szeeman, "and the time necessarily invested in reading them, request the dimension of emptiness for their installation." When it comes to a drain, Gober makes an exception – the item he mounts on a wall is purchased as a finished product from a hardware store. His washbasin operates unequivocally as a sexual signifier. This effect is configured by the association the gutter calls into play with the world at large. "He does indeed deploy the devices ordinarily used to present Minimalist sculpture with its attendant spacious environment," Szeeman adds, "but the effect is to heighten a pulsating, physical eroticism, inherent to the object, that widens – as in Marcel Duchamp's works – into a closed circuit through the viewer." An artist of social commitment, Robert Gober has gone beyond mainstream artistic vocabularies to stigmatise the alleged indifference of President Ronald Reagan to AIDS. Gober etches his wallpaper with the essential features of the human anatomy, fragments that stand for the human species (p. 32). His goal is to make palpable the universal, irrepressible carnal urge which has propelled humankind since its origins. He returns to an early prehistoric age, to the precursor of Homo sapiens – Homo eroticus. And thus by tapping and redirecting his sexual drive, the modern artist approaches our primitive, proto-creative forebears. Taking leave of the pedantry and prudery society everywhere heaps, the artist is master of that nebulous realm between reality and dream.

Jeff Koons
Naked, 1988
Porcelain, 115.6 x 68.6 x 68.8 cm
Private collection

Otto Mueller
Standing Boy and Girl, 1914–18
Stehender Knabe und Mädchen
Lithograph, 43 x 32 cm
Berlin, Galerie Nierendorf

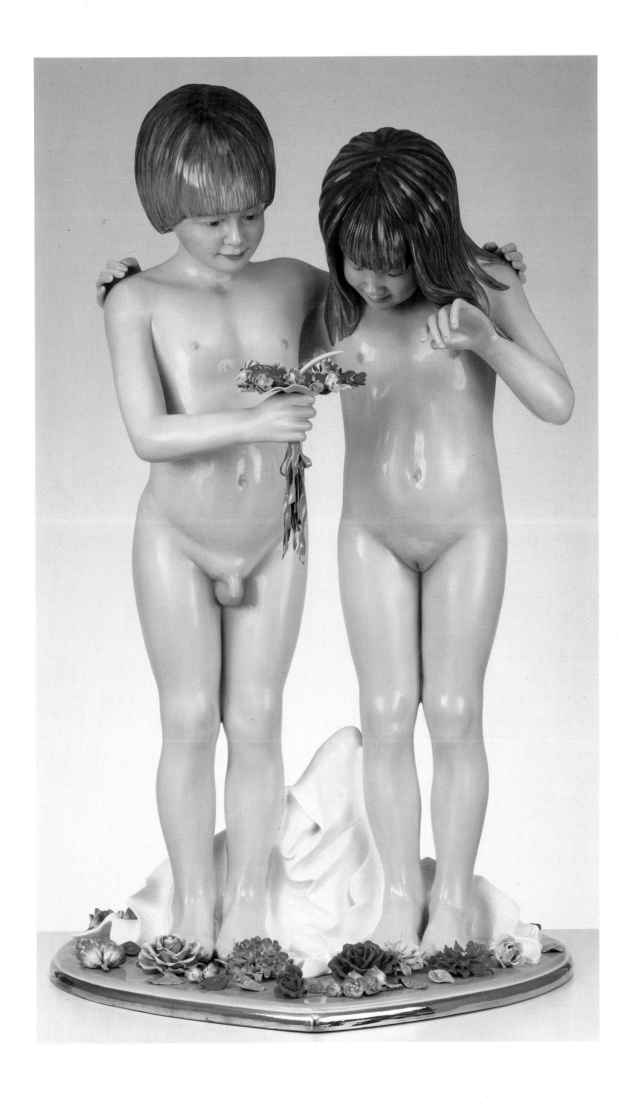

Franz von Bayros
Ex libris from the Library of the Boarding House,
1912
Exlibris aus der Bibliothek des Pensionats
Illustration to "Die Purpurschnecke"

Ages removed from primitive cave dwellers, Europeans live incorrigibly inside their brains. Not even in their artistic creations can they refrain from expressing some social or political commentary. Gerhard Richter elaborated his early work with such themes, as exemplified by his *A Demonstration of Capitalist Realism.* Does his attractive nude descend the staircase to become the immediate plunder of the male viewer? Another line of questioning suggests the artwork's dual intentions: the viewer is encouraged to interrogate reality – even though this image plainly corresponds with some segment. Can this blurry artefact have a formal value equivalent to reality? This juxtapositional questioning, directed towards both reality and the validity of its replication, inexorably leads us back to a closer examination of the painterly materials at work. What arsenal has art appropriated in order to simultaneously represent and undermine reality?

Plainly, striptease is no simple task once the artists go to work on it. This holds especially true for contemporary artists, whose intentions are plain: they set out on an investigation which encompasses the visible, the faculty of sight, and the painterly elements operating at the interface with the viewer. Gerhard Richter, seasoned in the techniques of photography, often employs documentary photos as the originating impulses for his work. His paintings might suggest that he is a Photorealist; but here again impressions are misleading, for Richter shares only a superficial bond with the Photorealists. His intentions go far beyond the sort of representational fidelity we might find at Madame Tussaud's or at the Museé Grévin. Not only is his selection of themes maverick to the Photorealist school, but also the manner in which his work becomes more and more insistently unfocused, like poorly developed snaps from wobbly cameras – an effect Richter accomplishes by superimposing layers of paint. His goal, as he investigates the deterioration of image in a surface increasingly textural, is the rediscovery of significant gesture. The realism in which an attractive woman yields up her charms (especially to our gaze) is highly problematic. Bearing just such issues in mind, Jean Clair characterizes this new movement of artists as the "painters of the imaginary", and as the "cartographers of the absent."

"I form a single being with painting, in the same manner that an animal becomes one with what it loves," explains Matisse, adding: "Essentially I do not create a woman, but paint an image... For others, the model is basically an instructive wellspring; for me she is something that whets my concentration. This is the source of my energies... I paint immediately before the model, working directly from her, my eyes hardly a metre from her, my knees able to brush against hers. I only gain the impression that I have made some headway once I notice that my work has more and more taken leave of the obvious influence of the model, from the presence of the model, who is necessary not for the possibility she affords of consulting her corporeal features, but rather to help me achieve a certain arrestation of mood, a condition of amorous enchantment which ultimately culminates in rape. The rape of whom? Myself, in an orgy of emotion before the beloved object.... The model is for me a springboard, she is the door I must pass through to reach a garden where I find myself alone and content – even the model continues to exist for me only in so far as I find her useful. What is for me of greatest importance? To work so long with a model till I have sufficiently assimilated her into myself to improvise, allow my hand free play, arrive at that point where I can venerate the sanctity and majesty of all of life." It would be difficult to formulate a more poignant and direct

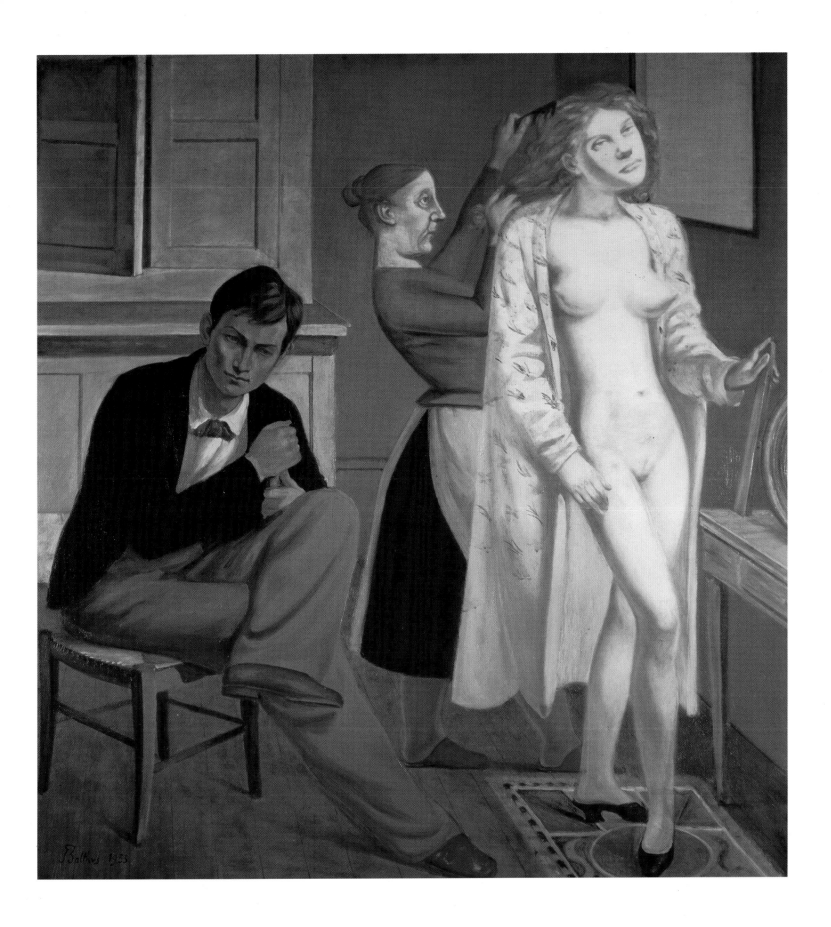

Balthus
Cathy's Toilette, 1933
La toilette de Cathy
Oil on canvas, 165 x 150 cm
Paris, Musée National d'Art Moderne,
Centre Georges Pompidou

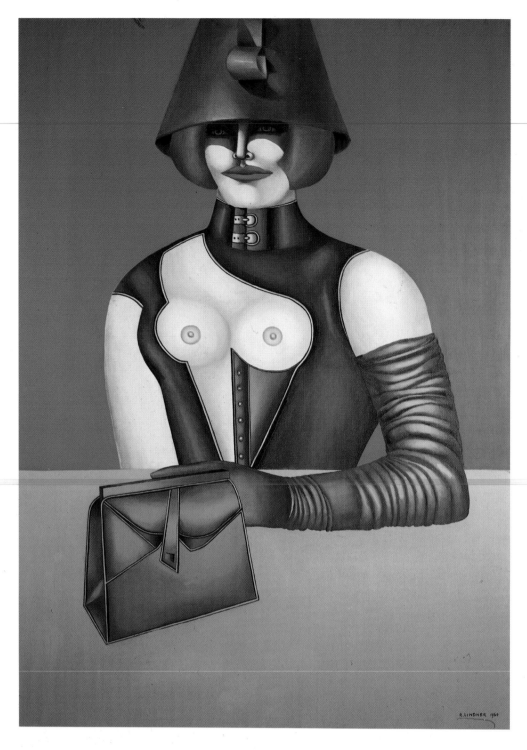

Richard Lindner
West 48th Street, 1964
Oil on canvas, 178 x 127 cm
Los Angeles, Mr. and Mrs. Max Pawlewsk
Collection

acknowledgement of the artist's creative symbiosis with the model, that paint-erly object, than Matisse here expresses. As he makes no attempt to hide, he drops to his knees before the model, then rapes her, penetrates her in order to find himself safely arrived "alone and content" in his secret garden. Once Ma-tisse had adequately concluded his round of preliminaries, he would begin to paint blindfolded, thus guaranteeing his intimate appropriation, his unqualified subsumption of the model. "Every portrait that is painted with feeling," re-marks Oscar Wilde, who well knew what he was saying, "is a portrait of the artist, not of the sitter."

In precisely these terms we find the female anatomy displayed throughout the graphic arts: it provides a screen for the artist's projections, is the midwife of

Kees van Dongen
Femme fatale, circa 1905
Oil on canvas, 82 x 61 cm
London, Christie's Colour Library

40

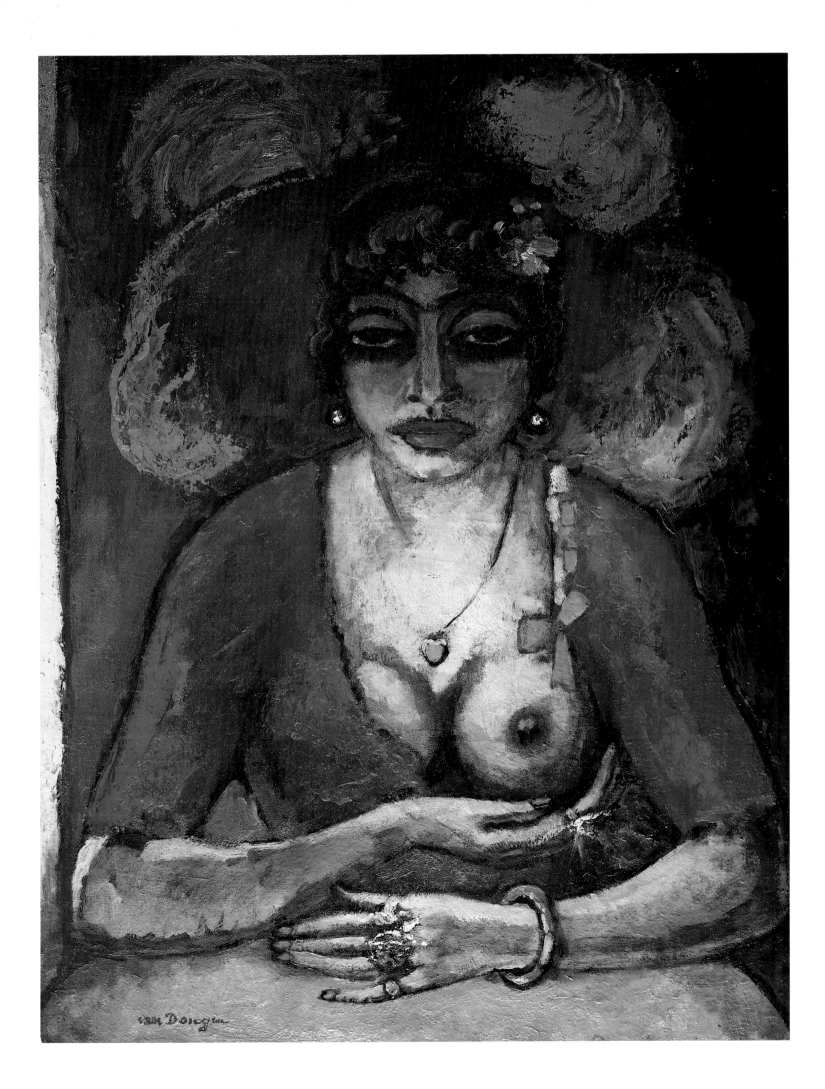

his work, his dearest intimate. The female anatomy is the double become flesh of a young girl, a *femme fatale*, a whore, a goddess. "What love is to the poet and storyteller, the nude is to the painter," remarks Paul Valéry. The same fantasies the artist projects into his work call forth reverberating echoes from the viewer – a circumstance wholly in keeping with the artist's intentions. The art image compels through its visual significance the individual's incorporation into the collective psyche. The beholder can say, as Renoir once did: "When I stand before a masterwork, I am satisfied simply to take pleasure in it..."

Many men over the age of forty are seized by a chafing bewilderment whenever they encounter prepubescent girls or child-women in the midst of puberty. These beguiling young creatures, whom Vladimir Nabokov immortalized in his novel "Lolita" – a book describing a forty-year-old male's sexual fixation upon a twelve-year-old nymphet, his fears, unease, and eventual seduction by her – can also be found in painting, where a long column of artists have given expression to a veritable legion of Lolitas. Balthus, Dix and Heckel are drawn to those episodes of hesitation, unease and furtive rapture familiar to every youth until the day arrives to venture out into the world. These artists, by abandoning themselves to the world of youth, relive just such precariously sensual moments. The world of adults has formulated those laws that must be transgressed in order to live a worthwhile, adventuresome life, to emerge into air fit to breath. One notices that it is not solely the girl's mysterious ripening which perturbs these adults, but also the tribulations of solitude which the nymphet brings back to mind, the sombre loneliness of childhood. These artists portray the world that surrounds them, a world of trite and colourless art in which one can bore oneself most regally. Into the midst of this world come these young girls, making themselves available to our every passion, every desire. They are creatures of a paradise at once achingly beautiful and hellishly torturous. They deliver themselves up to our voyeuristic passions, limn our wildest fantasies while simultaneously indulging their own girlish naiveté, as well as their penchant for exhibitionism: here a glimpse of a vulva lightly fleeced with pubic hair, there a flash of knickers. They await from their fledgling womanhood some unqualified sign of tenderness, investigate their budding anatomies with impish intimacy. Their tastes are somewhat shrill, perverse, as the author of "Alice in Wonderland" found for himself. Lewis Carroll was an aficionado of duplicitously seductive girls, and greatly relished photographing them. What melodies would emerge from a guitar strummed across the slit of a nymphet? (Balthus, *The Guitar Lesson*, p. 119.) Why is Cathy going to such lengths to make herself pretty? (Balthus, *Cathy's Toilette*, p. 39)˙

Balthus is content to represent the lusts of a forbidden world, one populated with dreamy, mischievous girls. Dix, on the other hand, deploys his Lolitas to lay siege to the ridiculous and roguishly thick-witted bourgeois class, to call attention to how deeply mired society has become in the muck of vulgarity. The figure of his *Venus with Black Gloves* stares nakedly out at us as if she were shorn of the world's last illusion of feeling. She is nude; but she makes us feel naked. She has lost all faith in the deliverance of ecstasy, stares out across the misery spread out before her. She seems to challenge reality to appraise itself as mirrored in her large eyes. Dix simply records, refusing to imbue the scene with any psychological value. His analytic gaze is fixed on the "bloated belly of Weimar." The eroticism in his work is harvested directly from Weimar's satyric

excesses. His portraits of coquettes border on pornography – the very outfits worn by his prostitutes blaze with carnality (p. 69). He wields kitsch to his purposes, attacks everything that perturbs his sensibilities, documents the coarseness of feeling which plagues his era, the score of monstrosities. Art always mirrors its age. Dix himself once said that it is the What which anticipates the How out of which the What proceeds... And What stands at the end? The surging sexuality which gave impulse to the nude figures of Dix, Schiele, Grosz, Schad and Heckel. With an almost pathological persistence, these artists took eroticism as the pre-eminent theme of their work. By exploring art's final frontiers, they reaped for themselves the inextinguishable reputation of being pornographers.

But another set of artists remains a comfortable remove from the pale of misery so powerfully captured by these "pornographers". These artists, equally audacious, move about in polite society. Figures created by Jeff Koons (p. 37), Otto Mueller (p. 36) and even Franz von Bayros (p. 38) appear to be engaged in completely innocent pastimes. Yet however idyllic and innocent a work of art

Tom Wesselmann
Bedroom Painting No. 9, 1969
Oil on canvas
© New York, Tom Wesselmann/VAGA

"To me a tit is erotic but the painting isn't." T.W.

George Grosz
Woman Undressing, 1939
Sich entkleidende Frau
Charcoal, 58.4 x 40 cm
The Hague, Collection P.B. van Voorst van
Beest

might appear, one must discount the artist's posturing, for he naturally has in mind that his work be received to his best advantage. Only after a work of art is successfully extracted from its contextual web can it be considered innocent.

How should we assess the lovable child couple by Jeff Koons (p. 37)? Through its utter banality this artefact irrevocably dredges up our own warmed-over images. The kitsch this artwork employs kills any aesthetic quality. Our sensibilities are numbed. The image is reduced to its superficiality, is stripped of all but its vital functions, is exhausted of everything but the trivial everyday ridiculousness to which it too must submit. There are only two possible methods to build upon the past. Either one must discover something which has never before awakened public interest, or one must identify oneself with a type of signifier that is so hackneyed and clichéd that it has already become an unavoidable part of our everyday surroundings. In the first instance, the artist relies upon the power of the theme he undertakes to transmit. In the second instance, he seeks personal amalgamation with the signifier or set of signifiers he deems to possess the highest possible recognition quotient. Jeff Koons – husband to Cicciolina, the comely porn star and Italian parliament representative, a veritable incarnation of our era's Eve – makes monuments out of his conjugal, vaginal penetrations, taking them as society's most widely recognised signifier.

Sex as apparatus calls to order an entirely different universe, one made up of dismemberings and abridgements, of amputated breasts and sexual organs lopped from their context. In this universe we see mirrored the erotic aggression of 20th-century society, rediscover a brutish culture deluged by advertising images, a civilisation unable to break the chill grip of loneliness which isolates its members. The American Pop artists, discovering in consumerism a societal ersatz for the Church, seem to have organised the distribution among themselves of a few pre-eminent motifs. For one, it is soup cans and Coca Cola bottles; for another, the poetry of the highway, dollar bills, the American flag,

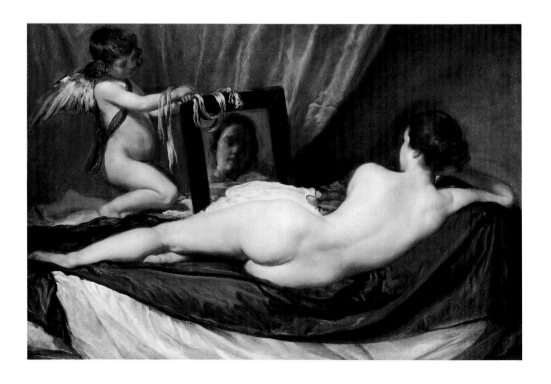

Diego Velázquez
The Toilet of Venus, circa 1648
La Venus del espejo
Oil on canvas, 122.5 x 177 cm
London, The National Gallery

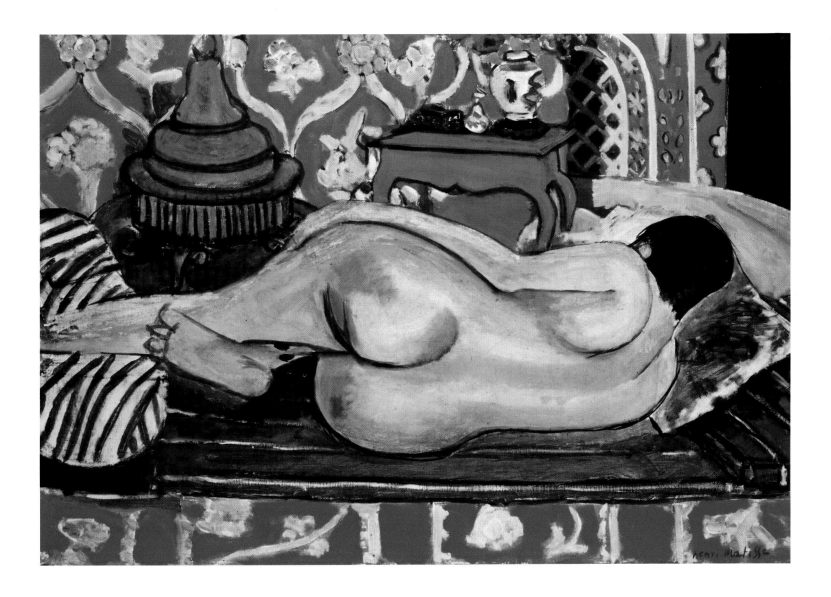

the painterly brush stroke. Richard Lindner, a German expatriate residing in New York, chooses sexuality and fantasy desires as his artistic theme (perhaps in response to his experience as cultural crossbreed). His work does not arise inside a vacuum, but is related to that of a host of other artists united by one vital trait: their refusal to become adults. This cult's graphic vocabulary is appropriated from the images of advertising, as well as from contemporary eating habits. Linder's personal iconography is derived primarily from advertising, as his *Pop Venus* exemplifies. In point of fact, the majority of American Pop artists actually began their careers in advertising. Warhol designed posters for Miller Shoes and decorated store windows for Bonwit's department store. James Rosenquist designed giant advertising billboards which propagated the manifold virtues of consumption. After arriving in America, Lindner made his living as an illustrator for numerous magazines. When he turned to painting, he brought along his experience as a draughtsman, but instead of devoting his talents to fashion, he leafed through a sadomasochist catalogue, giving it his closest attention, and there discovered every conceivable kind of fetish instrument: corsets and chains, rings and garter belts, page after page of soft torture equipment – the lineaments of his own erotic obsessions, a template for his work. Lindner employs a geometrical formal strategy remotely evocative of Fernand Léger (who also lived in

Henri Matisse
Reclining Nude, Back, 1927
Nu couché de dos
Oil on canvas, 76 x 60 cm
Paris, Les Héritiers Matisse

"For me nature is always present. It is the same with her as it is with love: everything depends upon what the artist can unconsciously project into what he sees. Whether he can create something alive depends very much more on the quality of his projection than on the presence of the living person before his eyes."
H. M.

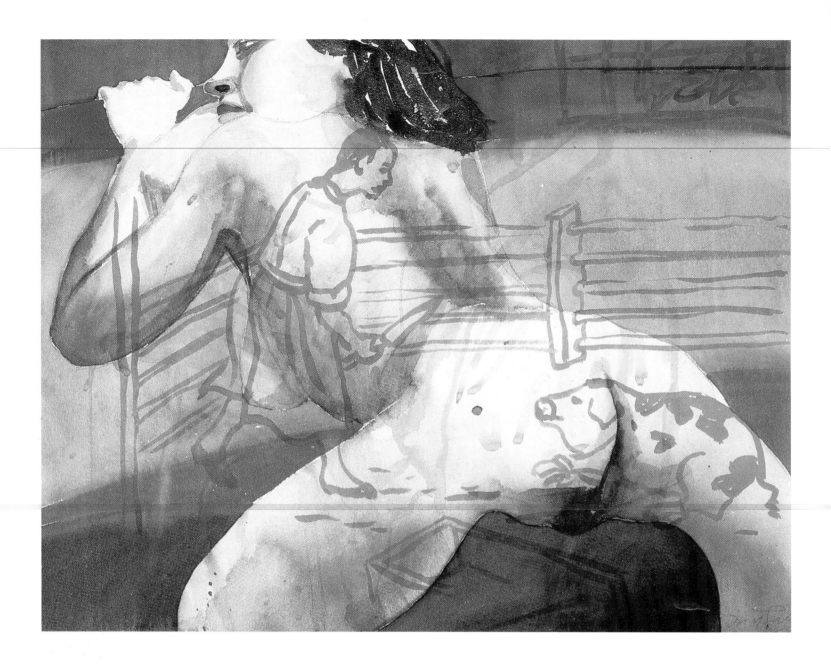

David Salle
Untitled, 1984
Watercolour, 63.5 x 78.7 cm
New York, Courtesy Mary Boone Gallery

New York during the war years), and achieves the threatening overtones characteristic of his work by overstating the genitalia and such sexually charged features as the mouth, breasts, thighs and, most especially, the legs. His perspective conveys the attitude of the world as seen through the eyes of a small boy. From this vantage women appear as gigantic Eiffel Towers with huge feet – an image which springs directly from the pictures of childhood and tellingly demonstrates a refusal to grow up. Sometimes a man goes his entire life trying to relive his first hot sexual stirrings.

It scarcely needs pointing out that the iconography of this American style endows the breasts with a hugely dominate role. We know that the Italians are most intrigued by a broad pelvis, and that the French are most beguiled by a pleasing set of legs. The primary fixation of the Anglo-Saxons tends towards a pair of firm and heavy breasts. Breasts become the crowning glory of art, the quintessential embodiment of male happiness. They are objects of adoration, almost superstitiously venerated as signs of the Great Mother. The devout worship of a bouncing curvaceous chest reveals a cultural trait almost diametrically opposed to that of the Italians, who prefer the bosom bound tightly back. The

German school prefers the triumphant, ostentatious breasts of the Valkyrie; the French school weighs every formal decision with meticulous care, ruminates through a thousand learned calculations before, correct in its displacement of space, the ideal bosom emerges: the distance between the breasts must harmonise with the distance between nipples and collarbone – that golden triangle which, as so potently exampled by Maillol, represents the epitome of traditional French sculpture. It is interesting to observe that among painters and sculptors too the various anatomical predilections are strictly observed according to geographical and national boundaries. One could scarcely dream up a dissimilitude so prodigious as that existing between the icy breasts served up by Lindner,

Cindy Sherman
Untitled No. 155, 1985
Colour photograph, 184.2 x 125 cm
New York, Courtesy Metro Pictures

"I feel myself drawn to Sherman's beguiling craft, the way she, like so many actresses, demonstrates vulnerability, and therewith provokes the (male) wish to rape and/or to protect." Peter Schjeldahl

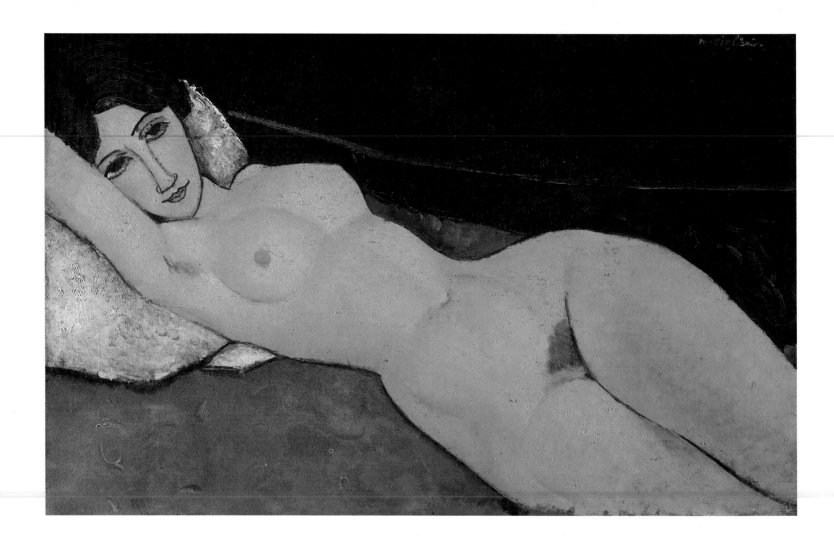

Amedeo Modigliani
Nude Reclining on a White Cushion, 1917
Nu couchée au coussin blanc
Oil on canvas, 60 x 92 cm
Stuttgart, Staatsgalerie Stuttgart

*"In their complete nakedness these bodies function
as symbols. Carnal desire has frozen these women
into sensual poses that are also remote. They are
forever unattainable, just like the nymphs of anti-
quity who were transformed into stars by the Gods
because their passions went ungratified."*
Jean-Marie Le Clézio

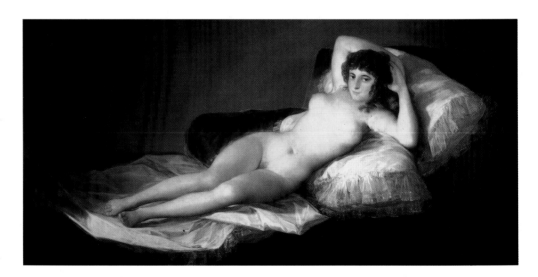

Francisco de Goya
The Maya Nude, 1800
La maja desnuda
Oil on canvas, 97 x 190 cm
Madrid, Derechos reservados
© Museo del Prado

ILLUSTRATION OPPOSITE:
Willem de Kooning
Woman, Sag Harbor, 1964
Oil on wood, 203.2 x 91.4 cm
Washington (DC), Hirshhorn Museum and
Sculpture Garden, Smithsonian Institution,
Gift of Joseph H. Hirshhorn, 1966

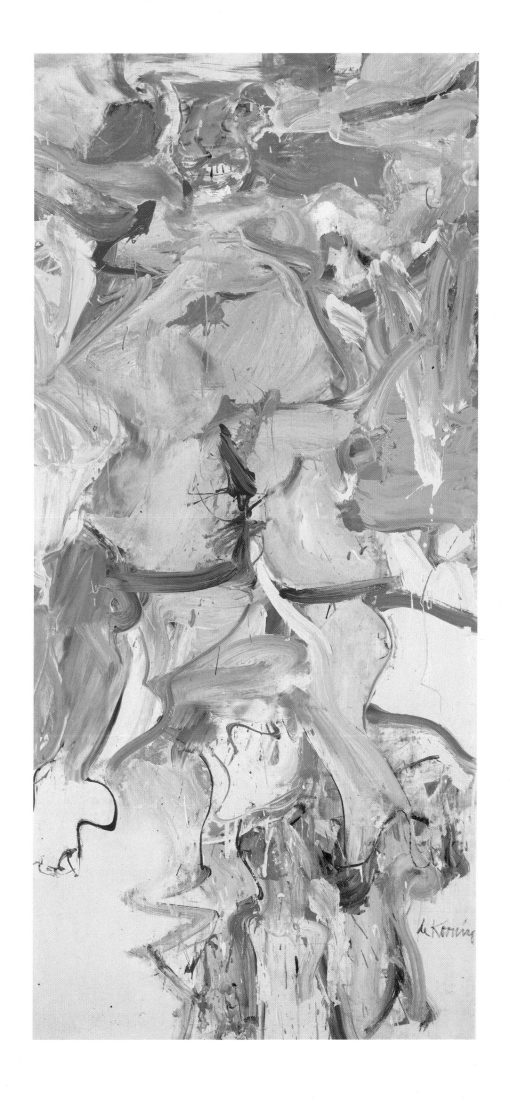

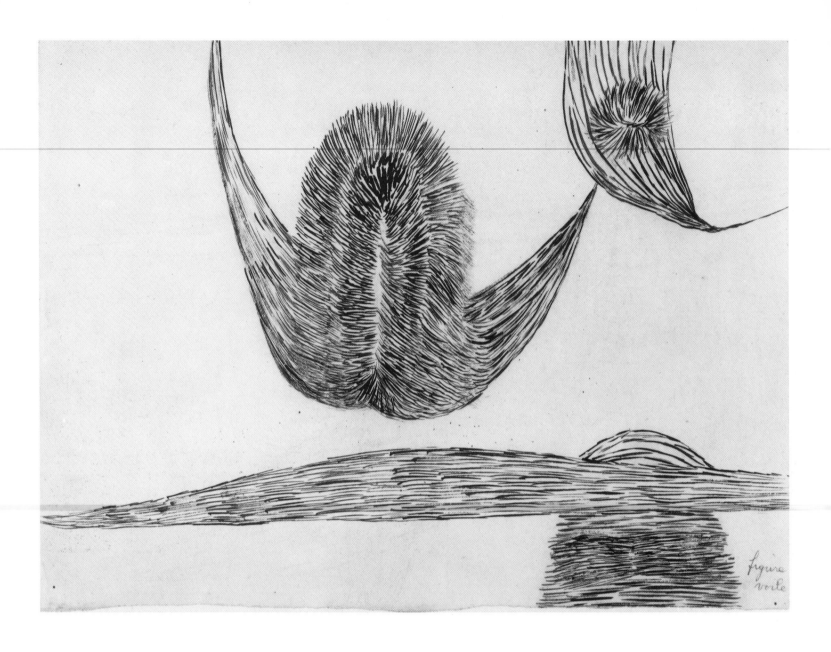

Louise Bourgeois
Flying Figure, circa 1949
Figure voile
Ink, 24.8 x 32.4 cm
New York, Courtesy Robert Miller Gallery

"The life of the artist is the refusal of sex. Art pro-
ceeds from the inability to seduce. I'm not capable of
convincing anyone to love me. In reality the equation
is: sex and murder, sex and death." L. B.

breasts possessing the shiny aura of a spaceship launching (p. 40), and the ac-
complishments of Kees van Dongen, breasts set vibrating at such an ultra-high
carnal pitch that merely to brush against them would scorch (p. 41). It comes as
little surprise to hear van Dongen confess that "painting is not natural, it has
something artificial about it (...) art begins where nature and rational under-
standing cease." One might even speculate that this Dutchman's nudes are more
evocative of the French tradition than of nature, for they seem bathed in the
erotic sensuality of Renoir's most voluptuous images.

Van Dongen's renderings of breasts, scattered across such a broad spectrum
of formal and volumetric possibilities, sustain long perusal without provoking
the slightest hint of monotony. This artist's creations would be supremely suited
to stocking a breast fetish catalogue. In the end the viewer must determine
whether the pointy, petite items are the most seductively enchanting, or, tum-
bling cataclysmically down, the Niagara Falls model.

As companion-pieces to the breasts there are the buttocks, which also come
in pairs. Their guise and size outfit the artist's fetish arsenal with another potent
weaponry. The end-product of the artist's ruminations naturally provokes a
reciprocating fetish response from the viewer. In the topography of fetishes we

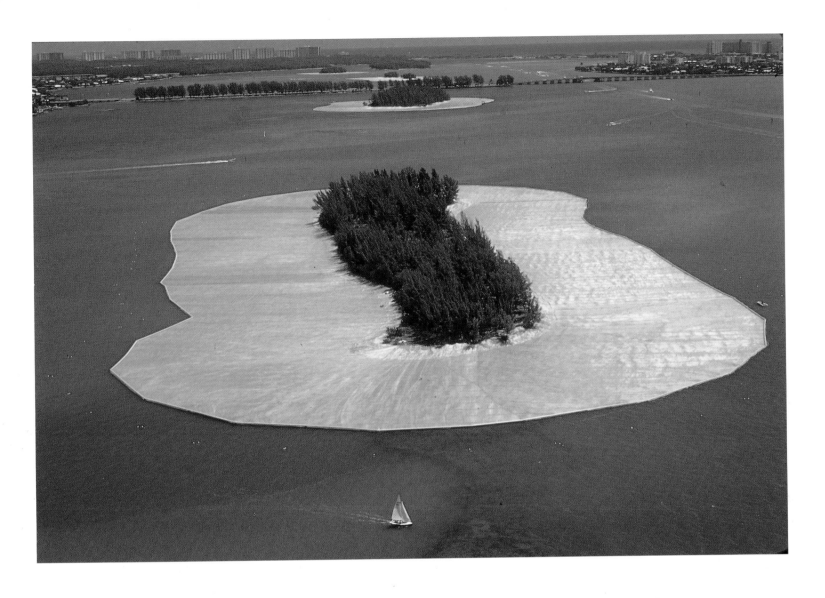

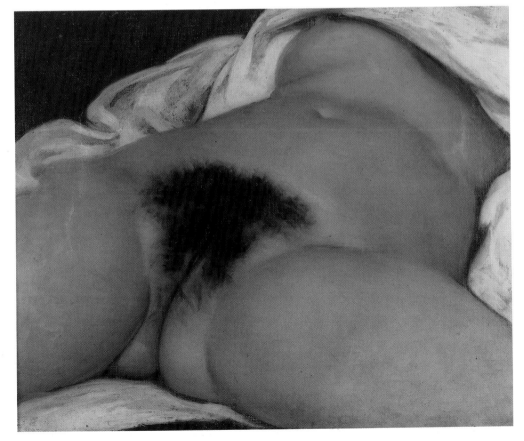

Christo
Surrounded Islands, Biscayne Bay,
Greater Miami, Florida, 1983
Installation
© 1983 Christo

"My media are not only landscapes, seas and water,
but also the human ferment." C.

Gustave Courbet
The Origin of the World, 1866
L'Origine du Monde
Oil on canvas, 46 x 55 cm
Paris, Private collection

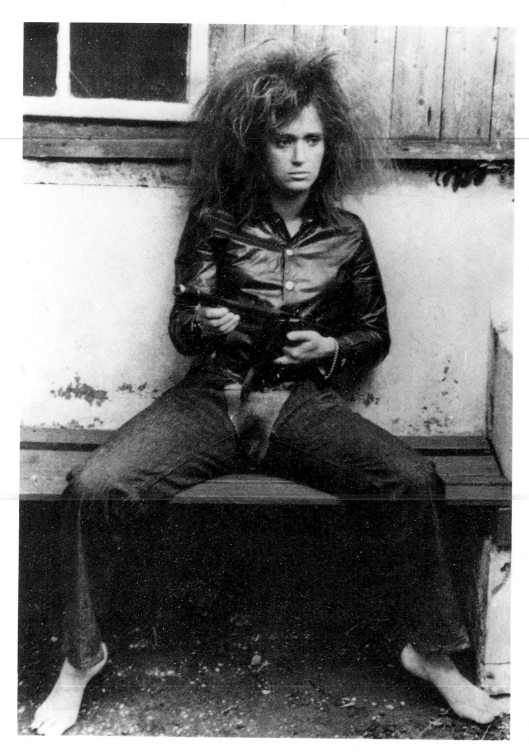

Valie Export
Genital Panic, 1969
Genitalpanik
Performance photograph
Vienna, Valie Export

"Operation Genital Panic – Valie Export was wearing a pair of blue jeans that had a triangle cut out immediately over her genitals – was exhibited within the context of the war art manœuvre. With these cut out trousers she planned to go through the seated rows of the audience, taking up contact ('indirectly sexual') with its members." Anita Prammer

find ourselves now traversing an area referred to by specialists as "subordinate" – a designation applying equally to the precious rondures of the buttocks, as well as to the contemplation of an exquisitely formed pair of breasts. Here again, with regard to the two major types of rear ends, the Atlantic delineates a boundary. As far as weight is concerned, Europe remains a plump jot ahead. "The Americans", writes one specialist, "are hard at work on a feminine model with the long legs of a basketball player. The waist is becoming ever slimmer; they keep the girlish figure under such strict control that girls more and more resemble boys. In the meantime this process has taken on such exigencies that, by comparison to the models of Jules Pascin or of Picasso, who usually had short legs and protruding buttocks, the American variation appears to have landed

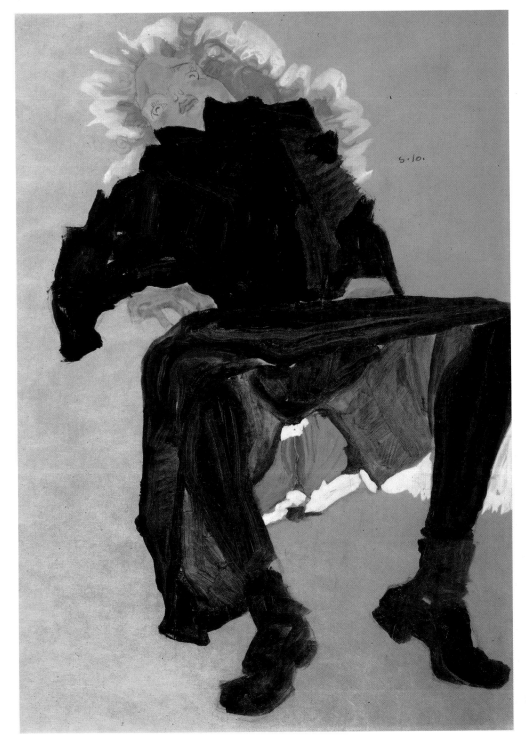

from another planet." The buttocks figures created by a Boucher, Renoir, Matisse or Grosz no doubt have something trustworthy and reassuring about them – at least for the male inhabitants of the Old World!

Let us now turn to the work of Velázquez, the prototypical European painter, a man who made a real woman from his Venus ideal. She is the first heathen nude in Spanish painting, and heralds a philosophical programme: enthroned as his painting's cardinal motif, hers is the first derrière to become the vital object of painterly intention. The delectable posterior depicted in *The Toilet of Venus* (p. 44) has launched and will continue to launch the dreams of countless painters and viewers. There is nothing so precious or delicious in the whole of the tender sex as a beautiful femal derrière. These fleshy globes come into their glorious

Gerhard Richter
Female Student, 1967
Studentin
Oil on canvas, 105 x 95 cm
Friedrichshafen, Galerie Bernd Lutze

own in the works of George Grosz (p. 44) and David Salle (p. 46). The motif of
the butcher who is about to slaughter a pig is essentially employed as a reminder
that since time immemorial the vagina and the wound have laboured under the
same nexus of meaning: both bleed. But then a woman, Cindy Sherman, arrives
on the scene (p. 47), to muddle our every assumption. The anonymity of the
rear end she extends to us is a matter of just speculation: is it male or female?
Sherman reminds us that the erotic fascination males as well as females are
capable of discovering for the buttocks can swing both ways: the posteriors of
a child or adult of one's own sex also work as libidinal signifiers. This fixation
is glutted with eligible candidates – to the point where we hear again those
whispered words: "Why run after the boys when a girl could give you the same
pleasure...", or vice versa.

Breasts, buttocks – who decides which is to be preferred? Sex decides, of
course. Art is at heart a sprawling compendium of samples assembled in praise
of the female anatomy and those portions which compose it. Both the painter
and the sculptor, caught up in the sorceress drives of their male libidos, seek
nothing other than to create the darling objects of their lusts and desires, female
figures generated directly from their sexual appetites, forms outfitted with every
seductive charm and feature of the female sex. Heading the list, naturally, is that

Auguste Rodin
Iris, God's Messenger, 1890
Iris messagère des Dieux
Fired clay, 24.7 x 35.3 x 13.1 cm
Paris, Musée Rodin

"... his nude studies; but his nudes are actually
such, that those who would care to offer them up for
sale would be doubtlessly pursued for marketing por-
nography, and if the truth be told, by the very people
who have organized this exhibition."

Anonymous, 1912

"People say that I think too much about women."
Pause. "But all things considered, what's more im-
portant?" A. R.

Auguste Rodin
Sex of the Female
Sexe de femme
Pencil. Paris, Musée Rodin

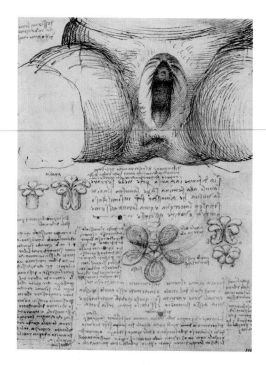

Leonardo da Vinci
Vulva, 1504/09
Pen and brown ink on black chalk,"
19.1 x 13.8 cm
Windsor Castle, Royal Library.
© 1992 Her Majesty Queen Elizabeth II

crack or slit behind which the cave of the vagina smoulders hidden, where the male's lust finally finds its appointed quenching. If all of art is erotic, then it is not too much to say that at the beginning of art was sex.

In prehistoric times representations of the female were not subject to censorship. The Egyptians, the Persians, the Babylonians, the ancient Greeks, the Polynesians and the indigenous peoples of Black Africa adorned their naked bodies with gender signs. Quite often these signs depicted the female triangle complete with slit and pubic hair. Whether ironically or in earnest, the exquisitely refined art of the ancient Chinese, and later that of the Japanese, mimicked these female representations; and the Hindus idolized the female genitalia. Dismemberment was already practised among primitive societies, phallic and vaginal images rent from their physical contexts to become emblems on amulets, talismans, or decorative symbols.

The art of the Occident is unique in its astonishing refusal to confer a special status on the genitalia. Instead, it banished the sex organs from sight. One must blame the Greeks for passing along this ill-bred tradition: they laid the foundation for two thousand years of untruth in the plastic arts. Death for the Greeks, as we know, was "without sense and dark, like woman." According to their way of seeing the world, man was fated to journey along a dark cave to arrive in the netherworld, a wide, sprawling network of tunnels with spongy floors capable at any moment of giving way beneath the feet to suck one down. The Greeks named this infernal hole "abyss" – a term which returns us to the female: at the centre of her body she carries an abyss. To penetrate the abyss is to return to the night before birth, to escape into oblivion. It is to renunite Eros and Thanatos, concepts which have long dominated Western art, and most especially those art movements which have originated since Sigmund Freud. Erotic desire mingles with the death instinct, an idea at the crux of Georges Bataille's work.

The affair between the painter's brush and the female's pubic hair did not

Pablo Picasso
Untitled, 1971
Pencil on card, 21.7 x 31.3 cm
Paris, Galerie Louise Leiris

"Art is never chaste, one should keep all innocent buffoons steered well away. People who are not prepared well enough for art should never be allowed near it. Yes, art is dangerous. If it's chaste, it's not art." P. P.

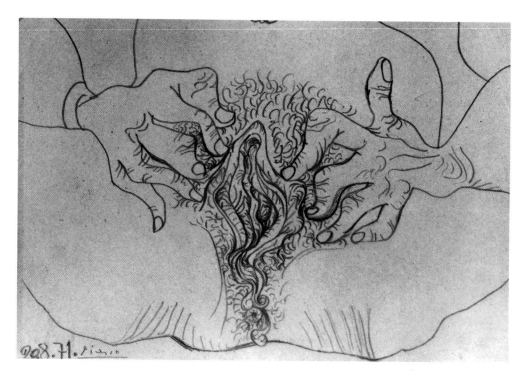

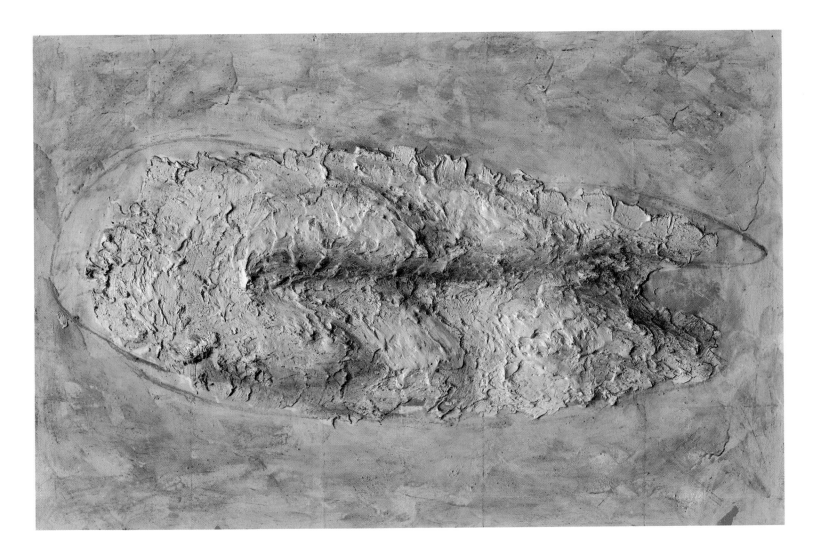

Jean Fautrier
It's How You Feel, 1958
Oil on paper mounted on canvas,
97.5 x 146 cm
Paris, Musée National d'Art Moderne,
Centre Georges Pompidou

begin until a few short decades ago; only recently did the sculptor's chisel reclaim for the plastic arts the lost genitalia of the female. It took the genius of a Goya, a Rodin – both pioneers in Western art's long and glacial process of aesthetic liberation – to lay siege to this sturdily entrenched taboo. Standing on the peripheries of the Romantic movement, these two masters were the inheritors of an aesthetic legacy determined by three major stages: the culture of the Greeks, the spread of Christian morality, and the philosophy of the Renaissance – forces which must share the blame for presiding over the creation of falsified sculptures that represent a vital fundament of our culture, creations which outfit the female loins with neither hair nor slit. (Gérard Zwang).

Thankfully, there were the great precursors, votaries of the godly rump and pubic hair: Velázquez, who created one of the most delectable derrières the tradition of art has to offer, and Goya, who dared adorn his *Maya Nude* with a flourish of pubic hair (p. 48). In their various styles, the Cubists, Modigliani, and the Surrealists contributed to driving the wedge between Church and State. Courbet and Picasso were artists who well knew how to assimilate the sensibilities of primitive naturalism into their work; their lustful creations dealt art's asexual nude a vengeful blow. Slowly, the empress, the analogous figure to the titular hero of Andersen's fairy tale "The Emperor's New Clothes", was indeed stripped bare. Naturally, this would never have come about were it not for the ingenious strategies employed by great artists in their quest for erotic expression.

They played a patient game of hide-and-seek, culling themes from the Bible, from legend, and from the eternal myths – whatever they found suspect; behind the pretence of ethereal sensibility, these artists lent powerful expression to their sexual urges and desires, allowed their talents uninhibited play without subjecting themselves to the grim fustigations of watchful censors.

Plato in his "Symposium" submits the idea of Venus existing in two visages: the sublime and the vulgar. Renoir frames this same idea with more colourful precision: "The naked woman will rise from the sea or from her bed; she will call herself Venus or Nini, and no one can invent anything better." Formerly, a nude painting could brim with the most extravagant eroticism, just so long as it carried the title "The Birth of Venus" or "Susannah Bathing". But not until the advent of modernism did living, breathing women in their everyday roles qualify as a suitable motif for art. In English we distinguish between "nude" and "naked". Nude refers to the artistic expression of nudity; naked, to everyday nakedness. Today we might say that the nude in modern art is naked.

The modern artist has ushered the unapproachable goddess down from her heights, has moved her in as neighbour. "How majestic and poetic we have become in our ties and polished boots," Baudelaire remarks, rummaging after modernity. It is immediately apparent that the nudes of Courbet would fail as sprite nymphs. His work ceaselessly awakens the impression that his models have slipped freshly into their birthday suits, that a pile of clothes lies in a corner of his studio, the frayed scarf, the rough petticoat, the muddied pair of boots. "If you want me to paint you goddesses," Courbet sneered, "then show me a couple." Because he actually preferred to realistically paint every square inch of

Tom Wesselmann
Great American Nude No. 91, 1967
Oil on canvas, 151.1 x 262.9 cm
© New York, Tom Wesselmann/VAGA

"I've got a certain long-range program about sex, though, that may put me in prison in five years . . . I am involved with eroticism but more in painting. I suppose my nude will become more erotic in time . . . the form intensifies the eroticism, you might say." T.W.

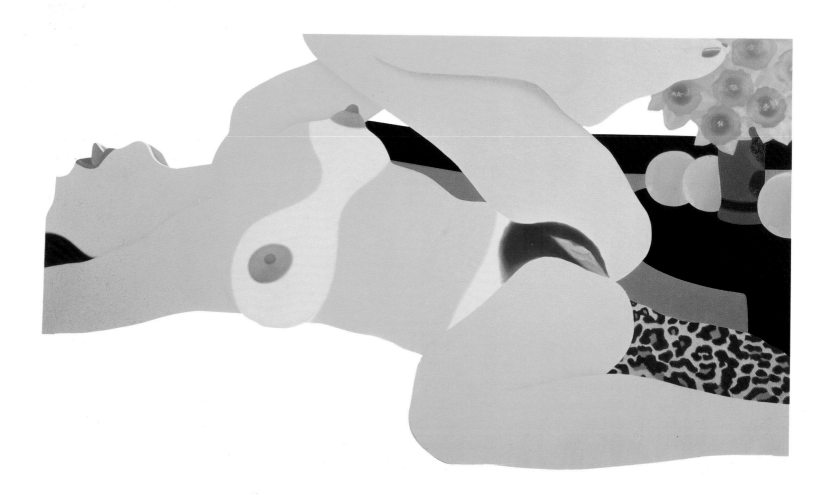

Robert Gober
Two Bent Sinks, 1985
Mixed technique, 244 x 191 x 66 cm
Switzerland, Private collection

"The calm remove, the obviously aseptic shape of these appliances, and the time necessarily invested in reading them, request the dimension of emptiness for their installation. This may explain why many critics read Minimalist traits into Gober's œuvre. He does indeed deploy the devices ordinarily used to present Minimalist sculpture with its attendant spacious environment, but the effect is to heighten a pulsating, physical eroticism, inherent to the object, that widens — as in Marcel Duchamp's works — into a closed circuit through the viewer. Unlike his predecessor, however, the younger artist does not hide behind mechanical operations that stand for eroticism; instead, he impregnates his abridgements with an immediacy that automatically engages the senses; the wet hands and the thumping heart are inevitable in the face of so much subtlety and evocative strategy." Harald Szeeman

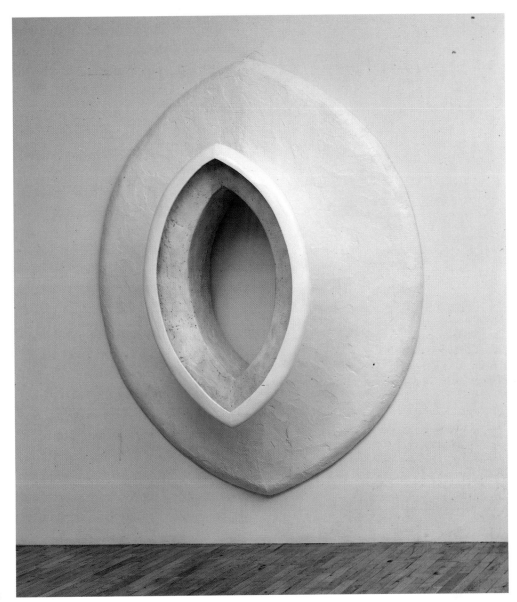

nubile female bodies — an erotic desire he gloriously fulfilled — he was discounted as the "painter of the ignoble". His aim was to demote the nude, to pull the female down from her pedestal. He is, to use the words of Emile Zola, a "painter of naked skin," a "supra-Velázquez". His mould of woman, his projection, has always the same almond eyes, the same ripe body, the same heavy mane of hair, the same hint of a womanly Florentine double chin. Whether embodying indolence or sensuality, his figures share one affinity: they each assume their place in his personal universe. Courbet is a powerful natural force, a man of unrestrainable urges. Of this his women were quite aware. With his painting *The Origin of the World* (p. 51), with this womanly trunk and these genitals — as beautiful "as a naked body by Correggio" (Goncourt) — Courbet outstrips his age, not solely because he is the first painter to discover in the female sex organs a theme for art, but also because he returns the genitalia to nature: the wild grotto amidst the thicketed forest is indeed "the origin of the world". This delicious site between the thighs (the thighs of whom? a princess? a whore?) escorts us from the woman to the story of creation, from naked anatomy to the sacred body — a deliverance via the power of eroticism. We find

Tom Wesselmann
Shaved Cunt, 1966
Pencil, 36.8 x 29.2 cm
© New York, Tom Wesselmann/VAGA

Allen Jones
Falling Woman, 1964
Oil on canvas, 122 x 76 cm
London, Waddington Galleries

this same theme recurring in the work of numerous great artists. Though made prisoners of the flesh by their desires, their painterly intentions reveal a manner by which the physical plane can be transcended. It is as if they say "open sesame" and a secret door slides open, a portal leading to another world. One of the most brazen audacities of Courbet, a precursor of modern art, was to paint figures he himself called "real allegories". Without Courbet, none of these women, derelict of any societal prestige, possessed any real chance of becoming the heroine of a work of art. It was also Courbet who invented the term "living work of art".

We are indebted to such artists as Courbet, Rodin, Modigliani, Picasso and Brancusi – each a vehement defender and champion of sex, talents possessing the magic key to open the secret portal – that modern art could free itself from taboo, that the enchanted triangle now harbours a slit, that pubic hair can flourish on statues. Rodin, at the urgings of verisimilitude, was the first sculptor to endow his female statues with genitals. He dared direct his gaze at the most precious site of intimacy our universe has ever known. Rodin once told Rainer Maria Rilke that when reading a religious tract, he allowed himself the licence of substituting the word "sculpture" for the word "God" – and that the substitution corresponded perfectly. Models, women of the world, rich foreigners, women no longer young and girls yet under-age – beauty was no essential – flocked to him offering to pose. Some considered Rodin the reincarnation of the Greek god Pan; others referred to him as the "Sultan of Meudon". Isadora Duncan told the story of how Rodin managed to convince her to dance naked before him, and how he "sculpted her flesh" before, with hands aglow, he turned his attentions to the clay. He would always moisten his paper with diluted water-colours when labouring over a sketch depicting the genitals, create a moistness in which his draftsman's eye could bathe. "Rarely has moistness left behind such an exciting, virile impression," notes France Borel with marked enthusiasm – for it is indeed a phenomenon that can leave no one untouched. "The excited pencil scratches and burrows inside the vulva. A fleck of colour, an excited stain moistens the genitals. The emotions flow. The drawn line snakes along and makes the figure dance, the line delights in the full of its ecstasy, deflowers the paper and makes its stains. It follows the dictates of desire, the beat of the pulse. Water and colour pigments spatter, evidence sensual arousal. Embarkation for Cytherea. The nude is the rapture and the desire, the fountainhead of creation, the intoxication. The bodies vibrate, extend, flounce about in orgasmic frenzy, defy the law of gravity, while in the depths between the widened legs the genitals quake electric..."

Although Rodin exhibited remarkable courage, he did not proceed so far as to give his sculptures pubic hair, nor model the vulva's clitoral region. *Iris, God's Messenger*, splays wide her thighs, but the region of the vagina remains unarticulated (p. 55). It was over this empty cleft that Bellmer, Lachaise and Louise Bourgeois laboured; their sprite sculptures, disquieting figures, reveal to our eyes that the painter and the sculptor desire nothing else than to submit themselves to truth's provocative charms.

We might well ask whether the censor isn't a fortuneless dullard with only meagre fare at home, compelled to snarl with rage whenever he witnesses the festive bounty enjoyed by others. Though this sort of censor still survives, during Modigliani's day the official censors were overbearingly sensitive and watchful. On 3 December 1917, at Rue Taitbout in Paris, Police Commissioner Rousselet

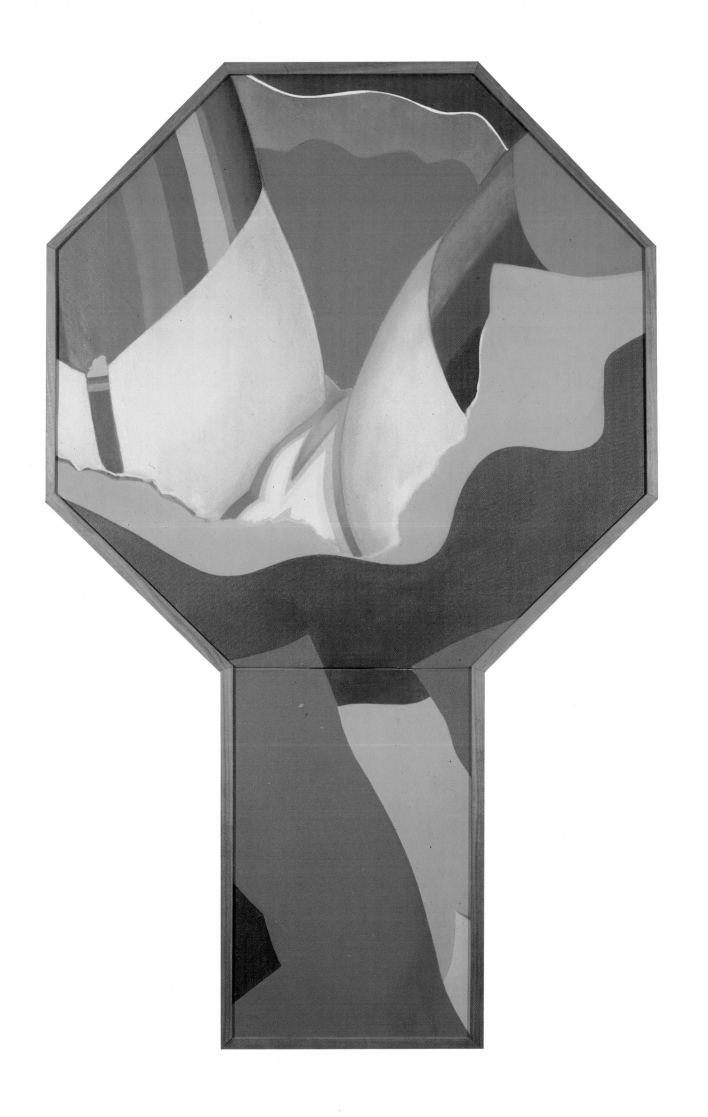

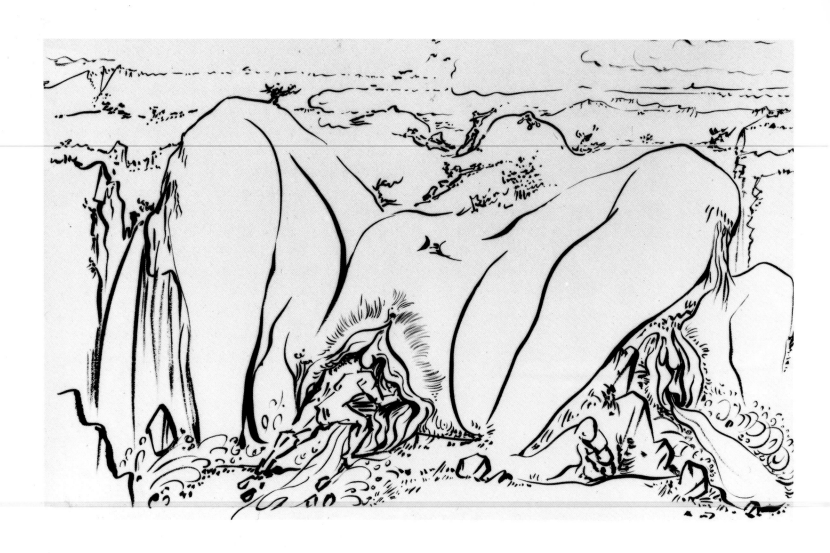

André Masson
Erotic Terrain, 1939
Terre érotique
Pen, 31.5 x 49 cm
Paris, Galerie Louise Leiris

was displeased by the goings-on he saw across the street from his office window. He lost no time in reprimanding a cheery, smallish woman: "Madame, I order you to remove this filth from the wall at once!" What filth did he have in mind? Some twenty works by a young unknown painter that Berthe Weill, the accosted business woman, had only just discovered. "Why?" she replied. "Because these nudes", the commissioner explained, "because they are all...stark naked, Madame!" Casting sidelong gazes at the shameful works, the incensed police commissioner fell into a stammering rage. Nor was he the only person to become so incensed. The premier showing of the sole exhibition Amedeo Modigliani's work would receive during the course of the artist's lifetime was attended by large crowds. His nudes, a scandal! In the exhibition rooms hung numerous others, each as disgusting and foul-mannered and...stark naked as those in the street window. The uniformed representative of the official censorship bureau saw red when his eyes lit upon *Nude Reclining on a White Cushion* (p. 48).

The artists who emerged after Modigliani were not satisfied to allow the gaping vagina to swallow up their painterly intentions, but went further. They worked the rich artistic lode of their forebears, thinking it out anew. They too suffered the occasional pummelling of this or that manifestation of censorship. Such bouts are doomed to occur until this silly plague is once and for all officially eradicated. Louise Bourgeois, a female artist who began to exhibit at the end of the forties, also fell foul of the censors (p. 50). Her sculpture *Girl*

(p. 76), which overtly echoes Brancusi's *Princess X*, was her version of a theme with pedigree. Regarding Brancusi's sculpture, Matisse supposedly told its creator: "Well look, the phallus..." Brancusi's work was removed from the "Salon des Indépendants" of 1920 without official injunction. The actual scandal lies in the fact that prudery in its most popular form accepts those representations of dismembered bodies that have been passed down to us from antiquity, the bust portraits or phallic symbols, but denounces as an act of moral provocation those artefacts of modern sculpture (as perhaps most importantly exemplified in the work of Maillol, Rodin and Brancusi) which fragment the anatomy into breasts, thighs, penises or other anatomical segments. Modern artists have seized the principle of fragmentation as one of its vital concerns – one might even say that the fragment is the fundament of modern sculpture. To give the difficulties a new face, some artists speak of "abstraction" in the modern and actual sense of the word, or of "fragment objects". The ambiguous titles Louise Bourgeois employs pun intentionally with the various anatomical elements, the breasts (*Trani Episode*), the penis (*Pregnant Woman*), the clitoris (*Knife Woman*), the vagina

Niki de Saint Phalle
The Figure Hon (= she), 1966
Installation, 23,5 m long, 6 m high, 10 m wide
Stockholm, Moderna Museet

ILLUSTRATION OPPOSITE:
Georgia O'Keeffe
Light Iris, 1924
Oil on canvas, 101.6 x 76.2 cm
Richmond (VA), Virgina Museum of Fine Arts,
Gift of Mr. and Mrs. Bruce C. Gottwald

*"Many found them (the flower paintings) to be un-
abashedly sensual, in some cases overtly erotic. Others
perceived them as spiritually chaste. There are stories
of parents who used O'Keeffe's flowers to teach their
children about the birds and the bees . . . But on the
subject of sex and religion in these works, one must
draw one's own conclusions."* Nicholas Callaway

Egon Schiele
The Dream One, 1911
Die Traumbeschaute
Watercolour and pencil, 48 x 32 cm
New York, Collection, The Metropolitan Mu-
seum of Art, Bequest of Scofield Thayer, 1982

(*Janus Fleuri*), and the uterus (*The Destruction of the Father*). Her handling of
materials – rubber latex, plastic, plaster, wax, resin or hemp – mimics the diverse
organic natures of the anatomical fragments she renders. When working in such
traditional media as marble or bronze, Bourgeois insinuates swellings and un-
dulations of the skin, as well as the translucent quality of membrane tissues. In
short, her artistic technique enhances the reality of the organs she is replicating.

 The drawings of Louise Bourgeois mirror her experience with the art of
schizophrenics. Other graphic artists have also investigated this area. The rapt
images and harsh lines characteristic of Aloyse, Klotz, Wölffli and Neter – men-

tally disturbed personalities who achieved widespread artistic notoriety – in-
fluenced the thinking of such painters as Max Ernst and André Masson, as well
as writers of such rank as Antonin Artaud, intellectuals of such standing as Roger
Caillois, and, not least, psychoanalysts such as Jacques Lacan. As Rosalind Krauss
also notes, the madness exhibited in the work of these disturbed personalities is
propelled by the same logic as the "fragment object", the segment object which
Gilles Deleuze and Félix Guattari analyse in the first chapter of their study,
"Anti-Oedipus". They call these locomoting forces "desiring-machines". In
their work, which takes as its theme capitalism and schizophrenia, they write:
"The meandering of the schizophrenic provides a far better lesson than the
neurotic stretched out on the couch." The body is exactly as devoid of life as
everything else. The individual is obliterated. Assuming the individual's place on
the grid of reality is an assortment of anatomical elements – the breasts, the anus,
the mouth, the penis – dismembered body parts signifying elemental needs.
Each of these fragment objects, or, using the term of Deleuze and Guattari,
desiring-machines, searches after a desiring-machine to which it can cling. The
desiring-machines function as binders or tourniquets to check the endless
streams of milk, urine, sperm, faeces; they dam one stream to generate another,
a stream which the next desiring-machine dams to likewise create another, and
so on. Each desiring-machine is a fragment object: breast machine, mouth ma-
chine, stomach machine, intestine machine, anus machine, etc. The relationships

Robert Mapplethorpe
Calla Lily, 1988
Photograph
New York, © 1988 The Estate of
Robert Mapplethorpe

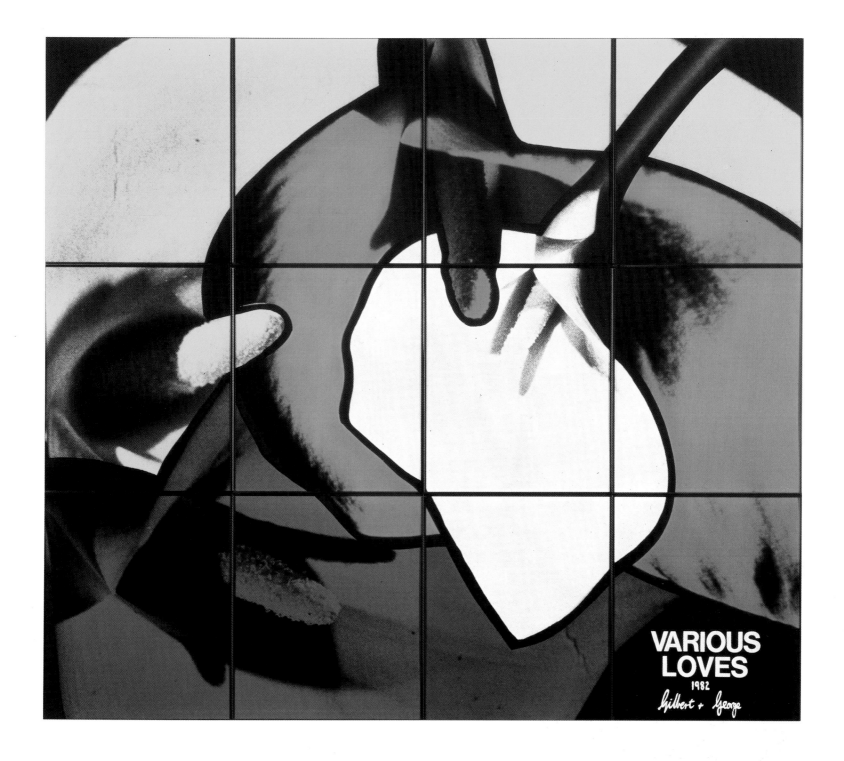

arising between desiring-machines are determined by the character of the streams: the stream one machine produces might function as the next machine's vital elixir. In this manner the evolution of art progresses at the same rhythm as philosophy. Deleuze and Guattari are convinced that their new explication of the logic of machines, of streams, of their social relationships and forms of production, not only functions as a working model for "capital", but also delineates a process profoundly immanent in modern art. It is legitimate to speak of capital because a transfer is indeed at work: the wish fantasies and desires are ejected from the site of ideals, where psychoanalysis had banished them, to anchor in the tangible universe. The desire is no longer an operation which takes place in the brain (in the unconscious, in dreams) but instead is attributed physical substance. When Deleuze and Guattari, then, transform the "fragment

Gilbert and George
Various Loves, 1982
181 x 201 cm
London, Anthony d'Offay Gallery

Wols
The Great Façade, circa 1941
Die große Fassade
Ink and Watercolour, 17 x 9.5 cm
Private collection

*"His Great Façade is a ride into the horror of a
bewitched female vulva."*　　Henri-Pierre Roché

ILLUSTRATION OPPOSITE:
Otto Dix
Metropolis (triptych), 1927/28
Mixed technique on wood, lateral panels:
181 x 101 cm, centre panel: 181 x 200
Detail from right wing
Stuttgart, Galerie der Stadt Stuttgart

object" into a "desiring-machine", they do so by analogy with the actual existing character of machines and their means of production, thereby turning the tables on Freud and Melanie Klein, who vested the activity of machines with parely symbolic values.

Of course modern artists, desperately seeking to rediscover the purity of childhood, play at being crazy. But forgetting what one has learned, one's "culture", has proven to be a difficult undertaking. Willem de Kooning worked tirelessly with female figurations, his muscular brushwork dispatching hanging breasts, grimacing faces, slashed skins. He passionately (and sometimes with a humour most dark) took an analytic look at human anatomy, returning the human species to conditions of savagery. At such moments his work becomes childlike – the technique we know from Jean Dubuffet and the painters of the Art Brut movement. Baudelaire said, "Genius is childhood with every medium of expression at its disposal." With regard to de Kooning's work as exampled by his painting *Woman* (p. 49), we can justifiably speak of Abstract Expressionism and of "non-significance". And with equal justice we can see him as an artist quite as obsessed with buxomly proportioned female figures as his predecessors back in Holland – and de Kooning does not omit to add a huge and gaping vagina. Confronted with his figures, we are immediately reminded of the whores of Georges Rouault – who in his own manner was one of de Kooning's forerunners.

In the artistic works of Leonardo da Vinci (p. 56), Picasso (p. 120), Fautrier (p. 57), Wols (p. 68), Wesselmann (p. 58), Gober (p. 59), Masson (p. 62) and Niki de Saint Phalle (p. 63), the female offers herself up, puts her charms on display, stretches out, strikes a pose that can only result from the artist's urgings, while the artist is at once commander, initiator, observer and high priest... or schizophrenic. The female double, according to the artist's idealizations, can aspire to the Great Mother, or assume the dread vestments of the Great Cannibal, a female Saturn capable of swallowing the viewer down, or spewing him back out – and this not from her mouth, but from her cavernous vagina (Niki de Saint Phalle, Masson, and others). It all comes down to a question of inner disposition: Niki de Saint Phalle seems to transform the female pelvis into a colossal, colourful game; Masson, on the other hand, desirously skews the pudendum into an expression of the primordial. Here, what else can the woman be but a landscape, a fantastic vulviform setting harbouring hairy, yawning caves, a vulval-vaginal temple replete with clitoridean stalactites. Masson might be viewed as a sort of archaeologist embarked upon the pursuit of the Golden Fleece, a man digging after the inexhaustible treasure concealed by the female in the hidden depths of her sultry being. In his own distinctive lyrical manner, Masson spontaneously annexes a terra incognita of lyrical spontaneity. He resembles the adventurers of ancient myth who quest for the Garden of the Hesperides. In like heroic fashion he ventures forth prepared to meet whatever fortune might cross his path, to hazard every risk, experience every magical encounter. The female body is at once the vessel which this modern Odysseus boards, and the sea menacing him with its every peril. He errs though the legendary forests of his dreams where, like the Beauty familiar from fairy tales, the woman of his desires dwells, enchanted by sleep.

The female body – subject to the artist's will, yet exerting a strange power over him, forcing him into utter chaos – seems capable of anything. That body

Victor Brauner
The Morphology of Man, 1934
Kleine Morphologie
Oil on canvas, 53 x 63 cm
Paris, Collection A. F. Petit

René Magritte
The Rape, 1934
Le viol
Oil on canvas, 25 x 18 cm
Brussels-Paris, Private collection,
Courtesy Galerie Isy Brachot,

sets a powerful morphological process in motion; cognate with Arthur Rimbaud's "aberration of the senses", this transforms the artist into a "fragment object", one supremely suited to fleshing out the unknown and exploring the new – especially with regard to innovative formal techniques. "In the *Demoiselles d'Avignon,*" Picasso explains, "I have drawn a nose on the side of a face, and I had no choice but to place it in this sideways manner in order to give it a name, in order to call it Nose! It is exactly as one finds with the four seasons market women. You want two breasts? Fine! Here you have two breasts…What matters is that the man who takes this in has everything at hand he requires. And then he himself can position them where they belong by using his eyes." In other words, the artist makes a suggestion, and we decide what to do with it. We are challenged to make a contribution of our own. We are asked to enter into that dialogue which has become the cornerstone of modern art.

The artist's obsession with a woman's sexual organs need not always end in explosive tumult. He can also go off to work some analogous vein, for instance by investigating the connections between the vulva and one of Nature's most

beguiling creations, the flower. Isn't the blossom, after all, the sexual organ of the plant? The natural metaphorical double for the female? The flower of love, the flower of Venus, the flower of desire, the flower of flesh, the rose, the carnation, the peony, the white ox-eye, the entire floral kingdom, which, deriving its power from the intimate affinities flowers share with both sexes, finds artistic expression everywhere from Georgia O'Keeffe (p. 65) to Gilbert and George (p. 67). The virgin is "deflowered" by her first lover. And it is for her, the woman of his desires, that the young man yearningly plucks the petals of a daisy. Does she love him? Or does she not? A man presents a woman with flowers as a token of his affections, or as a sign of the joy he feels at possessing her intimate blossom. Artists have long been fascinated by the similarities between women and flowers, metaphors which are not simply the pomp of poets. The physiology of flowers reveals that they too breathe, that they too perspire, that their most important physical function is to guarantee with their reproductive organs the survival of their species. Besides its stamen, its pistil, and its flowery petals, which find such graceful rhyme with the female genitalia, the flower also has an ovary

Paul Delvaux
Pygmalion, 1939
Oil on canvas, 135 x 165 cm
Brussels, Musées Royaux des Beaux-Arts

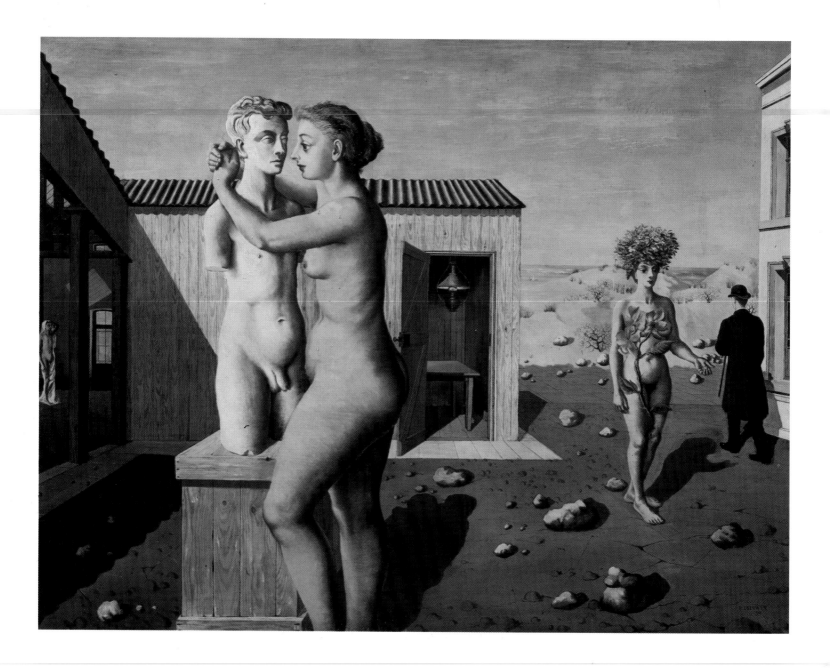

and ovule – read ovaries and eggs. And this egg is changed by the introduction of pollen into an embryo which grows into a fruit. Artists have always been aware of the flower's symbolic significance, from the stylized flowers of Mesopotamia to the lotus flowers of the Egyptians, from the palm branches of the Greeks to the orchids prized by the artists of Art Nouveau, who discovered in the orchid's purple-veined petals and aggressive anthers, its miniature thrust-out tongues, a symbol supremely charged with eroticism.

Man Ray, Edward Weston and Robert Mapplethorpe (p. 66) often employed the analogies of flowers and the female genitalia as motifs for their photography. But they also portrayed flowers which appeared to flaunt juicy, virile erections, and directed their interests towards fruits that afforded a further wealth of associations with the male sex organ (exuberant growth, stems, pepper pods, cucumbers, and so on). Mapplethorpe plays deliberately with such analogies, presenting his studies of flowers and nudes side by side in his publications and exhibitions. Mapplethorpe is often compared with Rodin. This comparison derives its aptness from the manner Mapplethorpe expresses his fascination with the human anatomy, the way he allows muscle, anther and stamen to mingle playfully, composes relationships between the lustrous skin of his models and the veined petals of his flowers. He captures not only the erotic charge of the "botanical" and "human", but also the aching lyricism of their most perfected forms. Neither flowers nor sexual organs are dramatized, but are placed in a poetic, almost sacred circumstance. When Mapplethorpe photographs a flower, Cocteau remarked, a male sexual organ arises from the negative – and vice versa.

ILLUSTRATION LEFT:
Rainer Fetting
Desmond B., 1984
Oil on canvas, 223 x 179 cm
Private collection

"When I see the body, the way it's put together, what interests me is sensuality, and then I want to paint the image." R. F.

ILLUSTRATION RIGHT:
Caravaggio
Amor Victorious, 1602
Amore vittorioso
Oil on canvas, 156 x 113 cm
Berlin, Staatliche Museen zu Berlin –
Preußischer Kulturbesitz, Gemäldegalerie

The result is an astonishing revelation. Afterwards, one can never appreciate a flower or a male penis as one did before. It is a logical consequence of self-portraiture: yet again, Narcissus has been transformed into a flower.

Although artists have repeatedly proven themselves to be both creators and connoisseurs of the nude, and although their own gestalts are woven into every nude they bring to expression, it would appear that art has retained one last vestment of taboo: the nude self-portrait of the artist. Of course, a few renegade examples do proffer themselves. Caravaggio, for instance, portrayed himself as Goliath being beheaded by David, and in another painting appeared topped by Medusa's snaky tresses. Enthroned upon the ceiling of the Sistine Chapel, Michelangelo nakedly quivers in the skin of Saint Bartholomew. Paul Gauguin is the figure of *Christ in the Olive Grove*, and Raphael is among the philosophers in the *School of Athens* at the Vatican. But these are costumes, role-playing, the mirroring of wish fantasies. Even *Dalí in the Egg* (the famous Philippe Halsman photograph) was careful to keep his penis out of view. Paul Eluard offers one

Jean Fautrier
For My Hands, 1955
Pour mes mains
Oil on card on canvas, 55 x 46 cm
Private collection

Louise Bourgeois
Girl, 1968
Filette
Latex, 59.7 x 26.7 x 19.7 cm
New York, Courtesy Robert Miller Gallery

"For Bourgeois eroticism is a projection of the viewer, a projection which she takes as a given and mixes around by parodying its sexual contents, thus achieving distance for herself."
Mignon Nixon

possible explanation: "While they are painting their portraits, they contemplate themselves in a mirror, without pausing to consider that they themselves are visible in the mirror." Albrecht Dürer is one of the few artists who has left posterity a nude self-portrait (p. 74). He reveals his physique right down to the smallest wrinkle, drawing his penis with the same precision as his face. One can hardly imagine a similar performance emerging from the brushes of Rembrandt or van Gogh, although both men did numerous self-portraits. However, we must keep in mind that Dürer's nude self-portraits were not necessarily created for the public at large. One nude self-portrait depicts a mature, athletic male. In another he gestures with his index finger to his spleen, below which is inscribed: "There, where the yellow fleck is, where my finger points, I bear a pain." Bearing in mind that this self-portrait was created at a time when the spleen was considered to be the seat of melancholy, we might well speculate that Dürer was calling attention to his emotional frame of mind – a condition called "splenetic" as late as the Romantic period – or that he had perhaps simply created this self-portrait as a sort of health dispatch for his physician.

Martin Kippenberger
Erection, 1990
Ständer
Oil on canvas, latex, 150 x 180 cm
Cologne, Private collection

Aubrey Beardsley
The Lacedemonian Ambassadors, 1896
Illustration to "Lysistrata"

Giorgio de Chirico
The Conquest of the Philosopher, 1914
La conquista del filosofo
Oil on canvas, 125.1 x 99.1 cm
Chicago (IL), The Art Institute of Chicago,
Joseph Winterbotham Collection

The double of the artist is not simply his doppelgänger. It has been said that Narcissus is the inventor of painterly expression. Leon Battista Alberti, in his work "Of Painting", insists categorically upon such genesis. "I mention quite often to friends, as the poets have already expressed, that when Narcissus transformed himself into a flower he invented art, and it is the long story of Narcissus which is the theme of this work. Or would you dare venture that painting has some other meaning than the embrace of Fate and Art, that outer raiment of the vital spring?"

Max Ernst
The Hat Makes the Man (the style comes from the suit), 1920
C'est le chapeau qui fait l'homme (Le style c'est le tailleur)
Collage and gouache on card, 35.6 x 45.7 cm
New York, Collection,
The Museum of Modern Art

"*Accomplished, natural lewdness, unnatural, interrupted lewdness, the fuck in meadow or woods, the connoisseur fuck, prostitution, rape, the burglarised fuck, the hindrance out of impotency, kisses on unusual body parts, kisses on usual body parts, kisses in the manner of pigeons, kisses devoid of ulterior thoughts, mundane kisses, the shot of sperm, simple and equivocating onanism, masochistic desires, chastity, premature ejaculation or the voluntary nightly pollution, the danger of pollution, sodomy, bestiality, the unchaste touch, the manner a married couple touches, the natural vase of the woman, the vase in front and the vase in back, the holy vessels, the plays, dances, hindered motions, the art of riding, the calculated dripping away, the imperfect sperm, the sexual ghosts, the demon, the incontinence, the thorn in the flesh, the generation of mankind, the sacred embryology – and all that muck of the Church Fathers. We know the worth of words; dangerous self-pollution has become so much of an ingrained habit that out of urbanity we manage to take pleasure in it. There are, thanks to the providence of the Church Fathers, disgusting, precisely delineated boundaries on the female body separating the shameful portions from the respectable portions. Owing to great and protracted passion these boundaries can occasionally be erased, only to be fated to return again in all their disgusting clarity until that blessed day when a joyous massacre rids the world once and for all of the entire clerical pest. Love is the mortal enemy of Christian morals. Once the Church with its confessionals and so-called sacraments of atonement broke into the human conscious and unconscious, it had discovered the most dependable tools to immediately and effortlessly belittle everything which stretches out towards love.*"

M. E.

Of the Five Senses

"'Cram it up my ass', Simone cried. Sir Edmond stuck the orb along her crack, shoved it deeply inside. I rose to hold Simone's thighs spread wide: she lay stretched along her side, and I saw before me something which I – so I now imagine – have always awaited, as a guillotine awaits the head to decapitate. I could feel my eyes swell with terror; I saw gazing out from Simone's bushy vulva the pale blue eye of Marcelle. It stared up at me, shedding tears of urine. The traces of semen lathering the moist and steamy pubes completed this horrific vision's aura of sorrow. I held Simone's legs spread wide: hot urine streamed from the eye to rinse down her lower thigh..."

Georges Bataille has offered a few explanations concerning the origins of his book "The Story of the Eye", from which this passage is excerpted. In the company of Ernest Hemingway, who often touched upon this episode in his writings, he was present at the bull-fight arena the day a horn gouged out one of torero Granero's eyes. As Bataille confesses, the memory of this incident, which ended tragically, resurfaces within "The Story of the Eye", "in a hardly recognisable form, for at the time I was searching for the greatest possible obscenity... I had never seen the denuded testicles of a steer. I had imagined them as glowing redly, like meat. At this point in time it seemed peculiar to associate the testicles with the egg and the eye. My friend, a doctor, explained to me the aptness of my seeming error. We looked it up in a textbook of anatomy, and I learned that the testicles of animals, like those of humans, are oval in form, and that they are quite similar to the human eye in appearance and colour..."

The most important biological sense organs are the eye, which reacts to the excitation of light; the ear, which perceives sounds; the tongue, excited by taste; the nose, which is stimulated by odour; and the skin and those membrane tissues which are capable of distinguishing between hot and cold, caress and pressure, etc. It is the famous five senses, then, which pack the sensation into love-making. Without them it would be a spurious exercise. Without them we could never distinguish the world outside of ourselves or perceive the body of another – just as we can never apprehend more about another person than the perceptions he or she betrays to our senses.

In the hierarchical classification of the senses or "fragment objects" and the importance of their functions in assembling information about the external world, the eye wins pre-eminence by a wide margin. Such classification not only takes into account the highly specialised organs of sense located in the

Louise Bourgeois
Untitled, 1950
Ink and charcoal, 35.5 x 27.9 cm
New York, Courtesy Robert Miller Gallery

"All symbolic acts have something voluptuous. But people refuse to admit it." L. B.

ILLUSTRATION PAGES 80/81:
Christian Schad
Detail from: *Maika*, 1929
See page 85

Marcel Broodthaers
Watchtower, 1966
La tour visuelle
Mixed media, 88 x 50 cm
Edinburgh, Scottish National Gallery
of Modern Art

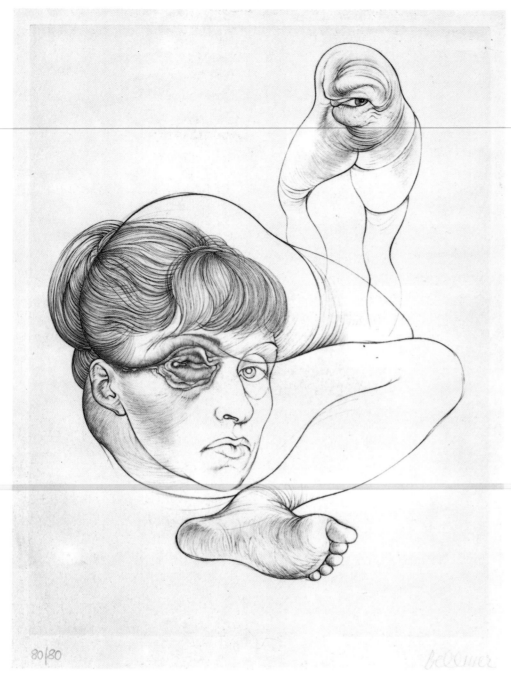

Hans Bellmer
Sexual Instructions I, Page 2, 1974
Unterweisungen der Sexualität I, Blatt 2
Copper point, 31.5 x 24 cm
Frankfurt am Main, Courtesy Graphisches
Kabinett im Westend

*"To grasp the message of the second manifest super-
imposal, proceeding for example from the eye to the
hand, one must first grant that the eye, weighed
down by the image of the sexual organs, cannot en-
tirely discount these supplementary and compromising
contents: we might suppose, surely without erring all
too gravely, that things have been seen, heard, and
smelt with such intimacy, that under the influence of
shock, despair, or feelings of guilt, their repression, or
say at first even the simple denial of vision, amounts
to the invocation: 'I refuse to see anything, I shall
never see another thing!' In this way the eye, ear and
nose are exposed to inhibiting reprimands that trans-
form them into new conflict centres, into 'hotpoints'
necessarily confronted with such virtual hotpoints as
the hand or heel."*
H. B.

skull, but also considers those segments of the body outfitted with decidedly
sexual functions, as well as the adornments of the torso (breasts), and the limbs
and their extremities (hands, fingers). The list of eligible candidates, as we shall
soon consider, is indeed diverse. Of the facial features, the poet is most fascinated
by the eyes, cherishing them as soulful vessels worthy of his lyrical nature. He
derives inspiration from the eyes to sing his songs of eternal love, perhaps even
divines in them love's true source. "The eyes", Charles Vellay praises, "...teach
us every secret of love, for love dwells not in the flesh and not in the soul, love
dwells in the eyes, their flattery, their caress, their ability to express every nuance
of feeling, every ecstasy, within the eyes the bestial urge is transformed into ideal
beauty. Oh! To live the life of the eyes, where each and every earthly form revels
uprooted: to laugh, sing, cry, to gaze into the eyes, to be immersed in them like
Narcissus at his pool."

Simone, Bataille's sadistic heroine, reveals a perverse desire for everything reminiscent of the eyes. From the eggs, which she cracks open on the rim of the bidet, to the bull testicles from the arena which are grilled and eaten after the fights: "Gonads of the form and size of eggs were pearly white in tincture, and veined with the blood-red of an eyeball." Finally Simone rips out the eye of a priest and has it rammed up her rear end. The violence of gouging out an eye can only be understood through fetishism: this is sacrilege's blackest punishment, the final outrage of torture. Here, luckily, it appears as part of an intoxicated fantasy's rhapsodic outpouring; still, numbers of lone perverts derive their pleasure from this passage. Yet there is indeed something mesmerizing about the fetishism of a monomaniac fixated upon a woman's eyes.

Bataille and his congenially minded friend, Hans Bellmer, create a philosophy from fetishism, one which touches upon the perpetual cycle of life and death, of Eros and Thanatos. "The art of Hans Bellmer", writes André Pierye de Mandiargues, "is erotic, sado-masochistic, fetishistic and perverse." Bataille and Bellmer launch a two-pronged offensive against a society which, perceiving

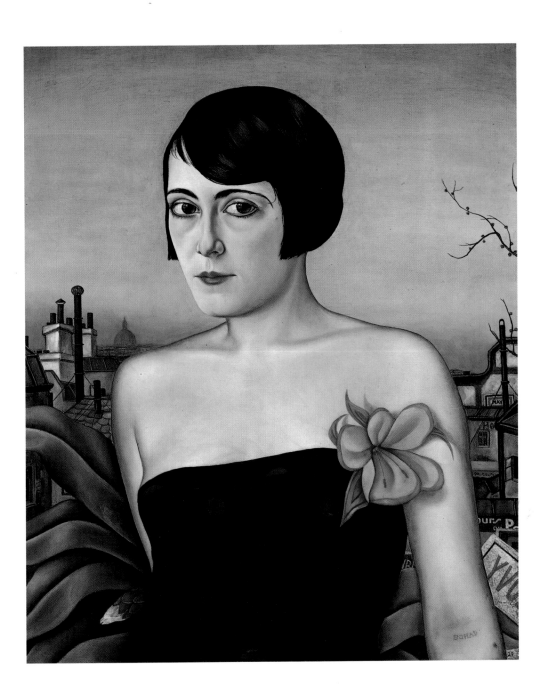

Christian Schad
Maika, 1929
Oil on canvas, 65 x 53 cm
Private collection

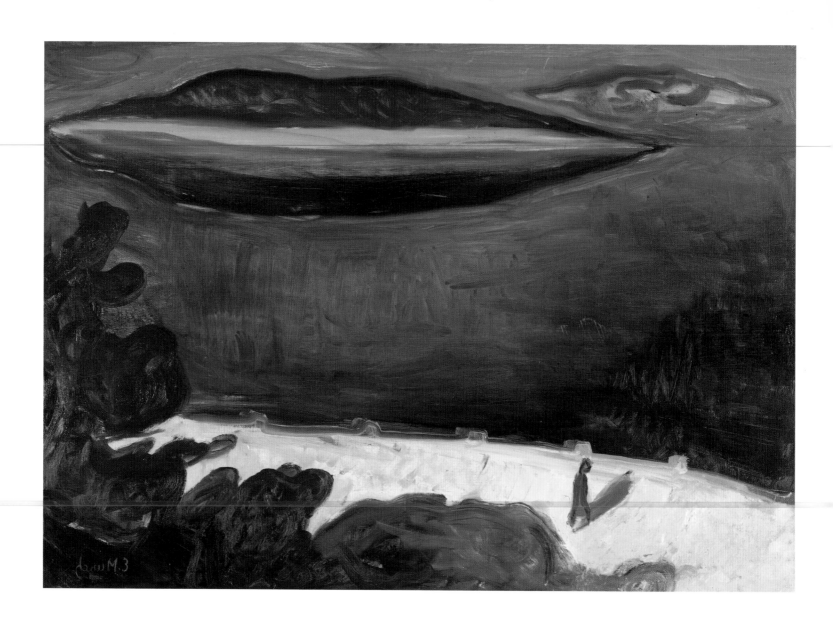

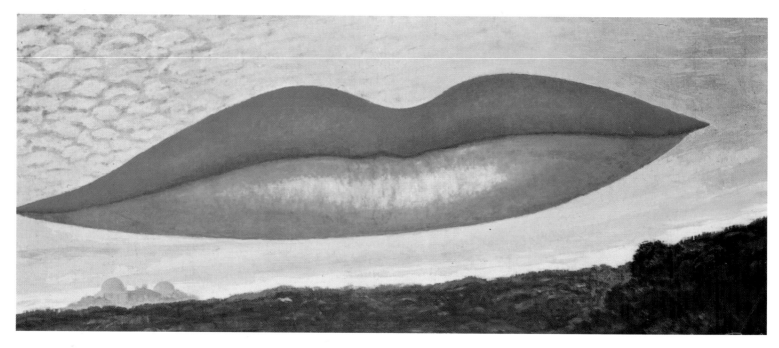

sexuality and death as twin aspects of chaos, sets up a channelling series of interdictions. One outcome of this process is a wild set of transgressions, be it in religion (renunciation, rapture), or through the revolt of the individual (the concepts of desire found in de Sade and Gilles de Rais). Bataille and Bellmer decide on "taking an uncompromising route wild with excitation, that of the unmaimed, holistic human being." The work of these complementary artists is informed with a point of view that denies every moral, religious or mystical prescription. The premise they share is that a human being who has not tested the bounds of erotic possibility is as fully estranged from the inner life as one bereft of subjective experience. These artists follow "the manic flight of desire and tortures of lust," arriving finally at that last outpost where desire and disgust conjoin to end in mutual obliteration. They employ their art as a medium of provocation, as a necessary act of violence with the declared aim of winning for art a value or ranking which can accord "man at the apex of his being a mortifying lesson." This is what engines Bellmer's relentless exploration of the forbidden kingdom of eroticism – uniting the obsessions and Freudian dreams of youth, male revenge, and a fearful loathing of satiety. The unmistakable in-fluence of the Surrealists is apparent in his work. We see it in his approach to perspective and in the imaginative spin he places on his associations. But no-where is Bellmer's talent more forceful than when he directs his feverish fantasy towards the female. In this connection he cannot dispute the lineage he shares with such great German masters of art as Matthias Grünewald or Hans Baldung Grien. The modulating, severe lines Bellmer employs to delineate volume and space witness a painful absence, or, equally, portend a desperate belief in chaos. Bellmer is both visionary and voyeur, and his artistic work configures beyond the "anatomical transposition" (phallus-nose, testicles-nostrils, buttocks-face) a realm richly steeped in fantastic association. In this regard he is by no means the

ILLUSTRATION OPPOSITE, ABOVE:
Edvard Munch
Summer Night at Ostafjord, circa 1900
Sommernacht am Ostafjord
Oil on canvas, 71.5 x 100 cm
Mannheim, Städtische Kunsthalle Mannheim

ILLUSTRATION OPPOSITE, BELOW:
Man Ray
Normal Time – The Lovers, 1932/34
A l'heure de l'observatoire – Les amants
Oil on canvas, 100 x 250.4 cm
New York, Private collection

Andy Warhol
Marilyn Monroe's Lips, 1962
Silkscreen on acrylic and pencil on canvas, two panels: 210.2 x 205.1 cm and 211.8 x 210.8 cm
Washington (DC), Hirshhorn Museum and Sculpture Garden, Smithsonian Institution, Gift of Joseph H. Hirshhorn

"Marilyn's lips weren't kissable, but they were very photographable." A. W.

inferior of Bataille. Bellmer acknowledges that his work derives "exclusively from physical experience." Throughout his œuvre he plays games with *The Doll,* the puppet body of an adolescent girl, its limbs somewhat askew. She wears a touching expression betraying a strain of backwardness mixed with lasciviousness. The contrasts in this figure generate a forceful jolt; she appears the proper sustenance for a most demented fantasy's wildest erotic imaginings.

Marcel Broodthaers writes in "Phantomas": "A more beautiful form than that of an egg? No. Or yes indeed, the mussel. The heart mussel. Two perfect forms, balanced, rich with unfolding... Objects that use the form of mussels, objects in the form of an egg, represent the world and the stars (painting? building? working?). One thinks of the pictures of Bosch and Brueghel, the images of Magritte: galloping eggs, inhabited eggs, eggs that are the hallucinations of the eye, that elicit the euphoric cant of unappreciated poets. Everything is an egg. The world is an egg. The world arose from the great yolk, the sun. Our mother, Mrs. Luna, is the colour of eggshell. And the stomach of a wave on the water is the white of an egg. The moon is a hoard of eggshells. Stars emerge from the dust of eggs. Everything is dead egg. And the poets are lost. Despite their dignity. This sun world, this moon, the movements of stars. Empty. Empty eggs..." And Broodthaers piles them together, stacks them, the eggs, the mussels, the eyes (*Watchtower,* p. 82).

In his "Traité des sensations" (Paris, 1754), the French empiricist philosopher

Auguste Rodin
Cast of Rodin's Hand Holding a Female Torso, 1917
Main de Rodin tenant un torse de femme
Plaster, 14.9 x 22.9 x 11.8 cm
Paris, Musée Rodin

"It is as if Rodin most prefers to regard the female form as part of his own handsome body, as if he desires that his eyes become the eyes of his adored one, his mouth her mouth." — R. M. Rilke

Etienne Bonnot de Condillac explicates the manner in which our every knowledge and cognitive faculty stems from the senses. Condillac proposes that the faculty of attention is the liveliest and the most superior of human propensities; the retention of cognitions is a faculty secretly hidden away; the ability to make comparisons is a form of double attentiveness out of which judgement proceeds; the faculty of abstraction is a quality of attention which perceives the form of an object; and the imaginative faculty is the power to associate images. In order to establish his system, Condillac designed a statue in which he enumerated the various senses and faculties, ranking them in their hierarchy. When Bellmer plays with his doll or Robert Mapplethorpe photographs a woman grasping her nipples (*Lisa Lyon,* p. 92); when Man Ray transforms the back of a woman into a violin (*Ingres' Violin,* p. 90) or Piero Manzoni adds his signature to a *Living Sculpture* (p. 91); when Helmut Newton (p. 98), Peter Paul Rubens (p. 96), Eva Hesse (p. 96) and Meret Oppenheim (p. 99) create a compendious parade of hair-fur possibilities; when Rodin delights in handling his creation (p. 89) or Gabrielle d'Estrée pleasurably passes the time of day with her sister (p. 94) — what are these artists doing other than provoking sense responses and closely observing the catalysed reactions? Body fetishism can be fixated on any aspect of the "fragment object" (or, to use Gilles Deleuze and Félix Guattari's term, of the "desiring-machine"). Each anatomical segment can operate as a foil for the entire body. The remainder of the physique, dispossessed of its normal standing,

Jean-Auguste-Dominique Ingres
The Bather of Valpinçon, 1808
La baigneuse de Valpinçon
Oil on canvas, 146 x 97 cm
Paris, Musée du Louvre

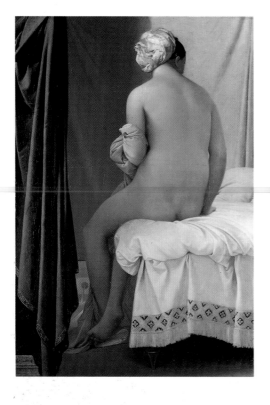

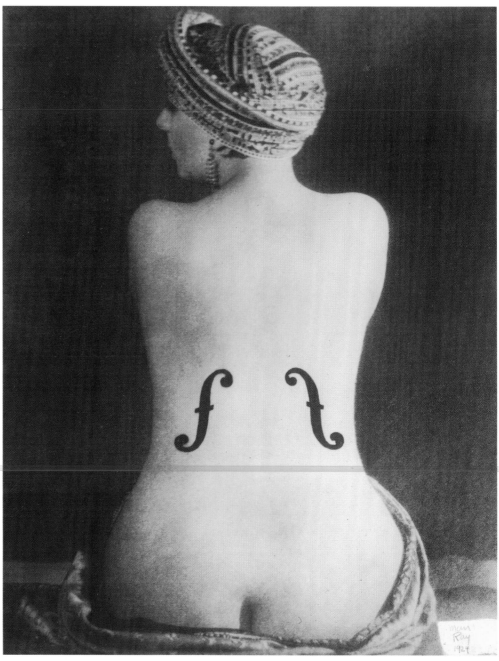

Man Ray
Ingres' Violin, 1924
Le violon d'Ingres
Photograph
New York, Courtesy Robert Miller Gallery

"Speaking of nudes, I have always had a great fondness for this subject, both in my paintings and in my photos, and I must admit, not for purely artistic reasons." M. R.

continues to exist in a supplementary or complementary role to the fragment object. This is why, for instance, a foot devotionalist might also be an adorer of the calves or legs; why a votary of the eyes might also be moved by the mouth; still others, as for instance hard-core nose fetishists, will only be able to give themselves over to the winsome qualities of the nose, its wings and nostrils. "Is there any portion of the anatomy inapt of sustaining fetish adoration," wonders Wilhelm Stekel, "and which therefore is ineligible to exercise the sexual provocation of the detail?" Havelock Ellis responds that every portion of the body is capable of becoming erogenic. And Roland Villeneuve adds in this connection: "The skin, purely the skin alone, becomes a fetish when its colour diverges from the commonplace; when it feels so beautiful and silky; when it is adorned with tattoos; when it calls forth a cannibalistic sensuality..."

Most fetishists, male homosexuals first and foremost, know the old adage whereby the size of the nose is said to intimate the length of the penis. The giant

statues erected by the indigenous people of Easter Island emphasise the nose as principal focal point. Also of recognisable interest is the prominent length of the nose in the paintings of Amedeo Modigliani. Pop artists yield themselves entirely to culinary excess, an intoxication encompassing the nude, which, when carved into portions, becomes a superelevated nude. In New York, as in "Alice in Wonderland", on every street corner there is a bottle reading "Drink Me", and nearby a little cake labelled "Eat Me". The prodigious, parted mouths Tom Wesselmann steers towards us are advertising billboards of an entirely duplicitous nature. They look as if they are drumming up business for a brand of toothpaste, or would love to find some way to sate their enormous appetites. A smile plays upon those lips because they find it impossible to conceal their happiness at being American mouths. And yet these lips make a parallel invitation, promising oral practice of an erotic nature... Eroticism and pleasure, the gourmet halves that mix so unmistakably in the fetishism of the mouth, the lips so often compared to ripe fruits. But with Wesselmann and Andy Warhol (p. 87)

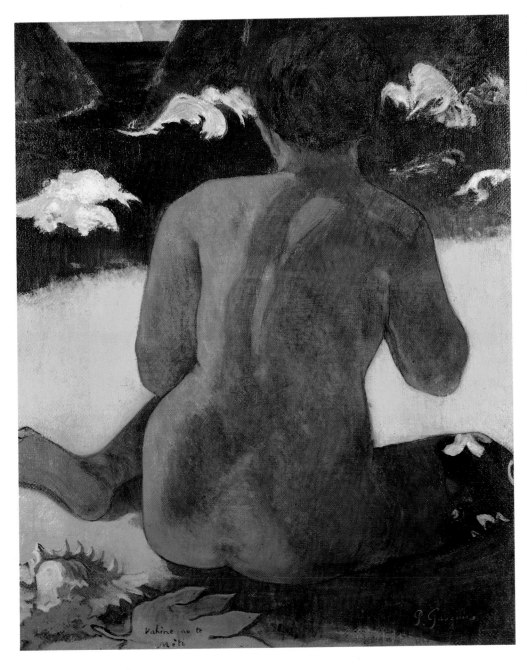

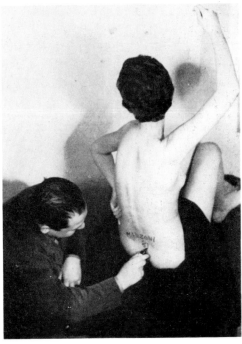

Piero Manzoni
Living Sculpture, 1961
Scultura viventa
In-progress photograph

Paul Gauguin
Woman by the Seashore, 1892
Vahine no to miti
Oil on canvas, 92.5 x 74 cm
Buenos Aires, Museo Nacional de Bellas Artes

Robert Mapplethorpe
Lisa Lyon, 1982
Photograph
New York, © 1982 The Estate of
Robert Mapplethorpe

one is squarely in the midst of America: Pop Art tows everywhere that same tight-laced bag of prudish naggings the Puritans brought ashore. It is no coincidence that most of Warhol's bottles and cans are sealed. Hot dogs, cakes and ice cream of enticing shades are made of plastic and settled behind glass, food exclusively for the eye. The nudes of Wesselmann are vigorously scrubbed down, plucked, deodorized – as hygienic as they are artificial, untouchable and impenetrable. They strike up affairs solely with voyeurs. This is a far remove from the work of the Surrealists, who employed the lips – as, for instance, Dalí's rendering of Mae West's lipsticked pair – as a place to recline, to get up and stroll about, to enter into a gracious waltz, or even to engage in an act of copulation. Man Ray portrays the lips as the ideal form of transportation for attaining the seventh heaven (*Normal Time – The Lovers,* p. 86).

Narcissus has never been so alive as in contemporary art. He has risen to the rank of box-office attraction, become art's ranking star. One can do nothing to diminish the drive of this ongoing phenomenon. At a Marcel Broodthaers exhibition in Brussels during 1962, Piero Manzoni declared that he could identify Broodthaers as an "authentic and genuine work of art," and gave his signature to "Certificate of Authenticity Nr. 071", its text reading: "It is herewith certified that Marcel Broodthaers has been signed by my hand and can therefore be regarded as a genuine artwork, valid for all intents and purposes, as of the date displayed below. Brussels, 23/2/62. Piero Manzoni." Broodthaers

Ernst Ludwig Kirchner
Semi-nude Woman with Hat, 1911
Weiblicher Halbakt mit Hut
Oil on canvas, 76 x 70 cm
Cologne, Museum Ludwig

"My wife always says that I never again accom-
plished another painting like this of a woman, and
here jealousy plays a slight role, because there are
also some very beautiful nudes of her. But perhaps
she is right insofar as in this painting for the first
time a profound love for the female figure comes for-
ward, and such a thing can happen only once."
E.L.K.

Vito Acconci
Adjustable Wall Bra, 1990/91
Mixed media, 731.5 x 243.8 x 152.4 cm
Santa Monica (CA), Courtesy of James
Corcoran Gallery

Ecole de Fontainebleau
Gabrielle d'Estrées with One of Her Sisters, 1595
Gabrielle d'Estrées et une de ses sœurs
Oil on wood, 96 x 125 cm
Paris, Musée du Louvre

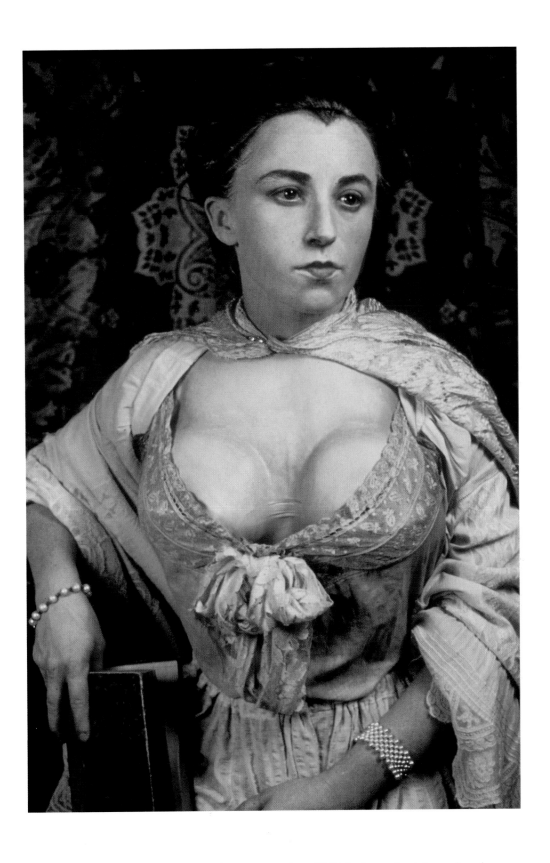

Cindy Sherman
Untitled No. 183, 1988
Colour photograph, 108 x 72 cm
New York, Courtesy Metro Pictures

later remarked with regard to this Happening: "We behaved with each other as if we were actors. This encounter with Manzoni on 23/2/62, the date of the certificate, the one authorising me as an artwork, made it possible for me to imagine the interval that separates the label from the art artefact, whereby they measure out the space of 'aesthetic art'. In other words, it has to do with the meaning of the message that states that here the label of the ware is identical with the ware itself."

This credo, which can be traced back to Duchamp, Dalí and Léger, declares in essence that, a priori, everything and anything is eligible to become a work

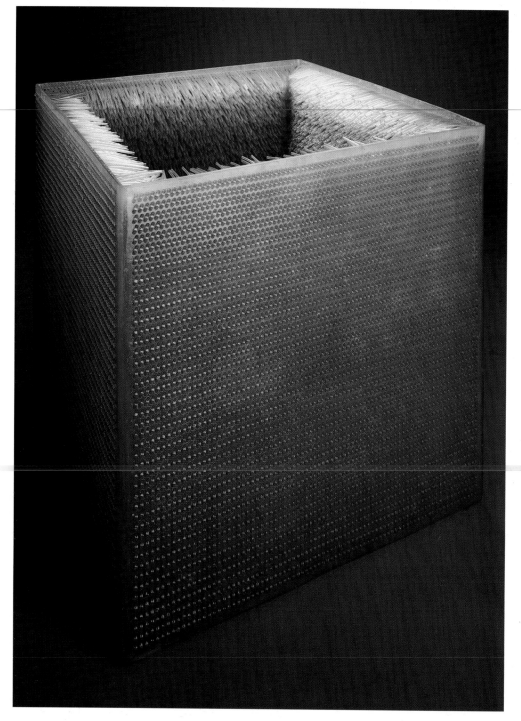

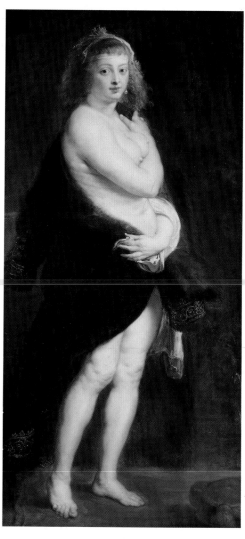

Peter Paul Rubens
The Little Fur (Helen Fourment, the Second Wife to the Artist), circa 1638
Oil on oak panel, 176 x 83 cm
Vienna, Kunsthistorisches Museum

of art. Once this premise is accepted, every ontological difference between a Coca-Cola bottle and the *Mona Lisa* is rendered unintelligible, void (Mona Lisa with a beard by Duchamp, Mona Lisa with a can opener by Léger). It is not a process of demystification, but rather a disassembly of the values, myths and legends ranging through society: to be exact, the society of New York, which during the Sixties functioned as the capital of a worldwide excess of materialism and hypocritical optimism. Warhol propelled everything a further remove, in-stating his own societal status as the central theme of his work. He manufactured print editions and signed them with his lips, a routine he duplicated with bank notes, subway tickets, cheque forms, T-shirts and cigars. He even gave his signa-ture to a baby so that the infant could be considered a work of art. Warhol claimed to get pleasure out of signing counterfeit Warhols. In much the same

Eva Hesse
Accession III, 1967/68
Besteigung III
Mixed media, 80 x 80 x 80 cm
Cologne, Museum Ludwig

ILLUSTRATION OPPOSITE:
Helmut Newton
Woman in a Fur Coat, 1976
Colour photograph
© Helmut Newton

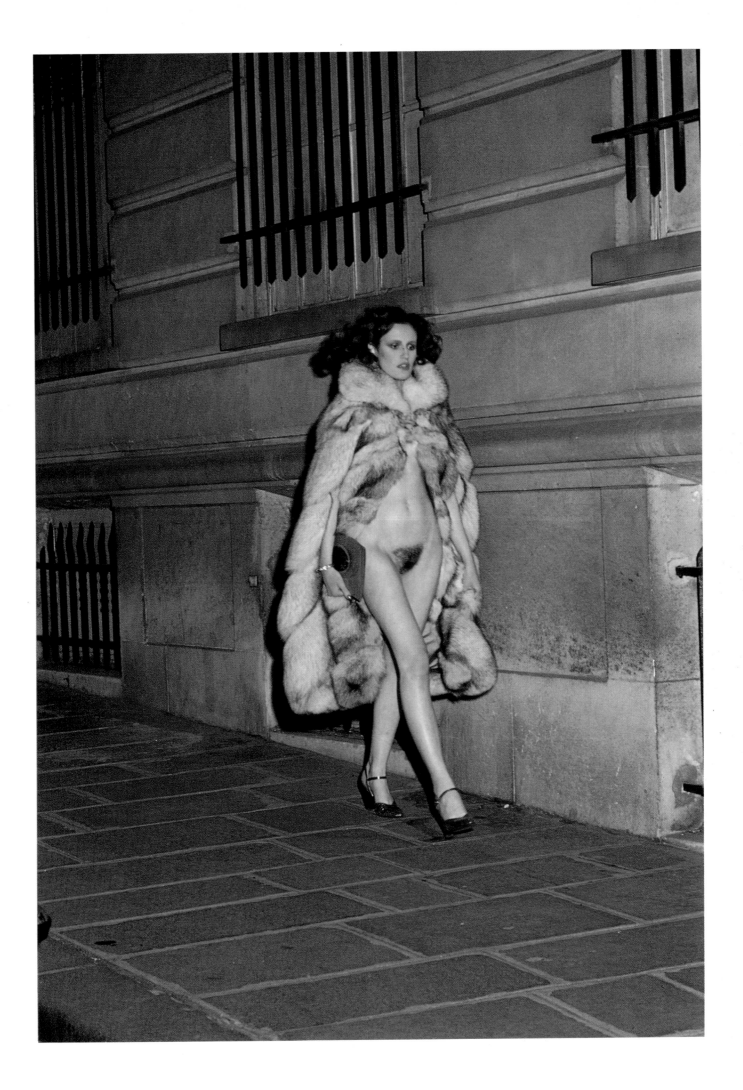

Tilman Riemenschneider
Mary Magdalene with Angels, 1490/92
Hl. Magdalena mit Engeln
Wood sculpture
Munich, Bayerisches Nationalmuseum

Helmut Newton
Arielle After a Haircut, Paris, 1982
Photograph
© Helmut Newton

spirit, Manzoni signed a woman's lower back (p. 91). Again we can observe Duchamp's nose (a long one) discerning something in the wind, can observe him taking his signed urinal out for a walk on the leash, his entire litter of ready-mades yanked along behind.

Roland Villeneuve, who delved into the various types of body fetishes to parade the fruits of his labour before the public eye, reserves a special ranking for the thumb. He explains that the thumb acquires a distinct role in the inner life of passive male homosexuals, that it serves as an image for something else, calls another image to mind. And he maintains that, among such fetishists, it is the length of the thumb that determines the intensity of pleasure. The hand with

its five fingers is an erotic signifier par excellence. Some people dream of magnificently long fingernails, nails worthy of a Chinese mandarin. The length of a male's thumb is said to correlate with the length of his penis. When one imagines the hands of Rodin sculpting female flesh, the heart quakes to attention (p. 89). When one considers the long fingers of Bellmer, the manner in which they press asunder the lips of the flower-sex organ, tickle the clitoris-pistil, or more deeply plumb the anal depths of a fruit, shivers cascade the spine (p. 88). We find ourselves wholly immersed in a profoundly tactile universe. Touch is naturally a supremely precious sense in the affairs of love and eroticism. Once the hands complete their metamorphosis into gloves, once they multiply, are

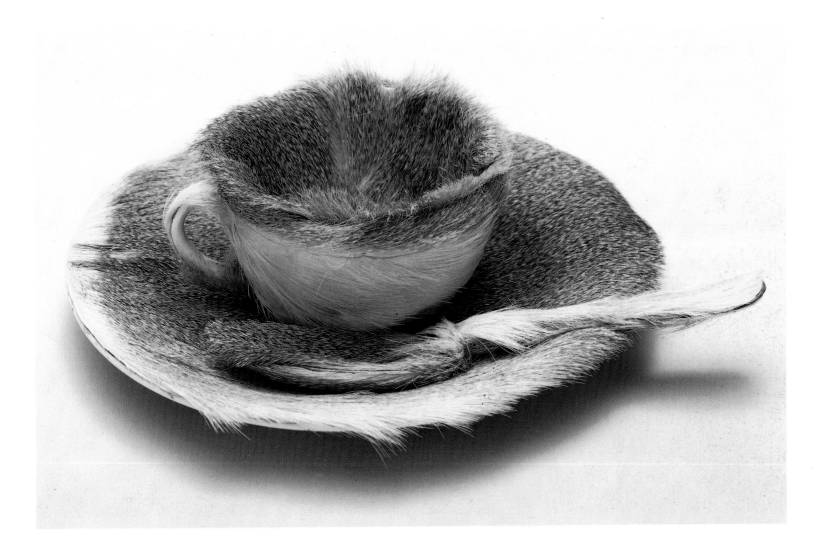

grouped atop each other, whip the female figure or caress her from within, the air brims with involuntary cries (Arman, *Torso with Gloves*, p. 88).

With the fascination of the human back we leave the arena of philosophy, cross the border into a realm of sensuality sovereign to art. When Man Ray transforms the back into a violin, he pays homage not only to Ingres but also to the female by comparing her form to that of a musical instrument (p. 90). Here again Nature imitates Art. Ingres, who actually did play the violin, would have been delighted by this motif. Ingres placed the priority of the line above everything else, called it "the correction of Nature", demanding of his students: "You must take the model's most conspicuous features and emphasize their

Meret Oppenheim
The Fur-lined Tea Cup, 1936
Object (Le Déjeuner en fourrure)
Fur-lined spoon, saucer and tea cup
New York, Collection, The Museum
of Modern Art, Purchase

prominence ... Take it, when need be, to the point of caricature. I say caricature in order to make the meaning of such a virtuous principle all the easier to perceive." Such modernity in Ingres! His critic Baudelaire, however, appears to be contemplating a Picasso: "Here we find a naval that has almost erred into the ribs, there a breast that too strongly accentuates the armpits." The photograph by Man Ray, as well as *The Bather of Valpinçon* by Ingres (p. 90), configure splendid perfections of form subtly embellished by eroticism. We can justifiably speak of an earnest and convincing libertine aesthetic.

The back and its unavoidable trailer, the buttocks, are one of Paul Gauguin's specialities, appearing and reappearing throughout his œuvre, from *Woman by the Seashore* (p. 91) to *Undine* to *Fatata te miti* ("Near the Sea") to the grandiose *Manao Tupapau* ("The Spirit of the Dead Keeps Watch"). This last painting depicts Tehura, a native woman harrowed by fear. She lies on her stomach, naked, her body stiff and her gaze hallucinatory, for she has caught sight of the Tupapaus, the Spirits of Death who emerge at night from the mountains. She

80/80

Hans Bellmer
Sexual Instructions I, Page 5, 1974
Unterweisungen der Sexualität I, Blatt 5
Copper point, 31,7 x 24,9 cm
Frankfurt am Main, Courtesy Graphisches
Kabinett im Westend

"Would it not portend the final triumph over the adolescent girls with their wide eyes turning askance as the conscious glance thieves their charms, as the fingers brimming with lustful attack begin their handicraft, languidly creating limb by limb all that the brain and senses have deigned to distil? Appendage meshed to appendage, configure childlike poses by urging ball joints to their fullest pivotal extent, to tarry along the hollows, to abandon themselves to the pleasures of the curves, to wanderingly err through the maze of the ear, making themselves delicious and a bit vindictive too, dispersing the salt of deformation."
H. B.

has stared into the awful phosphorescence of their eyes. This work is the Tahitian counter-perspective of Manet's *Olympia*. In marked contrast to Ingres, Gauguin made no pretence about which precincts his mind preferred to frequent. He even referred to his bamboo hut on the Marquesas Islands as the "House of Lust". As his life approached its close, Gauguin wrote to his friend, the writer and seaman Henri de Monfreid: "Every night girls possessed by the devil force their way into my bed, yesterday there were three I had to satisfy." Gauguin indulged his five senses by every imaginable means. A keg of wine stood always ready before his hut as he, his friends and the native women celebrated their

Max Pechstein
The Green Sofa, 1910
Das grüne Sofa
Oil on canvas, 96.5 x 96.5 cm
Cologne, Museum Ludwig

Gottfried Helnwein
Lulu, 1988
Watercolour on card, 63 x 55 cm
Collection Georg Lutz

Jeff Wall
Woman and Her Doctor, 1980/81
Colour photograph
Cologne, Collection Jörg Johnen

"prolonged benders". Incidentally, the native women, strolling about without a stitch of clothing, made themselves available to every guest.

However much the eyes may fascinate, the lips seduce, the breasts make the eyes or mouth water, the true dwelling place of beauty is the hair. A devilish adornment. Since antiquity poets have ceaselessly sung hair's praises. Aphrodite is the golden goddess of Homer. Grecian art demanded of its artists that the hair of Apollo, Dionysus, Artemis and the heroes be golden. Dante, Milton and Musset praised blonde tresses in their verse, while the Bible, Ovid, Lucian, and Chénier prefer brunettes. In more recent times, Toulouse-Lautrec and Klimt have given pride of place to redheads. In the "Metamorphoses" of Apuleius we hear a lover enjoin: "Come, lend me your greatest pleasure, open the braids of your hair, that your mane of curls might swaddle our love play with bountiful caress." Whether the curls be golden or swarthy, for many lovers they evoke the locks of the loin. And finally, the most treasured scents are those which rise ethereally from the hair. In this regard – especially when the armpits figure in our tally – it is the redhead who ranks first. Since Biblical times women have perfumed their "little furs" to enliven their first caresses.

In the "Story of O", the female heroine is told by her lover that she must wear an owl mask while her pubic hair is waxed away: "In her eyes it was clear that a startling connection existed between the hair of her groin and the feathers of her mask; it was also abundantly clear that this mask lent her the mien of an Egyptian statue, and that her broad shoulders, her narrow hips and her long legs, further magnifying this semblance, dictated that her skin be smooth and flaw-

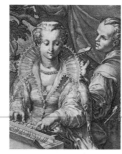
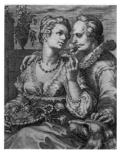

Jan Saenredam
The Five Senses
Die fünf Sinne
Copper point series after Hendrick Goltzius,
each 17.6 x 12.2 cm

less…" One dare determine that artists from every epoch have been on terms most intimate with the erotic that sprouts from the dialectic of nudity and hair.

If there is a paradigm example of a model summoning the artist's narcissism and wish projections to canvas, then it is the portrait *The Little Fur* by Rubens (p. 96). The model is the veritable embodiment of Flemish beauty, pale and strapping, buxom, fleshy, sensuous, desirable. Rubens had painted women under various circumstances for some fifty years before he finally succeeded in establishing this image of a female naked beneath a fur coat. It is Helene, his seventeen-year-old wife, the delightful young plaything he dresses or undresses as he desires. Here, employing an almost Titian palette, he ventures to share with us her undeniable charms. In these sublime tones Helene appears nuder than nude; we see her curly hair – she's a redhead, naturally – and admire her breasts so pert and alluring. In order to appear the more desirable, Helene, however preposterously, hides amidst a fur coat that is doubtless a few sizes too large. This pose launched Leopold von Sacher-Masoch into such an emotional furore that he was inspired to create his major work, "Venus in Fur". But is the lively expression gracing Helene's face the result of a certain untoward coolness creeping into her bones? Or does her visage mirror her overwhelming desire to obediently please her husband? Helene's eyes will always hold the answer secret.

Already as a twenty-year-old Octavio Paz sensed something distressing: "I'm not saying that we're living through the end of art: we're living through the end of the idea of modern art." Before him, Francis Picabia, in the Dadaist tradition, straightforwardly declared: "Where is modern art headed? To the shithouse!" And as early as 1920 Alexander Rodchenko put the problem as a pithy question: "I have eliminated every object to the point of perfect uniformity. Now I ask myself, where can we go from here?" As regards eroticism, one might frame the question somewhat differently: Where should she next be taken? Yet, as we have witnessed again and again in our considerations of this theme, artists always have an answer close at hand. But let's linger a moment longer with the hair/fur motif. A number of possibilities are readily available, some plying humour, others wantonly grotesque. Meret Oppenheim opts to take the route of humour, as she demonstrates with her surrealistic work, *The Fur-lined Tea Cup*, a creation that ceaselessly sends shivers of amusement (p. 99). The pun Oppenheim employs is obvious: one might take up the spoon and "stir back and forth." Eroticism is never far away. For this female Swiss artist, befriended with Man Ray and Max Ernst, such was of course a simple given. But she took it further: at the International Exhibition of Surrealism in 1959/60, she served the public her work *Cannibal Banquet* upon a female nude. A square sex organ is the evocative accomplishment of Eva Hesse (*Accession III*, p. 96), a creation which immediately calls to mind the image of a fakir on his bed of nails indulging in sexual strivings. When humour is pushed out onto the field of play, fetishism receives apt reinforcement. In his work "The Life of the Gallant Ladies", Brantôme declares: "I have heard the story of a woman who has a fur hide, a pelt of hair across her breast and down her stomach and across her shoulders and along her spine, and her abdomen, too, is pelted. Exactly like a wild animal. You can judge for yourself what this might portend. If the old saying rings true, that a person with a pelt of hair is either rich or lecherous, then, I can tell you in all honesty, in her case the one meets its mark as well as the other; and she can exhibit herself most gratifyingly, make herself desirable." At least since Bran-

Francesco Clemente
The Five Senses, 1981
Pastel, each 66 x 49.5 cm
Zurich, Courtesy Thomas Ammann

"When in one of the pastels of the series, The Five Senses, a naked man appears with red streaks across his buttocks, we can hardly distinguish the difference between the sadistic activity represented in the scene and the sadism of the painterly line itself. The red streaks have no artistic presence; in their awkwardness they have no place in the fictive contours of an illusionist world. Instead, taking the sexual theme literally — for this is sadism — they deliver a wound to the image. Here Clemente's line becomes an instrument of pain, the erotic 'pain as desire'."
J.L. Koerner

tôme's time, then, nothing more can surprise us. Louis XIV kept a hunchback, Mademoiselle de La Vallière, as mistress. The French king must have possessed an extraordinary fetish, for this was a liaison of a precious duration. From where do the desires arise, Descartes puzzled, where do these gadfly powers take residence in our being? The French philosopher found the charms of cross-eyed women irresistible. And de Sade was surely not completely wide of the mark when he wrote in "The Hundred and Twenty Days of Sodom": "The beautiful is most mundane, the hideous most unique, and every passionate imagination, so far as lust and lechery are concerned, doubtless prefers the unique over the mundane; the debasement of the hideous harbours a much more powerful blow … Divers people prefer to gratify their lusts with an aged, hideous grandmother, though she greatly reek, than with a young and fetchsome maiden…" The deciding factor is that all five senses be sated.

ILLUSTRATION PAGES 106/107:
Jeff Koons
Ilona with Ass Up, 1990
Oil on canvas, 247 x 366 cm
Cologne, Courtesy Galerie Max Hetzler

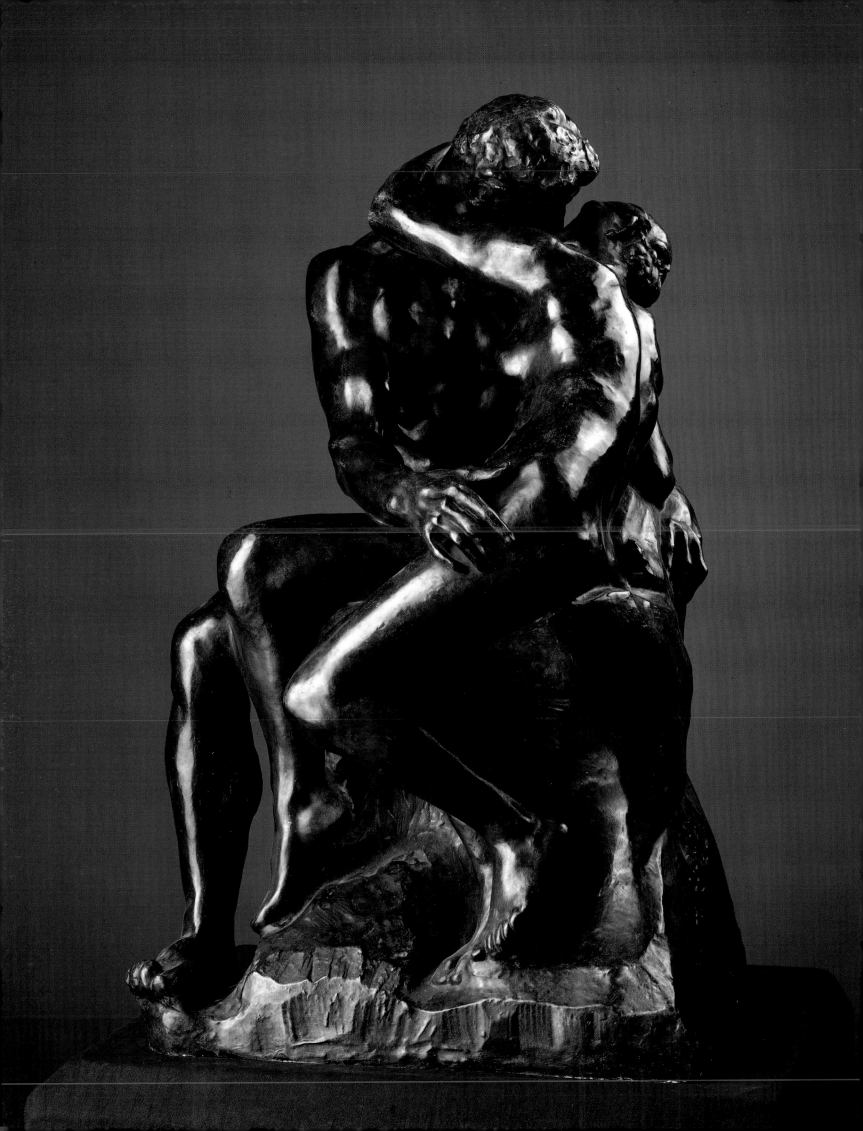

The Anatomy of Love, or, The Beauty of the Obscene

Any artwork deserving of such a designation can be interpreted by means of a variety of approaches. Just as a novel by Dostoyevsky can be read at various levels – as a crime story, for instance, or as a human comedy in the style of Balzac, one in which the author, attempting to fairly delineate Western and Slavic mentalities, captures in words the pulse of his epoch – so too philosophy and mysticism, addressing the fundamental questions of being, portray the manner in which humankind is perpetually torn between evil and the search for God, between the poles of the conscious and the unconscious.

Such questions and philosophical ideas can also be found in painting. Since the dawn of modernism, however, these elements have become increasingly difficult to decipher. This development has been determined primarily by the bold evolution of the visual element. No longer do we find the forms and motifs familiar to us from classicism. Over time, owing to the changing flux of motivations, the artist has changed, become more sophisticated. The birth of photography marked a decisive milestone in the history of art. Today, of what possible value can it be to replicate reality with consummate fidelity when anybody can pick up a handy gadget, press a button, and create a snap? Were one to arrange in a row those artworks created with the intention of interpreting some aspect of reality, works at the same time informed by widely disparate goals, then one could compose an anatomy of love which ineluctably, step by step, would lead to the beauty of the obscene. One would proceed from the heightened passion of Rodin's *Kiss* to the pornography of Grosz, from the theme of homosexuality in Francis Bacon to the suffering, orgasm and death – however major or minor – of Munch, Kienholz and Klossowski. Behind the formal semantics of surface dwell nothing other than the true intentions of the artist, intentions that change with every given work.

What connections can possibly be explicated between the icy, Mannerist, yet clearly highly eroticized work of Bronzino (1503–1572; p. 110) and the morbid, disingenuous eroticism of the fin-de-siècle as exemplified by Klimt (1862–1918; p. 111)? Both works interpret the kiss motif, of course, and the figures they depict are caught in a broadly identical attitude of embrace. Also, both paintings employ ornament to the point of exaggeration – one could actually make a case that they stem from the same formal lineage. But a second level of analysis soon wrestles the fact to daylight that some four hundred years separate these two compositions, that they emerge from two vastly different worlds, lend

Constantin Brancusi
The Kiss, 1912
Le Baiser
Limestone, 58.42 x 33.02 x 25.4 cm
Paris, Musée National d'Art Moderne,
Centre Georges Pompidou

Auguste Rodin
The Kiss, 1886
Le Baiser
Bronze, 87 x 51 x 55 cm
Paris, Musée Rodin

Agnolo Bronzino
Venus and Cupid, 1540 – 45
Allegoria di Venere e Cupido
Oil on wood, 146.1 x 116.2 cm
London, The National Gallery

expression to two widely disparate mentalities. One particular quality, however, unaltered by the interval of time, stubbornly insists that these two works be inseparably associated: the erotic in which they revel.

"All artists carry the imprint of their epoch," Matisse writes, "but the greatest artists are those most profoundly marked by their era." They harbour inwardly, as Garaudy once called it, "the formative consciousness of their epoch." And Fernand Léger submits the following explanation: "When painterly expression changes, then modern life has only effected what was necessary." With Bronzino and his contemporaries, Pontormo, Parmigiano and Rosso Fiorentino, we find ourselves in the midst of Mannerism, a movement of the late Renaissance. Standing outside the scope of classicist canons, the Mannerists took pleasure in their use of elongated forms and the expression of bizarre motifs, intellectual games reminiscent of the Fontainebleau School. The Mannerists would return to the old and trusted sources of art, to religion and mythology, and locate subtle yet provoking themes for which tradition would have to assume responsibility.

It comes as no coincidence that eroticism has a central function in this school's metaphorical depiction of certain macabre or perverse themes. There is hardly a work of more sumptuous eroticism, and such accomplishment in the Mannerist style, as the gallant masterpiece by Bronzino, *Venus and Cupid* (p. 110). A youth together with a woman in full bloom – one need not puzzle long over the cause of cavort. And the fact that so many voyeurs are privy to this frolicsome scene, including one old sulk, is also a feature that demands our mindfulness. The sheer charm and sensuality of these two bodies so ready to partake in love's blithe games can leave no one unmoved. Cupid's youthful buttocks would

Gustav Klimt
The Kiss, 1907/08
Der Kuß
Oil and gold on canvas, 180 x 180 cm
Vienna, Österreichische Galerie

have given Michelangelo's fantasy wings – after all, it was Michelangelo himself who remarked that one paints "with the brain and not with the hand". Also, the anatomy of the woman is of a most uncommon vintage – she appears completely devoid of bone, as François Boucher once remarked. This soft and tender female figure is bereft of hair about the loins; her mound of Venus – here most deserving of its name – swells only very slightly. The gentle being appears far too tender to be making ready for love's wild clutchings; our imaginations are overwrought. She manifests a startling contrast to the painting's erotic designs, its mythological theme. One further detail of importance: Cupid is the son of Venus. We are admiring a candid representation of incest. As a "cerebral" painter and Mannerist who eschewed the banal and treasured the bizarre, Bronzino could not keep his brush from portraying this theme, from culling it out of the everyday.

Another age, another set of headaches: Viennese society at the turn of the century regarded death and sexuality as dark chaotic factors to be shunned, hidden from view. Religious aberration and individual revolt were two counterbalancing effects provoked by this stark morality. Klimt's response was to pursue an artistic route fraught with passion and rebellion, anguish and suffering. He

questions what the individual can even realise about his vital existence. According to Georges Bataille, all authentic art is necessarily Promethean. Klimt's œuvre bristles with symbols of the human revolt against the tyranny of materialism and its self-righteous claims on truth and ideals. Wasn't it Zeus himself who inaugurated a just form of rule by granting Prometheus pardon? Vienna did not possess the majesty of a Zeus, and Klimt, throughout his artistic career, was embroiled in battles with censors. It would appear that between the epochs of Bronzino and Klimt a backslide, a regression, had taken place. Because Klimt was less free than his predecessor, he was forced to struggle more resolutely. Klimt resolved his artistic problem by transforming anatomy into ornament, and ornament into anatomy. His seductive decorations force sexuality in its overt immediacy to disappear. Klimt's frequent use of gold functions as a sort of fig leaf, operating as a non-colour which, like some magic cloak that lends invisibility, restrains his images from betraying too much corporeal reality. Though the subject matter of *The Kiss* is unfit for its setting and era, Klimt's duplicitous ornamental guile so successfully cloys his thematic handling that not only is he able to elude the cudgelling of prickly royal censors, but is also able to secure an audience throughout the fussily conservative echelons of Viennese society. The crowning irony: *The Kiss* was eventually purchased by the Austrian government.

Roy Lichtenstein
We rose up slowly, 1964
Oil and magna on canvas, two panels
each 173 x 234 cm
Frankfurt am Main, Museum für Moderne Kunst

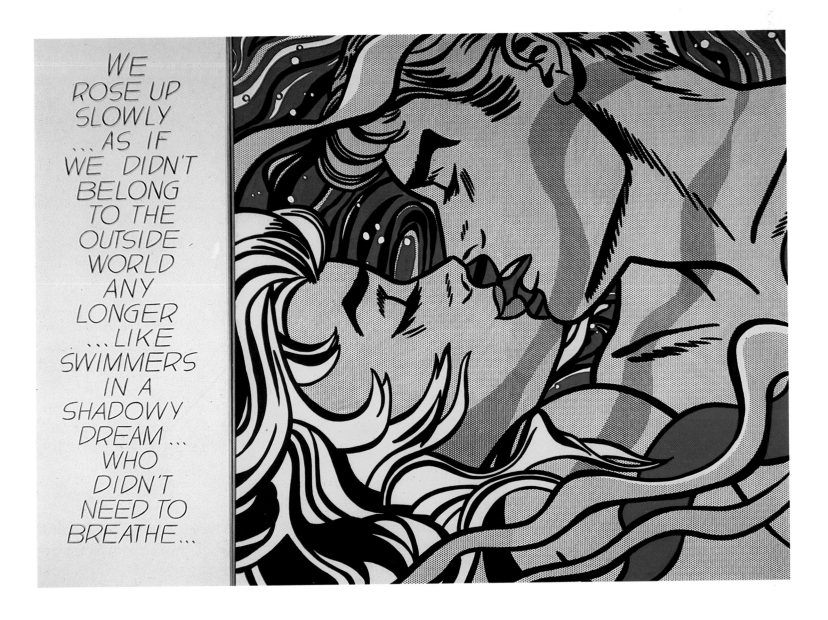

Lovis Corinth
The Embrace, 1915
Umarmung
Etching, 17.9 x 15.9 cm
Hamburg, Hamburger Kunsthalle,
Kupferstichkabinett

"You can photograph a landscape," Francis Picabia told his grandfather, a great admirer of Daguerre and photography, "but you cannot photograph what I carry around in my head." This one statement expressly delineates the grudge match between photography and painting. Yet gradually the specific spheres entrusted to these two art forms crystallized. The camera lens has the task of capturing reality, the myth that surrounds us. The traditional representational arts are assigned the task of using reality as a template for its creations, for "realisation" in the absolute sense of the word: coaxing something from nothing, lending feature to that never seen before.

At nearly the same time as photography was undergoing its pioneering strife, psychoanalysis unleashed a revolution, storming the brain's inhibitory safeguards, opening the sluices in the depths of consciousness, shattering the mirror which had provided an undisturbed reflection of Narcissus since the 15th century, a vision of being that had seemed objectively valid, perennially stable. The new subjectivity challenged the artist "to lower himself to those strange powers which operate inside us, explore the dazzling refuges within, the obscure and endless wealth, the forbidden promises" (Joseph Baruzi, 1911).

In 1908 Emil Nolde asserted in a letter that the great, truly important artistic battles had been fought in France, and that such great Frenchmen as Cézanne, van Gogh (sic!) and Gauguin had carried out the offensive. The French had stripped their work of every passé element, Nolde continued, such being the only way commensurate with establishing a new form of art, an art which could rightfully assume its place alongside the venerable art of the past. One can say, then, that the decisive reversals and transformations in the art world were consummated between the years 1880 and 1905. The processes loosed during these years effectively assured the dissolution of a painterly ideal which, following the careers of Uccello, van Eyck, and Fouquet, had seemed invulnerable and permanently established.

Since then, without relent, the image has become more and more determined by the apprehension of significant form, meaning that art proceeds from the signs of the real or of the imaginary. The possibility of discovering shapes in flecks or clouds, as Leonardo da Vinci long ago put it, represents the initial concession to the problems of the image. By virtue of the associations which the image perforce elicits from the subjectivity of the beholder, it creates a direct relationship with the known, and thus derives its meaning. The beholder determines the degree of a composition's figural expressiveness, a value which by no means need find consonance with the creator's original intentions. Theorists of pure abstract art underestimated this unavoidable psychological factor; only the strictest and most elementary geometrical forms, as realised in the art of Mondrian, stand outside its valuation. Without further elaboration, a square remains a square. It requires an extraordinary effort of imagination to spring the boundaries of such a clearly defined term: for instance, to discover in its formal purity a forbidden eroticism.

On the other hand, what belongs to nature, whether it be a detail, segment, or "fragment object", appears as a ready message from the cosmos and directly perturbs the most profound fantasy desires. This aesthetic revolution manifests the tail-end of a crisis of consciousness which had dominated Occidental thinking for some two hundred years, a crisis which placed the ontology of reality in question. The initiator of this heated debate was the English philosopher

Edvard Munch
The Kiss, 1897
Kyss
Oil on canvas, 99 x 81 cm
Oslo, Munch-Museet

George Berkeley. He started the avalanche rolling at the beginning of the 18th century by questioning the existence of an objective reality, maintaining that all we can possibly know is our own inner states, our own perceptions, and arriving at the conclusion: "It is inconceivable that anything should exist apart from, or independent of, the mind."

After decades of such debate, it comes as no surprise that modern art has been forced to resign from its merely decorative post, is no longer a phenomenon that unpacks its entire meaning upon the threshold of the retina. Eroticism, which had formerly relied upon the direct sanction of the eye, was newly commissioned to steer its solicitations towards the brain.

Marcel Duchamp announces this new form of expression: "There is a difference between a form of painting which merely directs itself to the eye, and a form of painting which goes beyond the eye, which uses the paint tube as a springboard to accomplish its leap."

"It was just so for the religious painters of the Renaissance. The paint tube did not interest them. What was for them of primary importance was to

Pablo Picasso
Frenzy, 1900
Pastel, 47.5 x 38.5 cm
Private collection; formerly Basel,
Galerie Beyeler

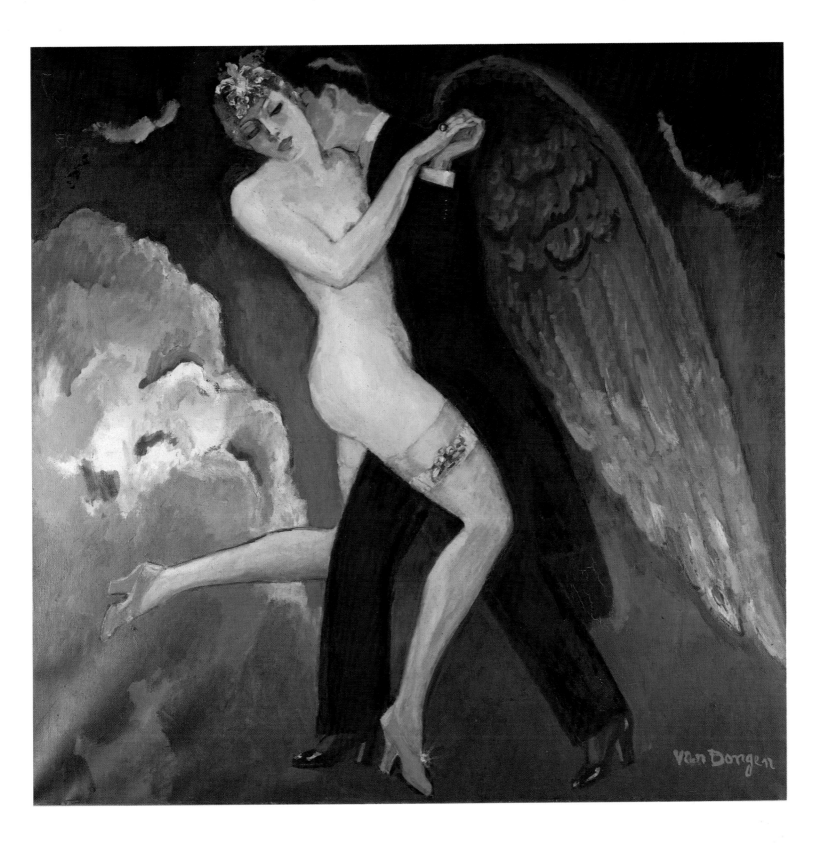

Kees van Dongen
Tango, 1923–35
Oil on canvas, 195 x 114 cm
Nice, Palais Masséna

express their conceptions of divinity in one form or another . . . Though I by no means repeat the same thing, it is this identical idea which masters me, that decorative painterly expression is in itself uninteresting as a goal. I have a completely different intention, one that is a formula or at least a statement which can only be realised in combination with the grey matter."

Following Duchamp, then, the "cerebral stimulus" was substituted for the "retinal stimulus"; from this point on, painting was outfitted with a new validating function. Shock was the new vital ingredient, for "a painting that fails to shock isn't worth the effort."

Under these circumstances, eroticism also underwent a radical revaluation of form. Duchamp is not the last artist to inform his entire œuvre, whether allusively or vividly, with this new element. "I place a tremendous belief in eroticism," he confesses, "for it is truly a thing that finds general validity throughout the world, a thing people understand." Taking *The Givens* (pp. 168/169) as an example, we can see that Duchamp flirted with eroticism throughout his wide œuvre – flirts that occasionally lapsed into expressions of overt pornography. One notices, for instance, that Duchamp has appended the letters *L.H.O.O.Q.* to his *Mona Lisa*. In French, phonetically, these letters intimate: Elle a chaud au cul – "She is hot in the butt." Such overtones range throughout his work, from *The Bride Stripped Bare by Her Bachelors* to *Fontaine* and *The Givens*. These last two works wax poetical on the theme of urination: the first, through the immediate bid of a urinal; the second, by enticing the viewer to peek through the crack of a door to observe a naked "virgin" so disported that she, while simultaneously an object of exhibition herself, can observe her own "yellow jet". In other words, she's taking a piss.

This warp of reality can already be observed by comparing Rodin's *The Kiss* (p. 108) with the like-named work by Constantin Brancusi (p. 109). The sensuality of the first makes the vivid quality of the second all the more impressionable. Brancusi – who, incidentally, refused to work with Rodin because, in his own words, "nothing flourishes in the shade of great trees" – never created a work that was expressive in the same direct manner as Rodin's sculptures. Brancusi couples a pair of "fragment objects" (a stylized man and woman), literally transforms them into a "desiring-machine", a closed system, a self-sustaining compact unit. Their symbolism, their will to symmetry and simplicity, and the purity of their abstract lines, endow these figures with that same

Frida Kahlo
Two Nudes in the Forest, or, *The Earth Itself,*
or, *My Nanny and I,* 1939
Dos desnudos en un bosque o La tierra misma
o Mi nana y yo
Oil on metal, 25 x 30.5 cm
Private collection

Balthus
The Guitar Lesson, 1934
La leçon de guitare
Oil on canvas, 161 x 138.5 cm
Zurich, Courtesy Thomas Ammann

"Balthus paints victims, but meaningful ones, that much is true. A knife, but never blood. His is another idea of pathos. He is interested not in the crime, but in the innocence. Victims too bloodied would bear traces of their murderers. But here they are, sacrificed amidst the pure innocence of the past, the hellish vortex of the intact yet unapproachable cities and time suspended to finally gain again this melancholy and awful paradise through which Balthus moves like the cats he paints with such relish. Here the Bluebeard connotation finds aptness. Balthus possesses too rigorous a sense of boundaries not to accommodate a crime that expresses the very pinnacle of black knowledge. Nearly all of his sleeping females appear as victims. They are the inconspicuous victims of stranglings. The others, older and guillotined, wear since their recent resurrections the dreamy expression that accommodates them to this scandalous natural universe."
Albert Camus

Franz von Bayros
The Stargazer, 1912
Der Sterngucker
Illustration to "Die Purpurschnecke"

charmed presence one might discover in Romanian folk art or in the idol images of primitive peoples. It is quite apparent that the work of Brancusi represents a breach with classicism, heralds a completely new – by comparison with Rodin – category of sculpture.

"I am also a painter," said Gaspar Félix Nadar, a photographer who had installed the first Impressionist exhibition at his Paris studio, alongside his famous portrait photographs. "So do it," Degas answered him, "false artist, false painter, falseograph!" (Untranslatable pun: "faux artiste, faux peintre, fauxtographe.") This adroit wordplay gives expression to the covert war which assailed the aesthetic arts once photography made its appearance. Naturally, for a while, the painters tended to overreact, for they imagined that their supremacy had been placed in question. But eventually it was not photography which swallowed painting – as many back then had feared – but painting which subsumed photography. In 1933 Salvador Dalí confessed that he had been swept away by the impulse of a "shrill, Sybaritic realism". Already he had declared that his works were "the hand-painted colour photos of hallucinatory and highly realistic images based upon concrete irrationality." Between the Photorealists and Jeff Koons there are a wide range of artists who employ photographs as their

primary referential aid. This is a photography that has been stripped of the Surrealist flair we know from Man Ray; instead, it is employed as an instrument, a pragmatic medium capable of assisting the painter in his investigations of the visible world. How could photography – so widely disseminated worldwide by the media – not also achieve a central place in the hearts and interests of contemporary painters? The photo, enlarged, prettified, becomes in the artist's hand a model, a "neutral" image of reality. From here he is allowed, without commentary, to cast or erect a version of reality, to render his work. This is the manner in which Jeff Koons lends his conjugal, vaginal penetrations the value of monuments. And so it comes as no coincidence that he entitled his first important New York and Chicago exhibition "Banality". But to shock with banality cannot be the intention, nor does it lie within the range of possibilities

open to every artist. Cicciolina once offered to ransom free the hostages Saddam Hussein was holding by allowing the Iraqi leader to rape her. Koons in his work quickly availed himself of this offer, greeting her largesse with the words: "She is one of the greatest artists in the world, my favorite artist in the world. Instead of using paint brushes or photographs, she articulates her genitalia." We may be less inclined to question the sagacity or method of Jeff Koons if we recall that at the Biennale in Venice a fanatic slashed one of his graphic works with a knife, damning it as "porno-kitsch" – a gesture which of course established the sacred status of the artwork.

Duchamp's ready-mades exert a powerful conscious pull upon those artists who avail themselves of photography's possibilities in their work. Some have even taken it so far – using Dalí's words – as to "hand-paint ready-mades" (the soup cans of Warhol, for instance, or the plastic female figures of Wesselmann). Dalí, highly enamoured by the possibilities of this process, goes on to explain: "There is no question that Vermeer van Delft or Gérard Dou, were they alive today, would not have hesitated to paint the dashboard of a car or the surface of a telephone booth, expressing all the timely similitudes they might contain." Today, the relationships between graphic art, photography and film have developed a certain constancy, a dependability. We have already noticed in the example of the Pop artists that it was their intention to substitute "the part for the whole". However, they transferred their photographic viewpoint into another space and time, played with contrasts and accumulations, with polarities and gravitations. The American artists devote themselves to their incontrovertible injunction of maintaining at all times a critical and ironic distance, while the English, such as Richard Hamilton or David Hockney, resign themselves to a plane of nostalgia and romance where they can directly question the factuality

Ernst Ludwig Kirchner
The Lovers VI, 1911
Liebespaar VI
Lithograph, 16.8 x 21.9 cm
Hamburg, Hauswedell & Nolte

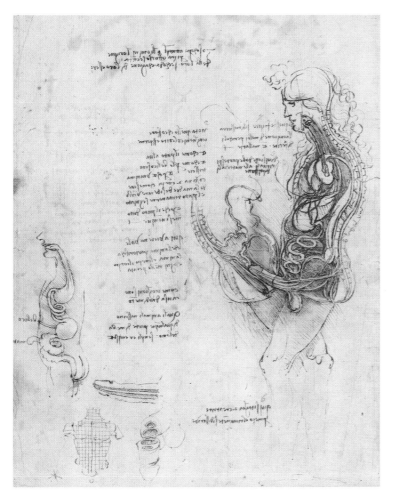

of their descriptive fragments. In the words of one critic, "The dots of Seurat's Pointillism are obviously visually related to Roy Lichtenstein's dots." With the aid of photographic enlargements, Lichtenstein can paint his newsprint settings like still lifes. His kiss entitled *We rose up slowly* – grainy, inky contours, coarse newsprint quality, skewed colouration – is faithfully rendered in terms of a reproduction of the original (p. 113). But the scandal Lichtenstein's work elicited during the Sixties was that – at a time when New York was firmly in the hands of the Abstract Expressionists, a movement thought destined to conquer the globe – this unassuming young man dared return to a childish world of comic-book figures and speech to play the role of spoiler for the Abstract artists. But Lichtenstein was no innocent. Like Jeff Koons, he was clued into the powers he was tapping. The comic functions as a sort of synonym for the American Dream. It outfits the artist with a medium he can use to funnel his message directly into the heart of our mass society. Considered from the sociological and psychological points of view, the effect the syndicated comic features printed by conglomerate newspaper dailies has on the public at large should not be underestimated – as a profusion of anecdotes attest. There was, for instance, the occasion when Dagwood and Blondie Bumstead, a popular comic-strip couple, were unable to decide upon a name for their second child. Spontaneously, 400,000 readers wrote to the newspapers publishing the syndicated comic to help their heroes with some name suggestions. Another anecdote told with relish is of the politician who dreamed up the idea of delivering election campaign speeches entirely pasted together out of sentences lifted from that

Alfred Kubin
The Spider, 1900/01
Die Spinne
Washed pen drawing, 18.9 x 24.6 cm
Vienna, Graphische Sammlung Albertina

"I am the organizer of the uncertain, hermaphrodite, dusky and dream-like. I'm striving for the secret domain in my human depths, to be poured into life and into lasting artistic forms." A. K.

famous comic hero, Andy – a man of the middle class. The politician was elected by a landslide majority. But there is no doubt that Lichtenstein should also be awarded a place in that long lineage of painters who have looked to Olympus for their themes, rendering in their works the figures of Zeus, Aphrodite and the other gods. The sole difference lies in the fact, that our modern idols bear the names of Marilyn Monroe, Michael Jackson, Superman and Donald Duck.

Jean Tinguely, in a 1967 article entitled "Art is Revolt", writes: "Art is omnipresent, for it can be 'made' out of everything: from stone and petroleum, from wood and iron, from air and energy, from gouache and canvas – or out of a situation, out of fantasy and confrontation, out of boredom or playful wit, out of anger, out of intelligence, out of glue and wire, out of antagonism, or with a camera. Consequently, art is also the vested competence of the engineer as well as that of the technician, even though they may create only unconsciously or by virtue of their functions. Everything is art. (Should art honestly remain the reserve of 'artists'?) And besides: art is everywhere – at my grandmother's, in the most unbelievable kitsch, or in a board left to moulder."

"What will remain of surrealism? The erotic", André Masson said, not without ulterior motive. In all likelihood the Surrealist works one can most easily

call to mind are indeed those generously dosed with eroticism. If one swaps the erogenous organs for the organs of sense, then one so inspirits the existence of the "erotic object" (in the sense of the Surrealists) that the concept of beauty is sublimated by the profane. Georges Bataille remarks in a sense similar to that of Masson: "No one today uses the word Surrealism exclusively as a term to describe that artistic direction connected with the name of André Breton. Personally, I have always preferred to speak of Mannerism, a designation I elect to use in order to single out those paintings bound together by something fundamental: their compulsion lies therein, to transcribe the fever, the desire, the flaming passion. I am not referring to the artistic skill or craftsmanship which this word tends to bring to mind; if this word is connected to base desire, that is something that takes place in the minds of those who discern such emphasis. The important connection between the painters of whom I speak resides therein, that they abhor the conventional. Only this impels them to love the fire of eroticism – I am speaking of the intolerable heat which eroticism sets free . . . Before everything else, the sort of painting of which I speak is boiling over, it lives . . . it burns . . . I can not speak of it with the coldness necessary to pass on a judgement, ascribe a classification"

Matta
The Offences, 1941
Les délits
Lead and wax pencil, 57.2 x 72.7 cm
Paris, Musée National d'Art Moderne,
Centre Georges Pompidou

They defy classification, those artists whom André Breton, the eulogist of "L'Amour fou" ("Mad Love"), endeavoured to herd with his lash. Breton, an admirer of Joan Miró, André Masson, Max Ernst, Salvador Dalí, René Magritte, Francis Picabia and Man Ray, among others, cannot subdue the displeasure he feels regarding the liberties his "comrades" – not "comrades in arms" if the Surrealist principles hold any sway – so deftly preserve. Breton wants to instate Amour fou as Surrealism's household motto. And he means nothing other than the exact formulation he himself imagines, for only then can he put his trust in the future and the future in the female. But the artists have no idea how to begin with such a programme. Instead, they rely very much more on their own immediate desires, their own fantasies, and dispense with the idea of order. Naturally, one thing binds them together: they propagate eroticism as a mode of life in order to approach the state of "reconciled human beings". They are feeling out a way to defend themselves against that fundamental fear that already appears in prehistoric cave paintings. In this respect, the Surrealists are of one mind with Charles Fourier, the theoretician whom they admire for his evaluation of eroticism as a dynamic power capable of cutting through the tyrannical web of taboo which society spins in order to safeguard its own survival. Fourier also contends that it is by virtue of eroticism that humankind first discovers the

George Grosz
Three Figures, 1920
Drei Figuren
Watercolour, 51.5 x 69.2 cm
The Hague, Collection P. B. van
Voorst van Beest

Jeff Koons
Jeff on Top (Dirty), 1991
Plastic, 119.3 x 268.2 x 177.8 cm
Private collection

fullness of its nature, that eroticism restores the integrity of identity by allowing people to live out their vital lusts. But indeed, the projections of each Surrealist artist are confined to his own individual space, his own dream room of creations, his own *Garden of Delights,* a personal universe such as Hieronymus Bosch once painted. Each artist has his own erotic theatre, dresses carnal desire in its many habits, motifs ranging from the achingly sublime to the most shocking and bizarre. We can enter into these desirous, erotic landscapes, their dimensions and physical potentialities configured differently by each visitor, and can move about in them. They even afford us the possibility of entering into the dangerous grid of perversion. A perversion always portends the transgressing of boundaries. Perhaps a challenge is made. Or perhaps a challenge is refused. Yet over everything hovers the discomforting shadow of the Marquis de Sade, that grammarian of every conceivable perversion, that annunciator of fantasies so scatological that they extend beyond the realm of possibility, a route that inexorably moves towards annihilation – which, after all, is their final destination.

With regard to the group of artists linked together beneath the banner of Surrealism, Jean-Jacques Lévèque remarks: "With hesitating step, a woman named Desire enters Surrealist painting. She languishes; waits; allows herself to be adored. It is through betokenings, gestures and murmurings that she articu-

André Masson
Untitled
Ink, 24 x 35.5 cm
Paris, Galerie Louise Leiris

lates her meaning." In the work of Giorgio de Chirico one discovers her as a dress mannequin, as sign, as object. Max Ernst sneaks her into his paintings under the camouflage of humour: it is the *Femme cent têtes*, the mechanised female. The mechanised female, whom Duchamp painstakingly reconstructs from the individual parts at his disposal: *Nude Descending a Staircase*, and *The Bride Stripped Bare by Her Bachelors*. Picabia and Man Ray, preferring to exhibit her in the company of her lesbian alter ego, can also stray off to express her as a completely mechanical figure – for instance in *Love Parade* (p. 151), where Picabia transcribes the functions of the entrails and the skeleton into those of a machine, a strategy once employed by Leonardo da Vinci. The main point of difference between Leonardo and the Dadaist and Surrealist movements is the complex and fanatical manner with which these two groups express their fascination with mechanical objects. They might, for example, turn the women of their dreams into spark plugs or motors. Buffet transfigured his wife, Gabrielle, into a windshield, and Marie Laurencin, the mistress of Guillaume Apollinaire, into a fan ventilator. These artists, as exemplified by Marcel Duchamp, embrace a twofold intention: they endeavour to strip both the female and the machine of their functional contexts, to create a vacuum from which a new identity might emerge, because in the final analysis, so they claim, the painterly mimesis of a turbine is in no way more imbecile than the painterly mimesis of apples as accomplished in the manner of Cézanne! The puttering homosexuals Bruce Nauman fashions out of neon lights and clear glass rods are also machines (p. 135), and even the two figures appearing under the shower in David Hockney's painting are nothing other than machines (p. 134).

Hockney himself once remarked that his painting is about art and not about life, maintaining that he had always thought that there was a plain difference between art and life. He thought it was his purpose to approach this particular barrier as closely as possible, but also had the impression that it could not be pulled down. If there were no difference between art and life (thus Hockney), then art would simply have no purpose, would cease to exist, for everything would be life and everyone would rejoice because life would be so intense that the function of artists would be completely superfluous. But we haven't arrived there yet, Hockney concludes; more time is needed.

Dalí, employing hysteria in the clinical sense of Freud, extended art's imaginary terrain, adding a whole new dimension to the investigation of love. His style of representation takes as its point of departure the chaos and aberration of the senses (as promulgated by Rimbaud); his artistic visions are so fantastic that every censor is circumnavigated. For these brave Surrealist painters, each a modern Odysseus, the female body is at once the vessel they embark upon and the sea that bodes them peril. Dalí, the most courageous of their lot, steers towards an island named Hysteria. Max Ernst wanders the legendary forests of his dreams, in which the desired woman waits for him like the Sleeping Beauty of fairy tale. Miró illustrates the fables and stories of his childhood. Magritte stares transfixed at the riddle of the hidden woman, the woman of veils, the forbidden woman. "How can one better make the blindness of love visible," writes Marcel Paquet, "than through the duplication of the phenomenon by placing a veil over the faces of the lovers?" These fishermen have struck out with their water-colours and magic nets to capture the hidden woman, and on this adventure they can count on reinforcement from photography: the works of Man Ray are propelled

by the same aesthetic; this photographer was likewise a painter. He employed new techniques to attain the same coastline as his colleagues, realises in his prints an equally imaginative delirium and allure.

But not all artists are the heroic explorers of the kingdom of the unconscious – there are also those who prefer to remain amidst familiar surroundings. Artists of this sort only pull back the drapes a tiny bit so that we might peep through the window at their sensuous revel. The subjects of these shadowy rooms are not so much secluded or protected as isolated, cut off. One is struck by the thick atmosphere of lust and desire. In Balthus' work, eroticism is primarily played out behind a foil of hints and double entendres. His art functions at the level of the question. Balthus is cloistered in the maddeningly voluptuous paradise of the artist. Edvard Munch dwells in similar surroundings. His paintings are populated by figures that seem to dissipate or melt, that hold their angst-fraught heads in their hands, figures that mirror the psychic mood of their troubled creator. Munch abhorred hyacinths and all indoor plants because their fragrances too

Richard Oelze
Dangerous Wish, 1936
Gefährlicher Wunsch
Oil on paper on board, 13.9 x 17 cm
Frankfurt am Main, Städelsches Kunstinstitut und Städtische Galerie

"Carnal desire is the background to the miniature 'Dangerous Wish', a landscape fragment veined and overgrown with parasite-like vegetation."
R. Damsch-Wiehager

"To create, not describe moods – yet, more modern – to make not the object itself important, but the effect it generates. The sensual effect of the object-condition."
R. O.

129

Joseph Beuys
Pair, 1958
Paar
Pencil and oil pigment on stationery,
29.7 x 21 cm
Private collection

"Art expresses the phenomena of experience and goes far beyond the comprehensible logic of subject matter. For art is based only on experiences, and experience should naturally have as its goal the decodification of worldly content." J. B.

strongly reminded him of death's mortifying stench. Not once did Munch attend a funeral. He found his female lovers in the artist and Bohemian circles of Oslo and Berlin, embarked on the unhappy romances which so rigorously determined his artistic vision. This explains why we find throughout his œuvre females in the guise of vamps, women who cast spells over their lovers through their self-sufficiency, their dominance and their talent. These were the women who saw Munch to his grave.

Man is alone once he has been stripped of his neighbours; between individuals there exists no connection. Nor can sexuality inveigle more than a fictive hook-up. The ultimate joining together of a man and woman is impossible; they cannot overcome the metaphysical antagonism keeping them apart. Walter Serner once made a remark in this vein about the work of his friend, Christian

Max Ernst
And the People Won't Know a Thing, 1923
Les hommes n'en sauront rien
Oil on canvas, 80.3 x 63.8 cm
London, Tate Gallery

"Love, which is supposed to give life its meaning, is watched day and night by the clerical police. The Church exists to rob the loving of their rights. Love must – as Rimbaud said – be invented anew." M. E.

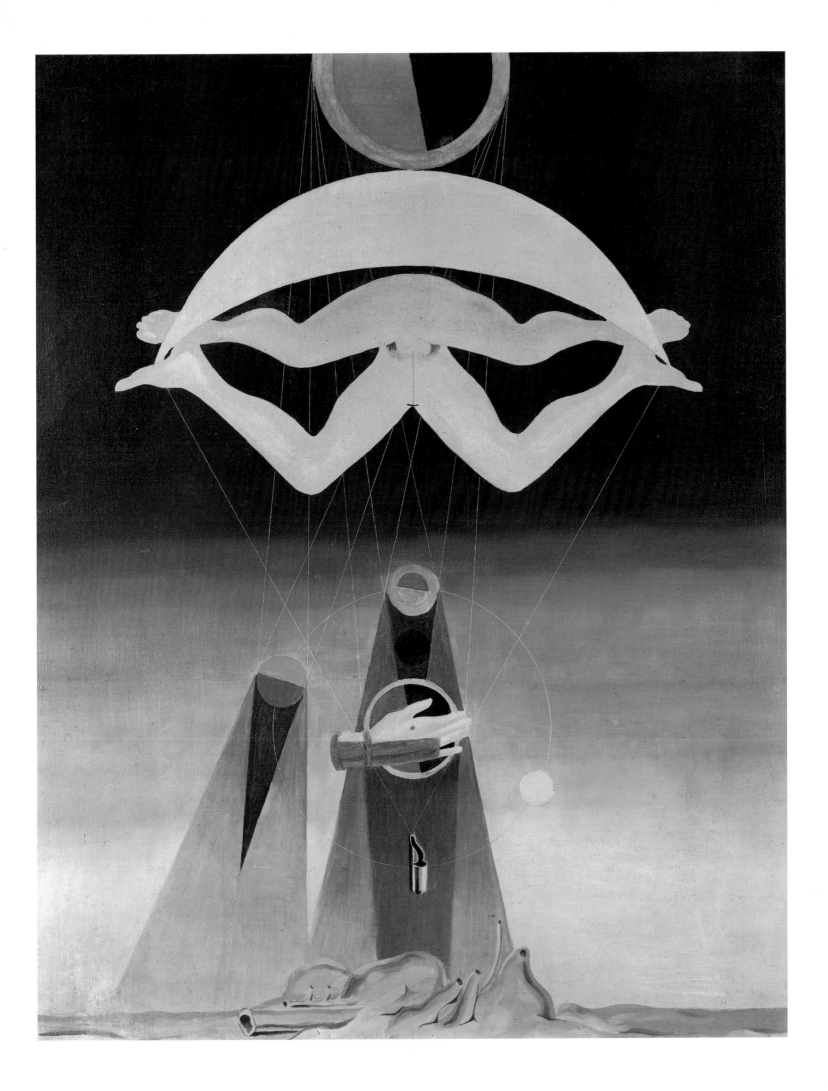

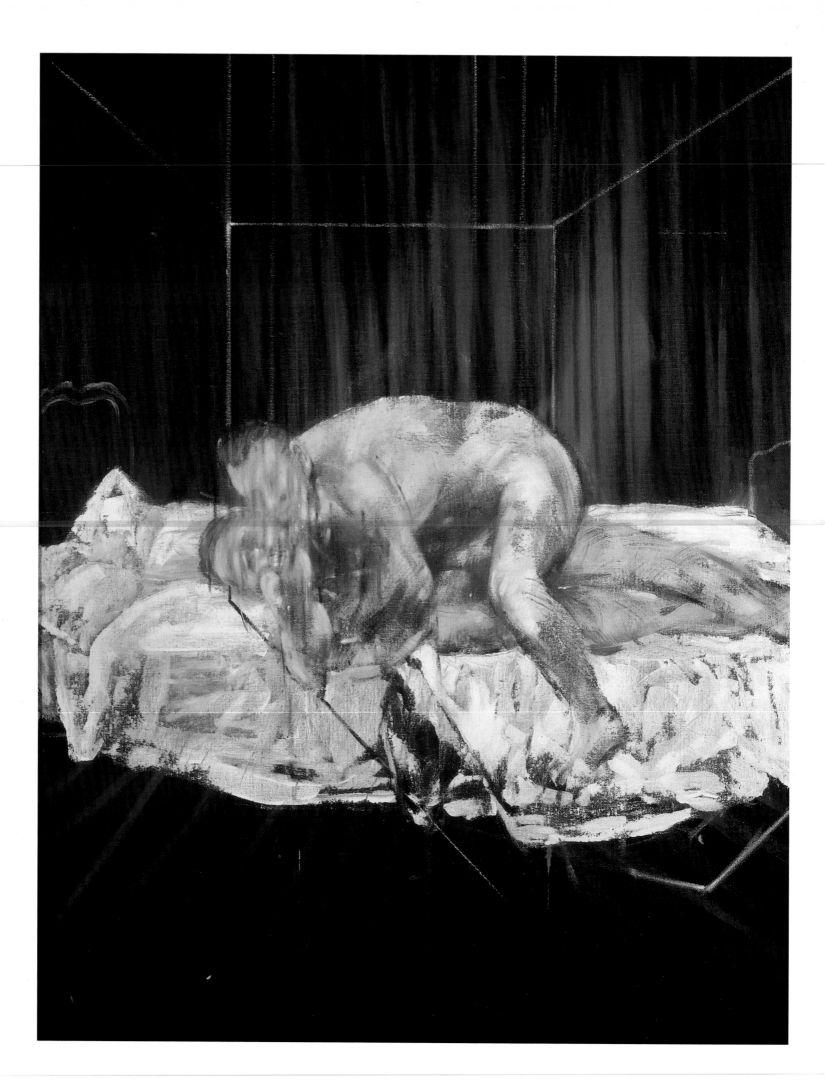

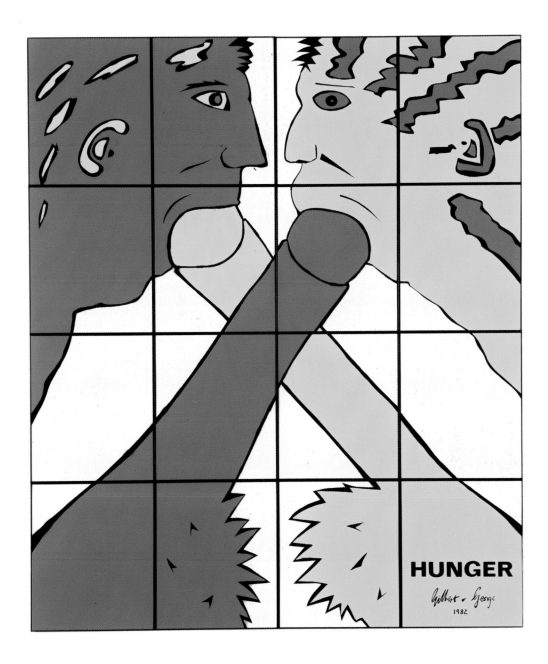

Gilbert and George
Hunger, 1982
241 x 201 cm
London, Anthony d'Offay Gallery

Francis Bacon
Two Figures, 1953
Oil on canvas, 152.5 x 116.5 cm
Private collection

"You concentrate on something which was an obsession, and what you would have put into your obsession with the physical act you put into your work. Because one of the terrible things about so-called love, certainly for an artist, I think, is the destruction."

F. B.

Schad – but we can apply this existential supposition to the work of a large spectrum of modern artists, a line that runs from Egon Schiele to Otto Dix and George Grosz before arriving at Günter Brus. The images of these artists, however disparate they might appear at first glance, are wrestled from the same solitude of being, artefacts of the individual's fundamental condition of estrangement. Absolute solipsism announces the first moment of Decartes' philosophical method, a radical dialectic that skewers our every collective certainty with doubt. Such metaphysical circumstances are responsible for the driving compulsion the artist feels to escape, to flee – a flight that leads him to eroticism, for there he finds his most visible and most secure hideaway. The escape route extends into the furthest reaches of obscene pornography.

They all attracted charges of obscenity. Schad, for example, was accused of positioning flowers of an explicitly sexual nature alongside withering, naked human skin. Even his technique, which bordered on photographic realism, was denounced as depraved. How can this "voyeur" dare to use such intimate clichés when choosing themes like observing a pair "after love", or two women in negligees masturbating, or two young boys kissing on the mouth! Schad

133

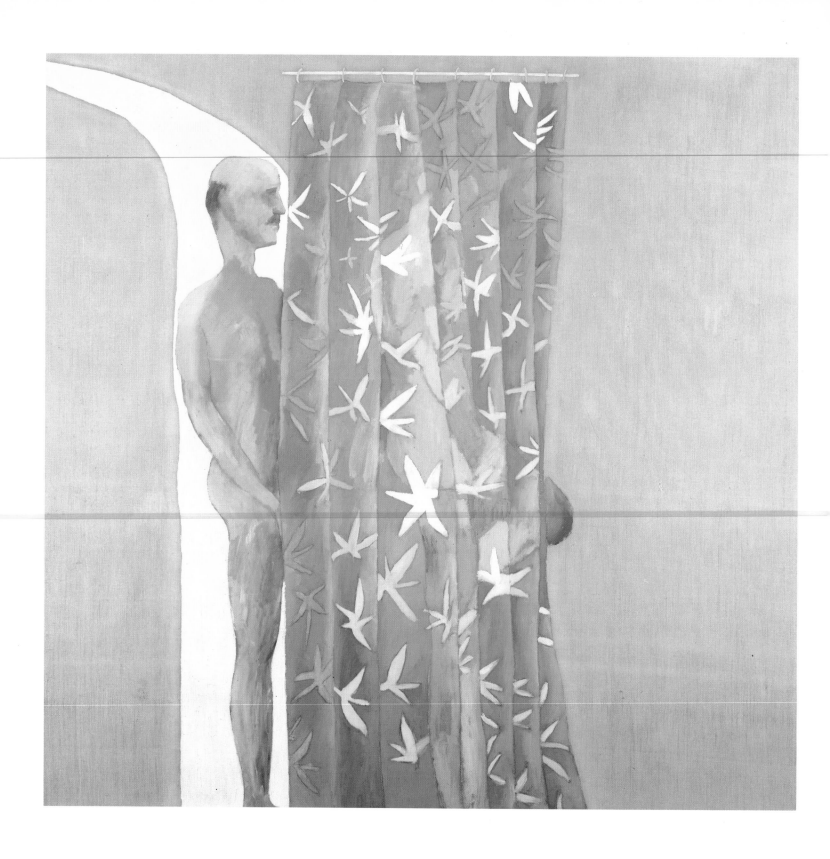

David Hockney
Two Men in a Shower, 1963
Oil on canvas, 152.4 x 152.4 cm
London, Waddington Galleries

answers that it is all too simple to mock Raphael. While in Italy, he found himself suddenly consumed by the desire to give expression to contemporary phenomena steeped in all the weight of their native material. Egon Schiele was denounced by a retired officer for seducing his daughter, Tatiana-Georgett-Anna, a nubile young thing of fourteen. The judge sentenced Schiele to twenty-seven days in jail. Schiele was also accused of hanging pornographic drawings in his studio where they could be readily viewed by the girls he used as models. One of the incriminating drawings was burned as a symbolic act of justice. Schiele was found guilty of seducing under-age females.

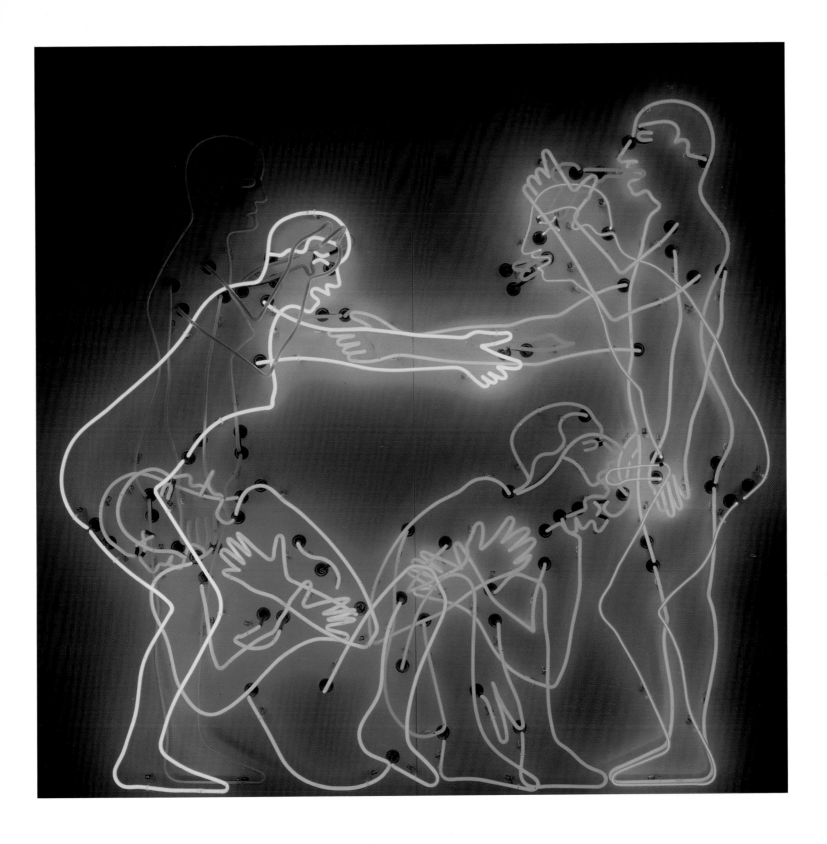

Before Freud, Schopenhauer attempted to establish how human affairs, artistic and otherwise, were shaped by sexual forces. According to Freud, the role of the artist is to give aesthetic form to his sexual fantasies and base desires. If the artist thereby successfully placates the grimness immanent in each desire, then he does so only to return again to the human plane, to a society suffering from sexual repression as does the artist himself. In this manner, the artist opens the route to an aesthetic pleasure that participates in the "realisation of the urge for omnipotence". The value of the aesthetic forms created by the artist is determined by the manner in which he imposes order upon the endlessly chaotic

Bruce Nauman
Sex and Death by Murder and Suicide, 1985
Neon and clear-glass rods on aluminium,
182.9 x 243.8 x 30.5 cm
Basel, Öffentliche Kunstsammlung Basel,
Museum für Gegenwartskunst

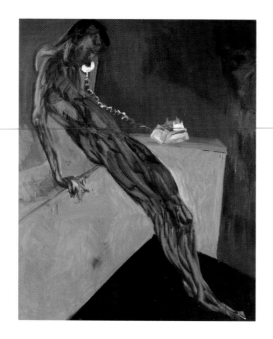

Rainer Fetting
Phone Call, 1984
Acrylic on canvas, 223 x 179 cm
Cologne, Private collection

Jeff Koons
Butt Red (Close Up), 1991
Serigraph on canvas, 230 x 150 cm
Cologne, Courtesy Galerie Max Hetzler

"She [Ilona Staller] is one of the greatest artists in the world, my favorite artist in the world. Instead of using paint brushes or photography, she articulates her genitalia."

J. K.

world of primitive sexuality. But Egon Schiele did not care to play by such rules – and in this respect his work shares something vital with Schad, Dix, Grosz and Klimt. Schiele refuses to convene order; quite to the contrary, he suspends order, unleashes, excites. Schiele intentionally steered a confrontation course with conservative Viennese society, sensibilities so inhibited that, as Stefan Zweig recalled in his memoirs: "A young woman from a respectable family is not allowed to have any inkling of the male anatomy, nor idea of how children come into the world, for the angel should enter marriage not only physically intact, but also with an unblemished soul. Among girls of that era the concept 'well-bred' meant so much as kept sheltered, innocent; an estrangement from life that accompanied some women to their graves. Yet today I am amused by the grotesque story of an aunt of mine who on her wedding night at one in the morning suddenly turned up again at the apartment of her parents to cry with anguish that she never again wanted to see that horrible person, the one she had married, for he was a madman, a monster, had tried everything in his power to convince her to remove her clothes. Only with a great struggle was she able to save herself from such plainly sick longings."

The works of George Grosz were plagued by judgements arising from similarly sheltered understandings. During one of the countless court proceedings lodged against Grosz, the presiding judge asked him whether, in the first place, it were absolutely necessary to exhibit things wretched, miserable, naked and melancholy, and whether it were not completely superfluous to underline the sexual aspect of such things, and to shove the body elements of his figures with such vigour into the eyes of his viewers. Grosz could only respond that a quick answer eluded his grasp, but that, at any rate, his conception of the world was overwhelmingly different from that of the presiding judge, for his own point of view was marked by negativism and scepticism. "I see things the way I present them," he continued. "The large majority of people, to my mind, have nothing beautiful nor pleasant about them. It is completely irrelevant whether I conjure up women or some family tableaux." The judge, obstinate in his convictions, pointed out that the artist's themes were nothing new to the court, and that by virtue of his public function he had often been confronted with vile and repugnant things, but that this fact by no means gave anyone the right to exhibit such themes in public. To which Grosz replied that he had not yet achieved such a rarefied level of enlightenment. His art was yet in the process of development, "and I see the things as I see them, and that's all." The judge answered: "Has it ever occurred to you, Mr. Grosz, that your work quite often transgresses every artistic boundary?" Grosz: "No, and again no!" The judge then went on to explain that the artist doesn't exist for himself alone, but as part of a community, and that because his creative activity derives its sanction from its communal good, he is bound by a set of rules, by those boundaries configured by his function as it exists. "Have you never realised that the laws of morality cannot and dare not be broken, not even by an artist?" Grosz remained steadfast in his view that even when he depicted wretched things – and he would by no means dispute that some of his images might occasion disgust in the eyes of various people – he was accomplishing a lesson of social commentary. And that often such was achieved precisely through representations of the wretched. "Even when my images represent the most vile debaucheries," Grosz continued, "they are always expressions of concrete moral tendencies."

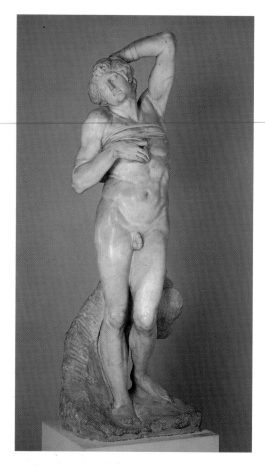

Michelangelo
Dying Slave, 1513
Lo schiavo morente
Marble, height: 229 cm
Paris, Musée du Louvre

A dialogue for the deaf! The most important weapon in Grosz's arsenal is anger. For him the representation of a woman, a nude, is not a matter of aesthetics. A sensual or erotic form is not purely for "cultivated people of high-strung sensibilities." Eroticism must contain a social message. Against medieval-style brutality, Grosz once said, and against the host of human imbecilities characteristic of our century, the graphic arts represent a power that should not be underestimated – but only when executed by a resolute will and an accomplished hand. Grosz once explained that while he was searching for a style commensurate with the wretchedness and misery of his models, he scavenged the public toilets for the graffiti on the walls and copied it down, for he felt it offered the most direct insight into naked, forceful feeling.

When we consider the brutish misery of such models as Grosz renders in his art, we are propelled along a path that ultimately terminates with the beauty of the obscene, and the beauty of death. Beyond the boundaries of desire begins the domain of harrowing terror, and it is from this dark kingdom that ecstasy acquires shape. Alphonse Allais tells the story of the pasha who, utterly bored, sent for a virgin. The sabres of the pasha's guards made short work of the stays of her dress. The pasha absently ordered: "More". Garment after garment fell to the floor, and the distracted pasha simply punctuated the work of his guards with "more" and "more" and "more". Finally the virgin stood stark naked before the pasha. "More," he yawned. And so the sabres of his guards set about skinning her....

This is the gruesome logic which appropriates art whenever love and its erotic pleasures effect only ennui. It was precisely this spirit which engined the abysmal assassinations of Hans Bellmer. The bloody, truncated anatomies of Francis Bacon – the body parts he hangs about as if he were decorating the window of some butcher shop – take this circumstance as their accepted given. Patrick Waldberg points out that this is the undeniable world of nihilism, a world of dismemberments and profane burials, from where, exactly like the macabre pleasures of Police Lieutenant Bertrand, the sick surgeries of Jack the Ripper or the remnants from inside the cremation ovens of Landru awaken. It is a wildly shrieking rhetorical horror appended to the body regarded as object. It is only in the service of drawings of images. Love approaches death. A slow majestic procession along a route strewn with seductions. A journey of initiation. But at the end of this sojourn one doesn't arrive at the promised garden of desire, nor discover the fabulous treasures of legend – instead, one stands at the edge of that terrifying abyss called the void.

The beauty of the obscene, the orgasm born of suffering, the brilliance of despair, all this is captured in the painting by Del Piombo in which the breasts of poor Agatha are about to be tortured by the set of tongs yet glowing in the fire. The tender Agatha, however, as rendered by Del Piombo's brush, appears to have already reached the other side of agony – her mused gaze contemplates a world of supreme desire. And then there is that androgynous Christ of Holbein, his legs crossed like some heinous virgin, rapt with the transfiguration of his lone suffering. Holbein paints Christ as surrounded by sadistic torturers, their pants swollen with pleasure, while a spectator spies upon the scene, a masochist voyeur who would love nothing more than to receive a few blows himself. Let there be no doubt, whether in Del Piombo, Holbein, Michelangelo, Correggio, Munch, Bellmer or Bacon: Eros and Thanatos are one.

Salvador Dalí
The Phenomenon of Ecstasy, 1933
Le phénomène de l'extase
Photo collage
© Photo Descharnes & Descharnes

"In our time, on our planet, to know a person means to question him to the point of vivisection," writes the sculptor Jean Ipoustéguy. "We all know how heavily the word 'question' is freighted with sadism. The inquisitor, the questioner, delves into everything. To know a person actually means to render the person no further possibility of existence. Consequently, I ask no questions. I consider a person, feel him out, breathe him in, I am overpowered by the strength of the unknown which he communicates, a quality which disdains analysis and will continue to do so unto Judgement Day."

"When I gaze at a woman," remarks Gustave Flaubert, "I must think of her skeleton." Leonardo da Vinci is a pioneer in these matters, but Jean Dubuffet is every bit his equal. The functions of the genitals set something into motion

Correggio
Io and Jupiter, 1530–32
Io e Giòve
Oil on canvas, 162 x 73.5 cm
Vienna, Kunsthistorisches Museum

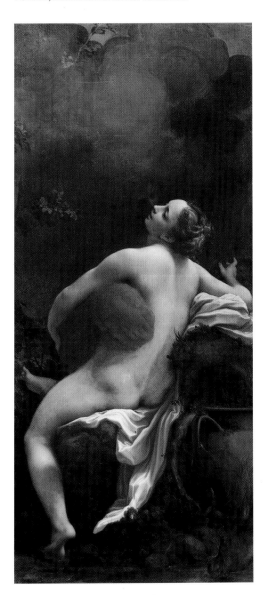

within these men. Leonardo da Vinci believed that copulation (p. 123), "with those extremities that this act brings together, is filled with such great coarseness, that, if it were not for the beauty of the faces, the raiment of the participants as well as their repose, nature would forfeit the human race…" The body, handled via the alibi of anatomy by the old masters, is a place of orgasm for modern artists, of sheer anatomical combat. The bodies in the work of Bacon have no skeletons, are compounds of magma, featureless lumps of living flesh stripped to the point of hysteria. "This is the rhapsodic praise of agony in a time of impetuous rush," writes France Borel. "This is life's final fireworks, the last explosions before annihilation, before the final curtain descends and total night commences."

The violent howl depicted in Munch's *The Scream* has left behind all trace of the human. "The face falls apart, as if it had been lying in an acid that devours flesh," remarks Gilles Deleuze. Bacon's pieces of flesh refer the viewer back to the artist's personal wounds. Bacon uses his photography to run through his memories in the manner of paging through a dictionary. Surgeon Bacon performs his operation using photos of his models as guide: "I find it less inhibiting to work from them through memory and their photographs than actually having them seated there before me… They inhibit me. They inhibit me because, if I like them, I don't want to practise before them the injury that I do them in my work." Bacon himself provides the key to his artistic work, explaining that the significance of the naked skin or flesh is not merely a question of what is visible: "I've always been very moved by pictures of slaughterhouses and meat, and to me they belong very much to the whole thing of the Crucifixion….Well, of course, we are meat, we are potential carcasses. If I go into a butcher's shop I always think it's surprising that I'm not there instead of the animal." Naturally, Bacon has his influences from the past. He especially admires a famous pastel by Degas hanging at the National Gallery, for example, the rear perspective of a woman in which "the spine almost comes out of the skin altogether." Meat, that's what Bacon would dearly love to paint, "as Monet painted a sunset."

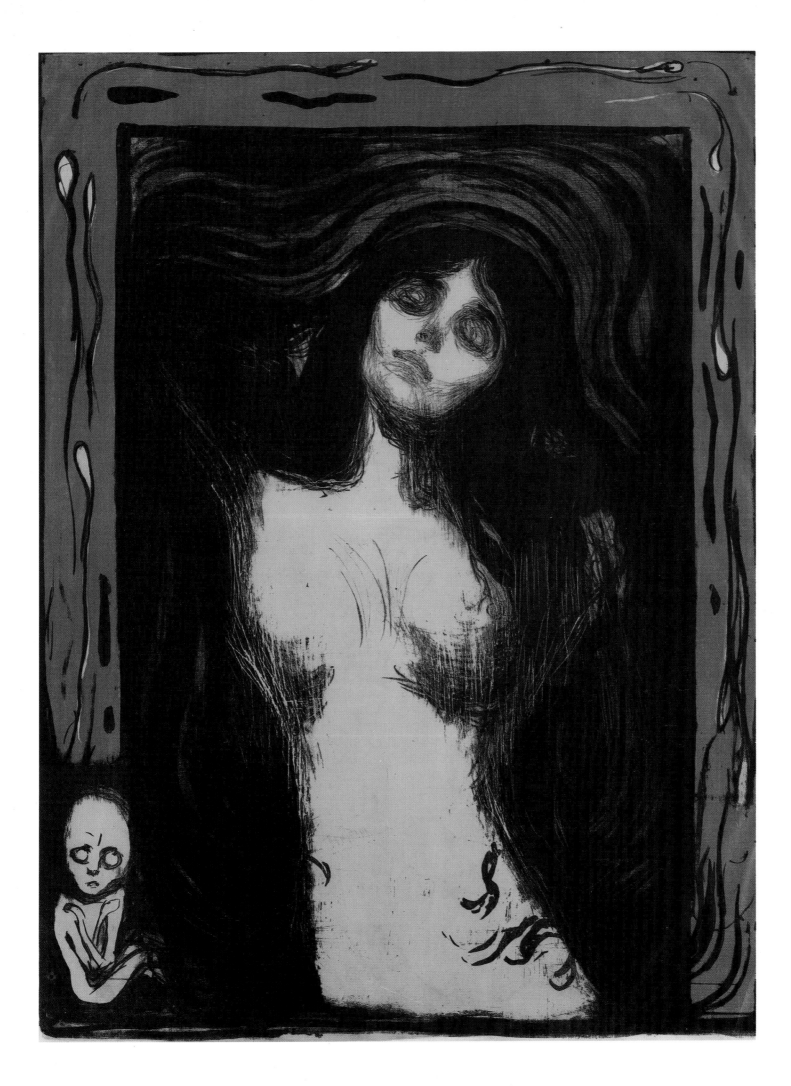

The Perverse Art of Playing with Dolls

The following story created quite a public sensation once upon a time in Paris. A Japanese student, who had fallen in love with a young Swedish woman, chopped her to pieces, then warmed another portion each evening for his dinner. He was found incompetent to stand trial by reason of insanity and released. Released in more than one sense of the word: from both imprisonment and psychosis. Since then he has travelled the great cities of the world lecturing on his extraordinary case. His memoirs have made him a man of fortune. This authentic story, translated into terms of the art world, functions as a model precedent.

But even Hans Bellmer drew the line at anything quite so spectacular. His entire life long, he had to be satisfied to play with his doll. At least he could bend her and twist her in every direction, abuse her, filch out her limbs. Bellmer's wishes and fantasy desires can be traced back to the time when, in the attic of his parents' home, he discovered a lone suitcase filled with toys. "Bellmer allows to take shape beneath his fingers those types of obsessions that at some point or other overtake everyone in their solitude," writes Daniel Cordier. "In an indirect, cunning manner that can work as perverse, Bellmer avows the obscene, thereby acknowledging one of the ruling structures of our being, the erotic." The patent leather shoes, the white socks, and the dark-haired page-boy hairstyle magnify the ambiguousness of Bellmer's doll. Her sexuality remains vague, although a number of features are readily visible: the light swell of the stomach, the peach-like breasts, the spidery hands, the rounded cheeks of the buttocks — her every surface underscores the impression that this is a "ready-made" supremely suited to the urgings of a lone male.

Bellmer's creation launched an entire school. His *Doll* (p. 149), a work of the early thirties which can be pulled apart, wielded or flexed into whatever shape one pleases, marked the debut of the so-called "object-woman" in art. Forty years later it is the table-women, the chair-women, and the stool-women who assume their places in museums — the female patched back together as slave woman.

The Surrealists played their part here — not only Bellmer but also Magritte, Dalí, Man Ray and Max Ernst, artists for whom the female represented both idol and enemy. This dynamic continues to be expressed in the sadomasochistic furniture of Allen Jones, for instance, or in Wesselmann's depersonalized assembly-line nudes, the mats of pubic hair glued to their synthetic skins forcing

Fischli/Weiß
Masturbine, 1985
Photograph from the work group
"Stiller Nachmittag"
Cologne, Courtesy Galerie Monika Sprüth

Hans Bellmer
The Machine-gun in a State of Grace, 1937
Mitrailleuse en état de grâce
Wood and metal construction,
78.5 x 75.5 x 34.5 cm
New York, Collection, The Museum of
Modern Art, Advisory Committee Fund

obscenity from its place of hiding. Titian's *Toilet of Venus*, and comparable achievements that emerged from Venice, that industrious capital of sensualism, have in the meantime been demoted to the category of bedroom art. Our society views such works as bordello paintings, gratuitous images directed towards base sexual urges.

It would be difficult to discover a more vulgar or more disputed Pop artist than the Anglo-Saxon Allen Jones. Born in Southampton, Jones's central preoccupation and touchstone theme is the manipulation of a violent-erotic iconography, a quest he follows to its bitter end. His piecemeal artistic approach establishes a sort of standard: in his first canvasses, Jones replicated slips and panties in large format; later, in a format yet more monumental, he depicted the

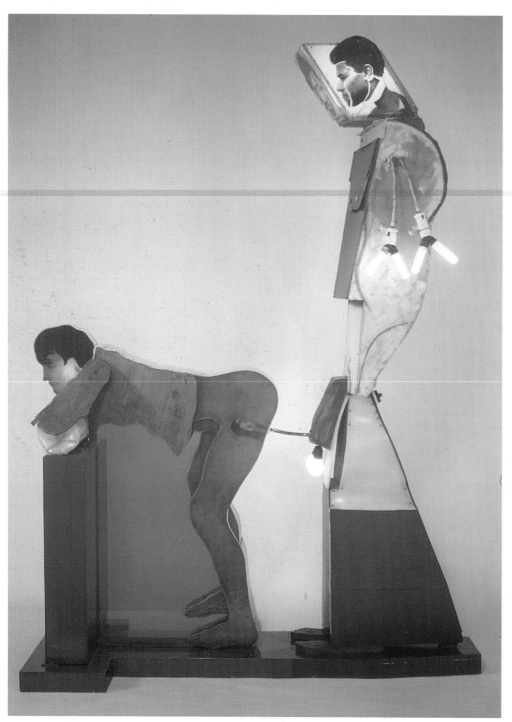

Larry Rivers
Lampman Loves It, 1966
Mixed media, 274.3 x 76.2 x 198.1 cm
Private collection

"I admire Indian erotic art, the soft, symbolic female and all that. But my view of woman is completely different. The little comic books we bought as kids influenced us more than anything else – those fantastic arses and phalluses. They were funny!" L. R.

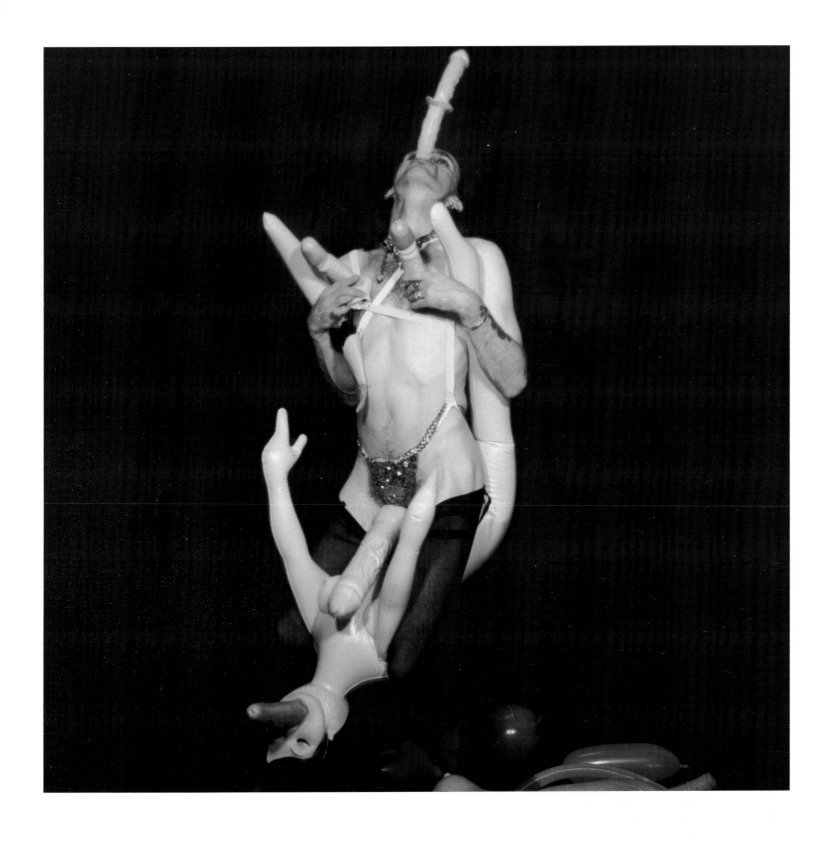

female torso and thighs; finally, his images of female bodies, or more accurately, images of the female lower torso, arrived at a stage in which the figures were outfitted with hyper-realistic fetish equipment, the same sort one can find in the pages of sado-masochistic porn magazines at speciality sex shops, or in such German porn films as "Madame X". But Allen Jones, not satisfied merely to give his sexual fantasies of leather and naked flesh replication in pigment, soon began ladling plastic over his canvasses, portraying in relief those anatomical features that most captivated him, composing generous formulations for the eye. By 1969, no longer content with the representational possibilities of two-

Jürgen Klauke
*Dr. Müller's Sex Shop or
Here's How I Imagine Love,* 1977
Dr. Müllers Sex Shop oder
So stelle ich mir die Liebe vor
Colour photograph, 19 x 19 cm
Cologne, Jürgen Klauke

Mike Kelley
Estral Star No. 1, 1989
Play animal construction, 80 x 30.4 x 15.2 cm
Los Angeles, Courtesy Rosamund Felsen Gallery

Mike Kelley
In-progress photograph, 1989
Frankfurt am Main, Private collection

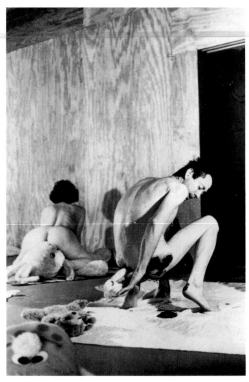

dimensional art, Jones had given up painting altogether, turning his talents to sculpture. He created a complete ensemble of dress-mannequin furniture, plastic "captains' wives" coated with synthetic leather. These luxury slaves in their pointy, lace-rimmed leather boots would have aroused the admiration of de Sade. They stand stiffly at attention, their hands outstretched in a gesture of submission – if nothing else, to at least find service as coat stands. The identical slave in a variety of formats, every conceivable variation: placed on all fours, they

carry glass platters on their backs, can be used as tables. The extremities of these creations are meticulously balanced to enable their easy manipulation into benches, stools, chairs. The next stop in Allen Jones' career was to design stage scenery for theatre plays, films and television, making use of that same prop element typical of his earlier work. Here again he continued to express what he sees as the essence of a society overrun with sham, one in which sexuality is simply treated as another commodity.

Andy Warhol's shrill Marilyn Monroe silkscreens also render the myth of the female sex object. The same imagination is at work in the *Cosmetic Ladies*

Hans Bellmer
The Doll, 1938
Die Puppe
Tinted photograph, 5.3 x 5.4 cm

"Wasn't it in the idea of the doll, which lives solely from a person's projections, and which despite its boundless submissiveness remains exasperatingly withdrawn upon itself, that one might find what the imagination seeks in desire and heightened transport?"
H. B.

Giorgio de Chirico
Hector und Andromeda, 1917
Ettore e Endromaca
Oil on canvas, 90 x 60 cm
Milan, Collection Gianni Mattioli

PARADE AMOUREUSE

Francis Picabia 1917

Francis Picabia
Love Parade, 1917
Parade amoureuse
Oil on canvas, 96.5 x 73 cm
Chicago (IL), Mr. and Mrs. Martin G. Neumann

Oskar Kokoschka
Self-portrait with Doll, 1918
Mann (Selbstbildnis) mit Puppe
Oil on canvas, 80 x 120 cm
Berlin, Staatliche Museen zu Berlin –
Preußischer Kulturbesitz, Nationalgalerie

*"Once the doll was removed from the pile of material
in which she was packed, instead of the realisation of
an absurd dream of desire, instead of the seductive im-
aginary being which had until that moment held me
so feverishly bewitched, a phantom stared up at me.
What I saw had dead eyes and flaunted her indecent
nakedness before every gaze. No illusion more could
be sustained; here, instead of the warmth of being and
the breathing skin of the seductive female gender, a
fabrication, a jointed doll lay in my arms."* O. K.

Cindy Sherman
Untitled No. 253, 1992
Colour photograph, 127 x 190.5 cm
New York, Courtesy Metro Pictures

of Richard Hamilton, or, disported alongside bananas, tubes of toothpaste
and automobiles, the bare-bosomed pin-ups of Mel Ramos. We can also say
that the "Nanas" of Niki de Saint Phalle achieve a certain humour, those
beings of claw and tooth liable at any moment to rudely scratch or engorge the
viewer.

In their erotic nakedness, each of these "dolls" lends added contour to an era
in which the female has become a consumer item which the male can purchase
to manhandle, impregnate, junk.

But a profound loneliness, introduced as an unavoidable reflex, as a counter-
balance to the erotic, also stands at the centre of these works – not only the
loneliness of love as so often reasserted by masturbation, but also the loneliness
of old age, of poverty, of madness, of alcoholism – the loneliness of the individ-
ual engulfed by crowds of people.

From Bellmer to Kokoschka, numerous artists have indulged in the perver-
sities of doll play. For a time the police of Dresden even harboured the suspicion
that Kokoschka, a respected professor at the local art academy, had perpetrated
a murder. In the grey light of morning marking the end of a night of bacchanal
tumult, a woman lay decapitated on his lawn. But eventually the police were
able to satisfy themselves that the victim of violence was nothing other than a
doll. On this particular morning the painter, at the age of thirty-six, had finally

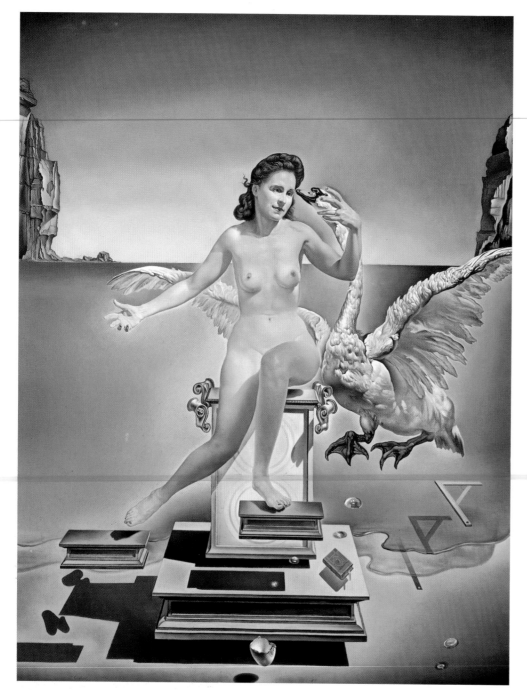

Salvador Dalí
Leda atómica, 1949
Oil on canvas, 61.1 x 45.3 cm
Figueras, Teatro-Museo Dalí

Paolo Veronese
Leda and the Swan, circa 1580
Oil on canvas, 106 x 90.5 cm
Dresden, Staatliche Kunstsammlungen Dresden,
Gemäldegalerie Alte Meister

freed himself from his past, from the painful spurning by his former lover, Alma
Mahler. After her chiding in 1915, and after being upset in his plans to trudge
off to war to end his sorrows of love, he commissioned the making of a life-size
doll graced with the features of his beloved Alma. In order to clothe her in the
style of elegance Alma was accustomed to, Kokoschka visited the finest tailors
in Paris, purchasing for his doll the most exquisite fashions and lingerie. The
doll was always at his side; on sunny days he took her for a ride in a horse
carriage, and it is even said that he rented a box for her at the opera. But then
something broke inside the man. He had tirelessly sketched and painted her, but
now at the end of a night of revelry he picked up a red wine bottle and smashed
in her skull, the head of the doll which so perfectly resembled his cherished
Alma (p. 152). At that moment, exactly like the gentleman from Japan, Ko-
koschka was finally cured of his dangerous obsession.

Peter Paul Rubens
Leda and the Swan
Oil on wood, 64.4 x 80.3 cm
London, Christie's Colour Library

Otto Mühl
Oh Sensibility, 1970
In-progress photograph
Zundorf, Friedrichshof Wohnungsgenossenschaft

The love of dolls dates back at least to that beautiful Greek tale of Pygmalion, who so deeply adored his Galatea, the virgin he had carved from ivory. We may well wonder, however, whether Pygmalion lived out his days a happy man after Aphrodite so graciously assented to his plea and imbued his statue with life. After reacquainting ourselves with Bernard Shaw's interpretation, we sense that there is sufficient room for doubt. Jean Dutour settles accounts in his own manner: "I sacrifice three years of my valuable life," his Pygmalion cries out, "in order to instil in this thing the greatest possible harmony, and then some crazy goddess comes along and fouls up everything! Look for yourself! Look! A nitwit! That's what my statue has become! She wiggles her hips! What a plague!" ("La fin des Peaux-Rouges") For absolute fetishists, that class of utterly convinced female-haters, the immobility of statues arouses an attraction quite different from the

Günter Brus
Milky, 1970
Pencil, 29.7 x 20.6 cm
Private collection

Pablo Picasso
The Mackerel (Allegorical Composition),
circa 1902/03
Le maquereau
Coloured ink, 13.9 x 9 cm
Barcelona, Museu Picasso

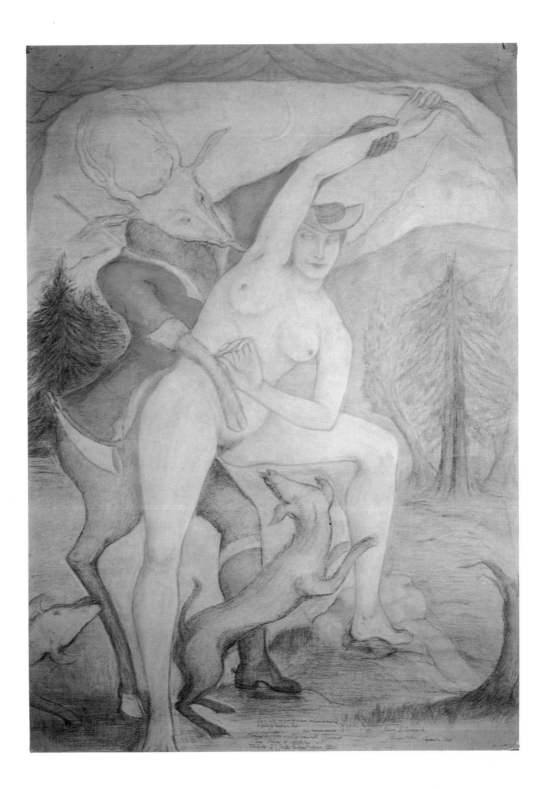

Pierre Klossowski
*Mr. de Max and Miss Glissant in the Roles of
Diana and Actaeon*, 1954–73
M. de Max et Mlle Glissant dans les rôles de
Diane et Actéon
Coloured pencil drawing, 152 x 107.5 cm
Turin, Collection Panero

animated grimaces of our corporeal physiognomies, and if Pygmalion had only continued to embrace his ideal, his illusion, then he might have become a happy man.

It is left to the end-user to locomote the object of his desire. Salvador Dalí intuited the connection between sexuality and motion. "The wheelbarrow," Dalí writes in regard to Millet's *Angelus*, "is loaded with an intentionality that is wholly concrete and wholly specialized: in the arsenal of fantasy wishes that express the erection – flying, gliding, fast movement and such – we realise that the animal tractive power, which is so often an obsession of painters and illustrators, that through this exaggerated toil which is actually the proper due of fornication, a complex of impotency or sexual incapacity is symbolized." Fol-

Jean Dubuffet
Rightwards Pisser IV, 1961
Pisseur à droite IV
Washed ink on paper, 43 x 33.5 cm
Private collection

André Masson
Cascade, 1938
Ink, 44.5 x 34 cm
Paris, Galerie Louise Leiris

lowing Dalí, then, the wheelbarrow carries a symbolic value denoting sexual infirmity. An endless miscellany of trusted, inanimate objects can be infused with fetish powers, such that their classification becomes quite arbitrary. Disciples of Freud and fans of Surrealism can rattle off long lists of such examples, beginning with the famous "sewing machine". In his classic investigation of onanism, Havelock Ellis blames the sewing machine for an epidemic of perversion, maintaining that one particularly venerable model was of especial blame, a model which was very heavy and which forced the user to drastically raise and flex her legs. Ellis, citing an explication by Langdon Down, is certain that this machine precipitated strong sexual overexcitement over the course of a few generations.

Today motorcycles and large lorries have appropriated the roles of the old-fashioned machines. Their speed, as Alfred Adler theorizes, accomplishes the function of reinforcing the perverse chase for pre-eminence. Without a doubt,

Pablo Picasso
Woman Pissing, 1965
La pisseuse
Oil on canvas, 195 x 97 cm
Paris, Musée National d'Art Moderne,
Centre Georges Pompidou

Rembrandt
Woman Urinating, 1631
Etching, 8.1 x 6.5 cm
Amsterdam, Rijksmuseum–Stichting

the motorcycle, regarded as an extension of the body, is a powerful phallic symbol of motion. In their own fashions, Jean Cocteau, Steve McQueen and Marlon Brando each helped this fetishism achieve societal acceptance, and thus the fetish cults of leather gear, boots and uniforms.

Everything that can be said about the motorcycle can also be said with regard to the car, which Roland Barthes in his "Mythologies" labels "the exact equivalent of the great Gothic cathedrals, the crowning achievement of an epoch. Automobiles are the passionate creations of nameless artists; in image, if not also in function, they hold significance for an entire society which vests these objects with, as well as appropriates from them, a magical status."

"The Beauty and the Beast", one of the greatest and most comprehensively treated themes of myth, is today so omnipresent that one can even sense its presence being played out in the automotive world. Artists from antiquity to Jean Cocteau have used this theme to engross the collective unconscious of their audiences, a theme which engages the wish fantasies of every individual audience member. Stories such as "Leda and the Swan", "The Virgin and the Hawk", or "The Lady and the Unicorn" are nothing other than the recycling

Jan Gossaert
Danae, 1527
Oil on oak, 113.5 x 95 cm
Munich, Bayerische Staatsgemälde-sammlungen

Gilles Berquet
Untitled, 1990
Photograph, 30 x 19.5 cm
Private collection

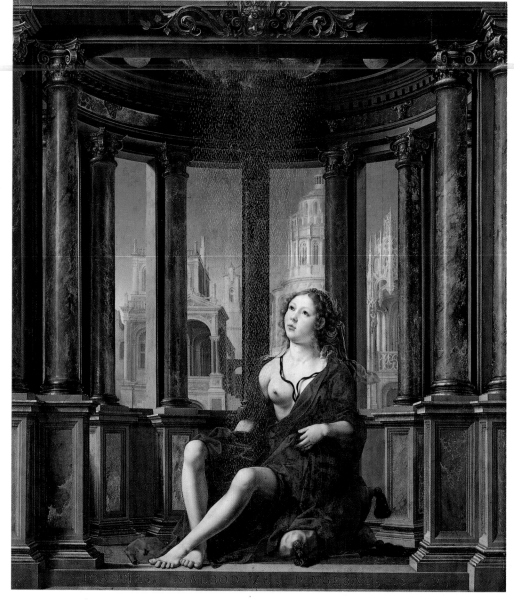

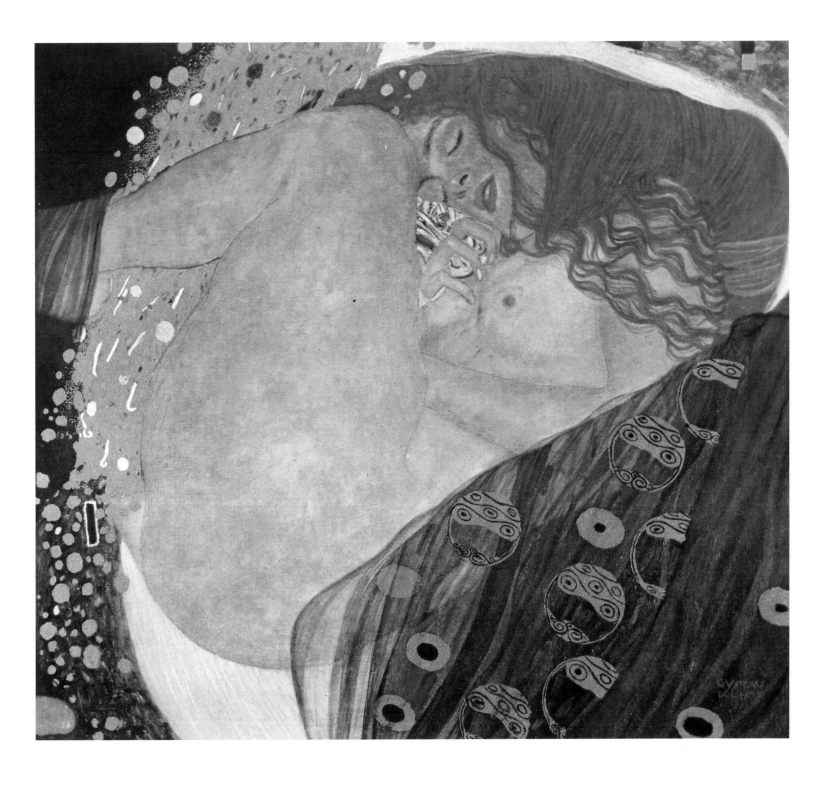

of the inexhaustible thematic material of "The Beauty and the Beast". The mythology rummaged through and reworked by artists is indeed a compendious bestiary. Phallic swans, for instance, are first amorously nuzzled by the women of ancient Greece, then those of Pompeii; a swan alights beside the painterly female creation of Veronese, then beside Leonardo da Vinci's figure, before finally landing in the interpretation by Ingres. From Leda across 1001 nights to King Kong, wherever the heroine-monster love story appears, a thorough-going and enlightening Freudian interpretation finds ready application. The collective unconscious has a decidedly inhibited imagination, and so art resorts to this bestiary of fantastic beings to auger its message. In the final analysis the thematic element here at work – as Edgar Allan Poe once set out to explain – is nothing other than a reworking of the Oedipus legend, the young man who

Gustav Klimt
Danae, 1907/08
Oil on canvas, 77 x 83 cm
Graz, Private collection

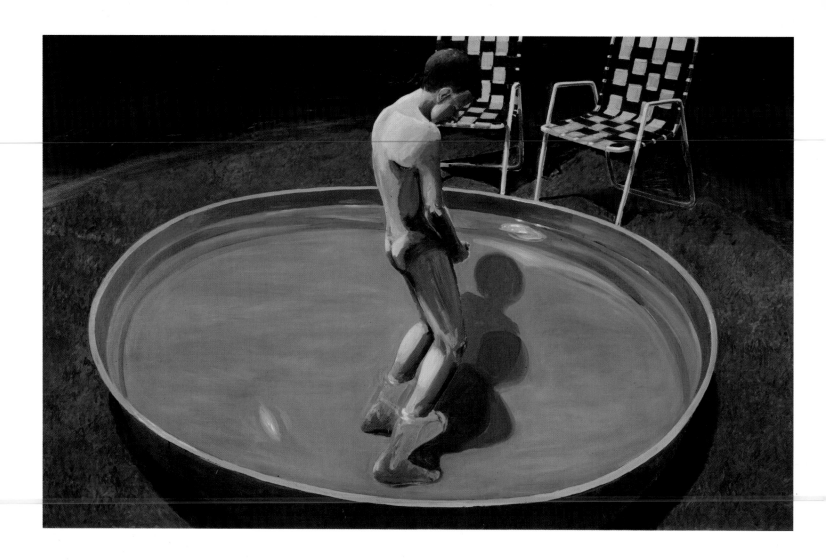

Eric Fischl
Sleepwalker, 1979
Oil on canvas, 182.9 x 274.3 cm
New York, Courtesy Mary Boone Gallery

*"His second painting, Sleepwalker, shows a boy mas-
turbating in a backyard plastic pool in sight of empty,
parental lawn chairs. It seems a pathetic image at
first, but the boy's fierce intentness gives rise to an
awed sense that this painting is about power: the pri-
mal, explosive power to give oneself pleasure, just dis-
covered by the boy. While painting it, Fischl says, he
burned with the boy's feelings, of enjoyment mixed
with fear of the shameful exposure which, as an ar-
tist, he was unaccountably guaranteeing himself: the
picture, whose illusionistic space was still taboo in the
art precinct Fischl inhabited, would look corny to the
hipsters and obscene to everybody else."*
Peter Schjeldahl

kills his father, the dragon, in order to gain the winner's spoils: his mother's hand
in marriage. But here – in order to more comprehensively round out this
zoological drama's cast of protagonists – a subtler variant also deserves mention:
once the beauty finally accepts the love of the beast and physically consummates
their union, the beast becomes the charming prince he formerly was and in
truth, were it not for the wicked witch who had transformed him into a frog,
would never have ceased to be. In this manner, the son takes the place of the
father through metamorphosis and not through battle.

No painting or work of sculpture depicting an animal or monster is innocent.
One must examine the artwork in greater detail to decipher the intentions of
the artist, whose work always recites the tendencies of his epoch. There are keys
hidden in such artworks, but usually it requires little explication to discover a
reference being made to the female genitalia. Although artists have traditionally
linked the female sex organs with particular flowers, it is quite generally ac-
cepted that a wide assortment of fauna – a list including swans, steers, centaurs,
deer, snakes and donkeys (one notices that this particular segment of the animal
kingdom tends towards the ignoble) – are also laden with sexual significance.
The bestial escapades of Zeus, ruler of Olympus, set an example hard to outstrip,
and this at a time when Pasiphaë fell in love with a beautiful cud-chewing
animal, Europa rode a steer possessing a splendidly shimmering hide, and Nep-
tune whisked away nubile nymphs on his back without bothering to conceal
the fact that – if we are to believe the engravings of Dürer – his anatomy, phallus

included, was covered by scales. Strangely enough, it would seem that 20th-century society, generally so exceedingly prickly in its moral judgements, here accepts the artist's erotic embellishments without emitting so much as a peep of indignation in defence of custom and propriety. If this were not the case, one would have to damn Leonardo da Vinci and Michelangelo, along with that master of birds, Tintoretto, as well as Veronese, Rubens and Fragonard, not to mention a long list of artists from this century, one stretching from Dalí and Picasso to Klimt, Klossowski, Bayros, Günter Brus, Otto Mühl, and Lindner.

A "little bird" could signify the sexual organs of either the female or the male. With regard to the female, Gérard Zwang, an arcane master of art's erotic zoomorphism, writes: "They are covered with a silky, shiny plumage. The outer lips are most marvellously exaggerated by the wings of the bird (alae). This bird of Venus is called by hunters, who relish the idea of capturing it, pigeon (which is also, in a more poetic sense, called colomba, a word that implies innocence), starling, sparrow, nightingale, chaffinch, or swallow."

Robert Gober
Untitled, 1990
Multi Media
Museum Boymans-van Beuningen, Rotterdam

Fischli/Weiß
The Celebrated Carrot, 1985
Die gefeierte Rübe
Photograph from the work group
"Stiller Nachmittag"
Cologne, Courtesy Galerie Monika Sprüth

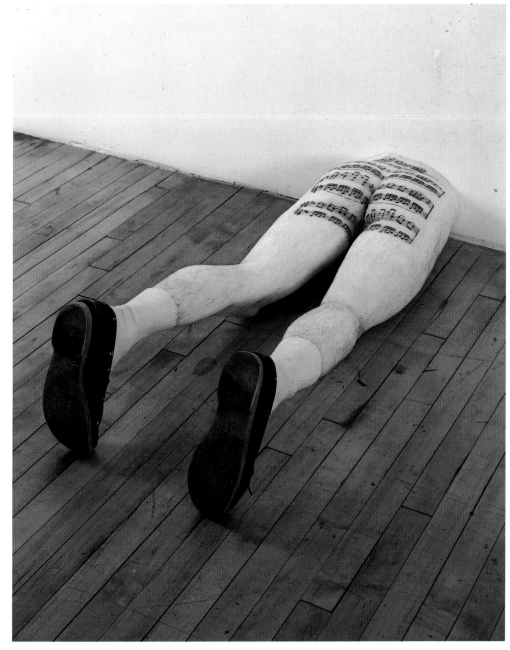

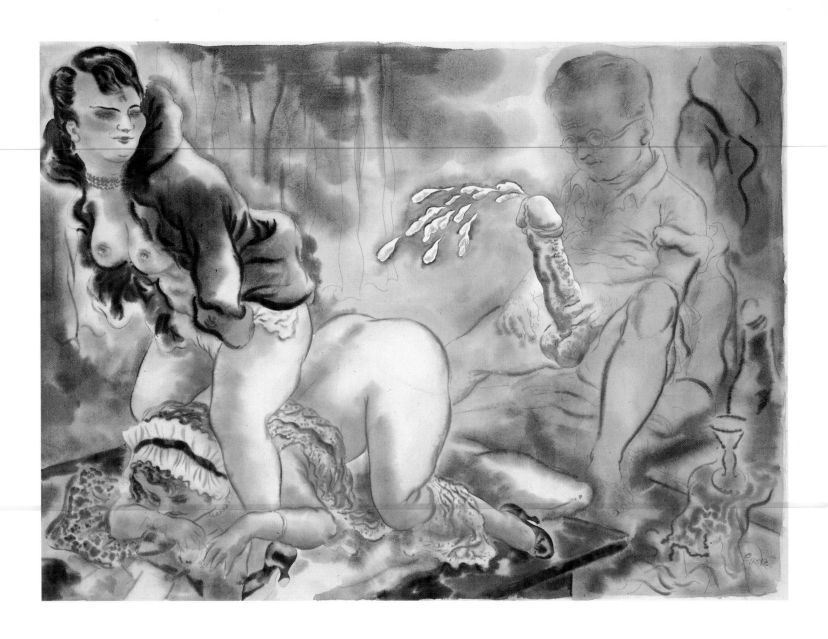

George Grosz
Self-portrait with Two Women, 1920
Selbstporträt mit zwei Frauen
Watercolour, 51.5 x 69.2 cm
The Hague, Collection P.B. van Voorst
van Beest

Dalí is without doubt a provocateur. The sheer title of his painting *The Great Masturbator* (p. 181) works as provocation. The heroine of this painting appears ready to consummate an act of fellatio. "Of all the beauties of the human anatomy," writes Dalí, "it is the testicles that hold me most powerfully spellbound. When I gaze at them in contemplation, an astral fervour consumes me. My teacher Pujols said they are the receptacles of beings yet uncreated. And therefore they represent to me the invisible and untouchable palpability of heaven. But I abhor those that hang down like empty bags! For me they must be full, firm, round and hard like bivalve mussels." When Dalí with such exacting precision renders the testicles ruptured by time belonging to the torso of Phidias, he seeks to "invent a new and beautiful way to serve the vital needs of the human race, as expressed among those specific modern sciences specialising in life's three absolutes: the sexual drive, the death drive, and the hysteric fear of time and space. Let us place the drive of sexuality before that of death: the unexcelled art to exalt the living."

Dalí also says: "Painting, like love, comes in through the eyes to flow out again through the hairs of the brush... My erotic dementia impels me to aggravate my sodomitic desires to the point of paroxysm." In Port Lligat he surrounds

himself with "the most delectable rears one can imagine. I convince the most beautiful women to step out of their clothes. I have always said that it is through the bottom that the most arcane secrets find foundation, and I have even discovered a deep analogy between the arse cheeks of one particular female guest in Port Lligat, who removed her clothes for me, and the continuum of time and space, which I have termed the continuum of the four buttocks [as an aside in this connection: this 'continuum' is nothing other than the representation of an atom – Dalí loves to cloak himself in the learned mantle of science]. I paint the most delicious and mad positions, in order that I might arrest my mood in a paroxysmic erection, and I have fortuitously rounded my experience by witnessing the successful consummation of an act of sodomy. All that I hold important arrives to me through the eyes. I succeeded in convincing a young Spanish woman to allow herself to be screwed in the arse by a young neighbour of mine, a man who had pined to become her suitor. Together with a girlfriend of hers – because other witnesses in my theatre are always important, carrying out the roles of scribes – I sat down upon the room's divan. Through two separate doors the two participants entered the room: she, naked beneath a morning robe; he, disrobed and with an erection standing at full mast. He immediately whirled her backwards and proceeded to try and penetrate her. His success was so astonishing in its alacrity, that I was forced to get up in order to persuade myself that this entire scene was not some fraudulent staging. I abhor being made a jackass. Then she began to shriek in piercing tones, her voice ecstatic: 'This is for Dalí, for the divine one . . .' I have never been able to tell this story without being swept away by the delicious feeling of having found out the secret of consummate beauty. Eros exactly as a hallucinogenic drug, as the science of atoms, as the Gothic architecture of Gaudí, as my love for gold, everything can be reduced to one single common denominator: God is present

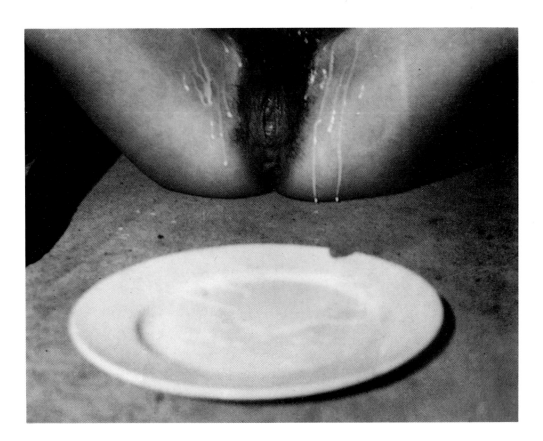

Hans Bellmer
Untitled, 1946
Photograph, 6 x 6 cm
Paris, Private collection

in everything. The same magic pulses at the heart of all things, and every road leads to the same unveiling."

Dalí had a most perplexing relationship with his sister, Ana María, both loving and hating her. Between his *Christ of Saint John of the Cross* and his version of *The Sacrament of the Last Supper*, he painted perhaps the most erotic picture of his long career, *The Young Virgin Autosodomized by Her Own Chastity* (p. 182). The creation of this painting has a story of its own, one which is importantly entwined with Dalí's relationship to his sister. At the time of Dalí's "scatological" period, which to his great elation caused such an uproar among André Breton and the Surrealists, he painted a portrait of his sister from the rear perspective, conspicuously embellishing the young woman's buttocks. In order to repel any possible thematic confusion he entitled the painting, *Painting of My Sister / The Anus Red / From Bloody Shit*. Did Dalí return to this theme in 1954 in order to revenge himself? Certainly the intervening twenty years had transformed, laundered his memory: Ana María Dalí had actually been a smallish, rather plump adolescent. In order to prettify her figure, Dalí sought out inspiration from a pornographic magazine. But indeed, it would appear that at the same time he was settling some secret score between himself and his sister. This particular series of events provides a patent example of Dalí's "paranoiac-critical" method: animated by some searing, indelible memory, the wheels of a complicated psychological millwork are set in motion to thoroughly mix the analytic intelligence with the weighty imaginings of erotic fantasy. One witnesses a genuine lyric feat in the painting dating from 1954, for Ana María's beautiful fortress-buttocks are discovered to be the imaginary relatives of the rhinoceros horn, a spectacle which bestows Salvador Dalí with an erection so fantastic that he is

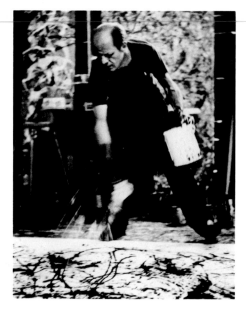

Jackson Pollock
Pollock in his Studio, 1950
Photograph
Photograph: Hans Namuth

Wols
Phallicism, circa 1944
Phallicités
Ink, watercolour and white zinc,
10.8 x 12.3 cm
Private collection

finally able to penetrate "The Anus Red/From Bloody Shit" of his sister. Revenge is a Catalonian speciality! But more than that, spared from personal carnal involvement by the foil of the rhinoceros horn, Dalí is able to preserve his own chastity, for by this time physical purity represents to him "one of the essential requirements of the spiritual life."

It has often been remarked that mythology provides artists with pretexts for their works. In the specific case of Gustav Klimt and his reworking of the Danae legend (p. 161), mythology furnished him with the warrant to depict, without arousing the venomous contempt of the Viennese censors, a godly ejaculation and the ecstatic transport of his female figure. Here again we are reminded that all great artists possess the special faculty or talent of being able to turn taboos around to suit their inclinations. After Zeus secretly came to Danae in the form of golden rain, a hero-son was introduced to the world: Perseus. Klimt, however, and this epitomises his cunning, makes the artistic decision to portray the hero's conception – one which was by no means immaculate. The visual trick Klimt here pulls off is to mix the golden sperm together with the golden coins between the outsized thighs of his comely sleeper. Klimt handles the image's sheer perversity in a sagely offhand manner: the painting's subtext is rape. The heroine is entirely passive, is swept along by events without her acquiescence – without even her conscious awareness. In this way viewers are confronted, as were the citizens of Vienna during Klimt's era, with sleeping Danae's unwitting eroticism, and are made in one fell swoop both voyeurs and accomplices. This secret aspect of the female sexual identity radiates a very direct and wantonly perverse eroticism which underscores all the more the power of this image's lusty female figure. Klimt gives her a strapping, very real anatomy embellished with the sort of sumptuous skin that is the hallmark of sensuous beauty. This model, who is of the redhead class, the kind of doll Klimt found so alluring, candidly represents

Jackson Pollock
Autumn Rhythm, 1950
Oil on canvas, 266.7 x 525.8 cm
New York, Collection, The Metropolitan
Museum of Art, George A. Hearn Fund. 1957

ILLUSTRATIONS RIGHT AND LEFT:
Marcel Duchamp
The Givens: 1. The Waterfall; 2. The Lighting Gas, 1946–66
Etant donnés: 1e La chute d'eau; 2e Le gaz d'éclairage
Installation, 242.5 x 177.8 x 124.5 cm
Philadelphia, Philadelphia Museum of Art, Gift by the Cassandra Foundation

that set of *femmes fatales* who have in the meantime become pin-ups. But more forcefully than elsewhere in his work, this painting is a meditation on the life principle which the female carries submerged within herself, the profound ground that makes her the central object of the male's, and the artist's, inquisitions.

The object-woman, who within the art tradition has again and again provoked the artist to give expression to her suffering, debasement and torture, her rape by males and even monsters, is now more than ever, as the modern era enters its decline, predestined to fulfil a role. Yves Klein, his work a forerunner of so-called "body art", employed the techniques of the Happening to transfigure the female into a work instrument, into a "brush-woman". Following Klein's directions, his naked female models smeared handfuls of blue paint over themselves, then pressed themselves against a wall or laid down on the floor to imprint great sheets of virgin paper with the outlines of their bodies (p. 186). Behind such provocation is hidden a sense of the absolute, of the endlessness of the cosmos. Klein, who also happened to be a fan of judo and was greatly fascinated by the Rosicrucians, takes as his point of cosmic departure the dis-

covery of blue, *his* blue. One must here again emphasize how terribly difficult it is to speak of modern art and to attempt to fathom its secrets without relying on examples culled from earlier eras. Pierre Restany, the mentor behind the Nouveaux Réalisme movement which claimed Klein, Tinguely, Hains, Arman, Dufrêne, Raysse and Spoerri as members, also ran into this problem, explaining to an audience that the ceremony of the "brush-women" was based upon one of the oldest creation rites. Klein himself remarked that he was most interested in evoking "the cave paintings of prehistoric peoples". Klein submits that the blue which inspired his monochrome works stems from the blue backgrounds of the great masters. During a discussion he remarked in this connection that the blue Giotto employed in the Assisi frescoes functions both as a sky and as a wholly monochrome backdrop. Gaston Bachelard, the philosopher of preference for many modern artists, is also called forward as a crown witness by Klein, who quotes a few handsome phrases excerpted from the work "The Air

Otto Dix
Myself in Brussels, 1922
Ich in Brüssel
Watercolour and pencil, 49 x 36.8 cm
Stuttgart, Galerie der Stadt Stuttgart

"I need the connection to the world of sensuality, the courage to wretchedness, life undiluted. No, artists should not teach and convert. They are far too small. They must only bear witness." O. D.

and the Dreams", where Bachelard speaks of a highly aggressive azure blue that "with never tiring hands endeavours to darn the great blue holes torn by wicked birds. At first there is nothing, and then a deep nothingness, and then blue depth."

When one considers performance art in its development, it becomes plain that the artist, by employing the body to assist his productions (wholly relying, as does Klein, upon the tradition of art), is spurred by the intention to revitalize visual communication and to overturn all existing formal rules, all aesthetic and moral norms.

During the performance the artist presents himself as the medium of both theoretical and practical processes. His actions work to recall in an estranged fashion the ancient religious ceremonies or magical initiations of primitive cultures. With his body he abolishes the distance which normally separates reality from its replication, for the art performance is for the sake of the art

Edward Hopper
Night Window, 1928
Oil on canvas, 73.7 x 86.4 cm
New York, Collection, The Museum of
Modern Art, Gift of John Hay Whitney

performance alone. The model and the artist's projections meld together as one. Art is life, and it is life itself which becomes the work of art.

Klein, Nitsch (p. 74), and Mühl (p. 155) were among the pioneers of the Happening. Each systematically and programmatically integrated eroticism into his work. A typical Happening demonstrating such tenor was *One Hundred and Twenty Minutes Dedicated to the Divine Marquis (de Sade)*, which took place in 1966 at the "Festival of Free Forms of Expression." A strong woman (the homeland), whose demeanour and appearance were meant to evoke the chief of state, was stripped, covered with whipped cream, greedily licked clean, and then "engorged" by the spectator-voters. Another such Happening featured a nun who, while launched in holy and ecstatic prayer, masturbated using leeks, carrots and other godly vegetables, which were later consumed by the spectators during the Happening's interpretative segment. At this point it was also disclosed that the nun was actually a man, or, if not a man, then at least, anatomically and psychically, a transsexual. One possible definition for the Happening phenomenon in its finest sense might be: the process of simultaneously making love, art and politics.

Marcel Duchamp enthusiastically related the story of the Happening he experienced at the Waldorf-Astoria Hotel in New York. Two hundred members of New York's high society, wearing tuxedos and evening gowns, could not forego the adventure of descending into one of the flooded rooms of the hotel basement, then wading through ten centimetres of fetid water in order to watch a naked prostitute flaunt herself at the top of a coal pile, in every possible pose and posture. Duchamp adds that the most extraordinary feature of the entire incident was the woman's atrocious looks. The Happenings in America are a perfect societal mirror, for all too often naked males and females are simply marched in review past the completely shocked participant-viewers, when actually there would be little reason for irritation if the naked performers were

Pablo Picasso
Painter and Model, 1964
Le peintre et son modèle
Oil on canvas, 89 x 130 cm
Private collection

"It's about the dialogue of the painter with the work in progress and the expression of the spiritual tension focused on its completion, as well as the relationship between the artist and the posing model and the natural eroticism she exudes. Spirituality and sensuality are for Picasso an indivisible unit."

Andreas Franzke

Eric Fischl
Bad Boy, 1981
Oil on canvas, 168 x 244 cm
New York, Courtesy Mary Boone Gallery

"Actually, with Bad Boy I didn't think there was a kid in the room. I thought it was a man and woman lying around after fucking. But the man didn't work out. He just doesn't for me. So then it was just me, painting, looking at this woman. Then, I don't know, I became aware that there was this other person in the room, actually in the room with her, watching with me. So I painted the boy. And I like him. It made perfect sense, take her, take the money, take everything." E. F.

not American youngsters in the habit of eating too much. In Europe, Happenings have in the meantime progressed to the point where the performance artist may ascend a ladder to piss in bottles. And faces.

In his "Diary of a Genius", Dalí writes: "During the last war Marcel Duchamp entertained me from Arcachon to Bordeaux with a monologue in which he spoke of the awakening interest in preparations from excrements, whereby the little amount one can collect from the navel qualifies as the 'luxury model'. I answered that I would very much love to own a navel excretion from Raphael. Today a very well known Pop artist in Verona offers excretions from artists in his exquisitely artistic bottles as if they were the genuine luxury articles. Once Duchamp realised that he had strewn the ideas of his youth to the wind, one after another until he had not a single one left, he refused in a most aristocratic manner to enter into this game, explaining that other young men should specialise in the chess game of contemporary art, whereas he himself had taken up chess."

Whether one terms it a ready-made or not, urine, or the act of pissing, it must be acknowledged, plays a role in art that should not be underestimated. Urination and ejaculation are bodily functions of close proximity. With this in mind Gérard Zwang remarks: "It is as senseless to complain of the near amalgamation of the sperm tubes and the ureter, as it is to complain of the absence of the third eye from the back of the head. The facts are irrevocable and require no elabor-

173

"Sexual motifs lose all importance the moment they are used to shock or to educate. There is a kind of comfortable misunderstanding which has become voguish that regards the understanding of sexuality as self-knowledge. Sexuality is solely compatible with disinterest." R. M.

Balthus
Golden Days, 1944–46
Les beaux jours
Oil on canvas, 140 x 199 cm
Washington (DC), Hirshhorn Museum and
Sculpture Garden, Smithsonian Institution,
The Joseph H. Hirshhorn Foundation, 1966

ation: a few times each day human beings use their love organs to urinate." One dare mention, however, that humankind has experienced a few discomforts due to such coarse propinquity! But then again, we can also understand the fascination showered on the female's discharge of urine by such artists as Rembrandt, Picasso, and Duchamp. Goethe in "The Travels of Wilhelm Meister" revealed his enthusiasm, as did Henry Miller in "The Tropic of Cancer", roaring out: "A man, when he's burning up with passion, wants to see things; he wants to see everything, even how they make water." Sexologists tell us that the male is driven by the strongest desire his libido can harness: he is possessed by the irrepressible urge to regress back to the womb of the mother, back to the amniotic fluid, back to the sea [an untranslatable pun from the French: retourner dans la mère, dans la mer]. When a woman allows a man to adore her naked features, she renders him a generous sacrifice indeed, for she offers up to his gaze everything which she has learned to hide, to keep aloof and far from reach. She was trained never to show it to anybody, always to keep it covered, never let down her guard. And now she stands this taboo upside down, this prohibition so deeply ingrained into our customs. One might remark of such an encounter that "she shows everything." This is the compulsion that drives Balthus and so many other artists to exhibit those sights normally kept well hidden beneath

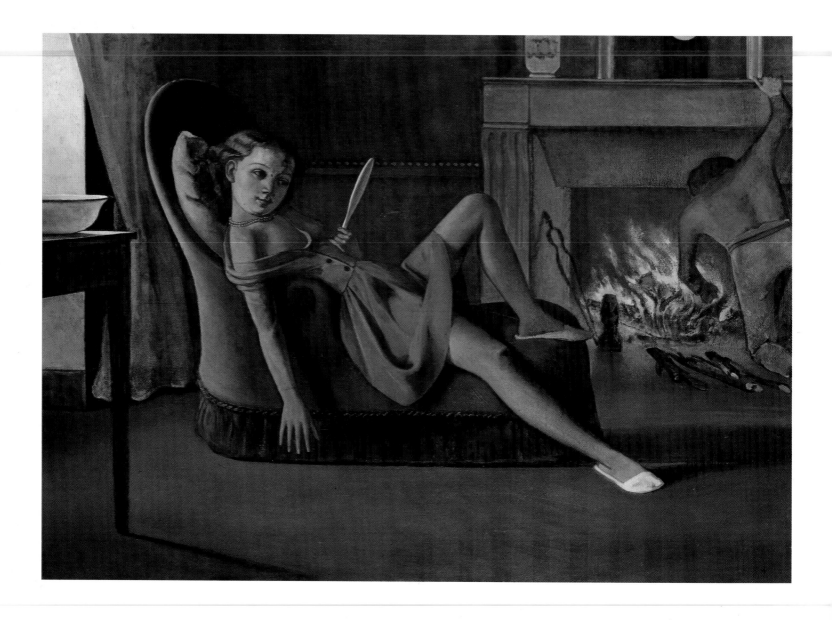

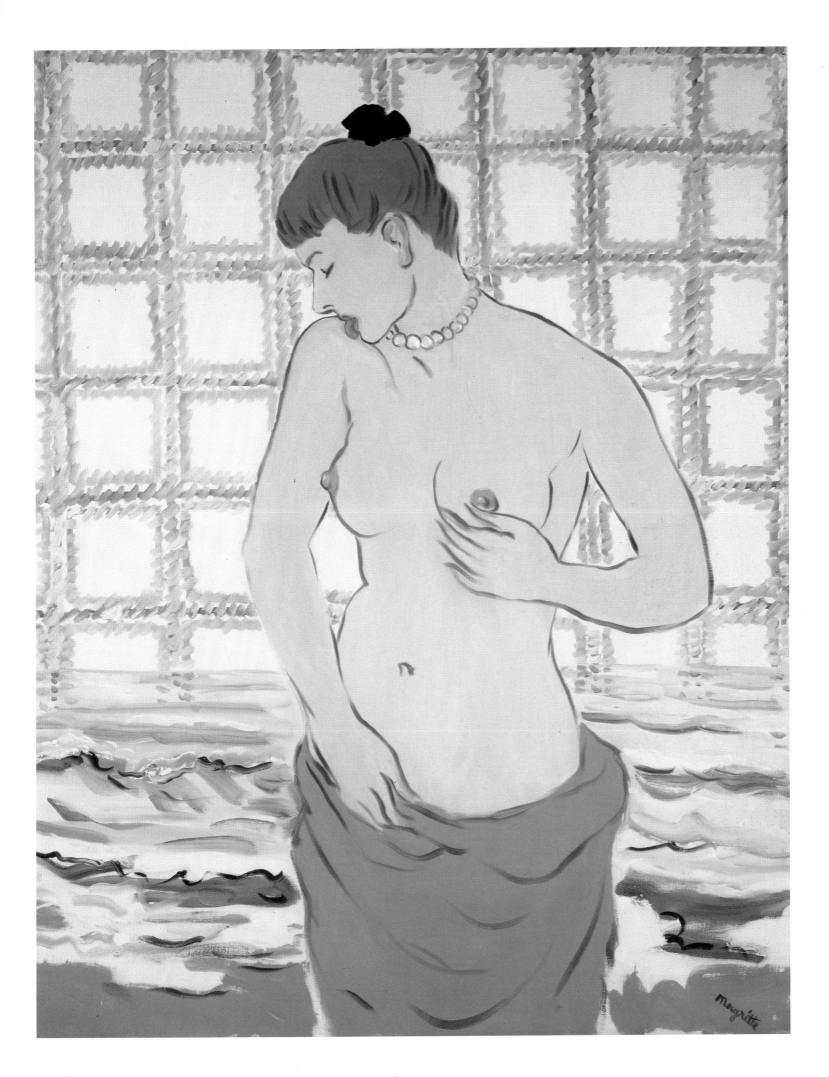

Gustav Klimt
Sitting Semi-nude with Closed Eyes, 1913
Sitzender Halbakt mit geschlossenen Augen
Pencil, 57 x 37 cm
Vienna, Historisches Museum der Stadt Wien

skirts. Not being allowed to see is equal to being tortured. Seeing means peace. Henry Miller confesses that he once laid down beneath a woman at a park, situated himself so that he could "view everything", and that this sight filled him with such peacefulness that he drifted off to sleep. The slight pout of the vaginal lips – which in French are also called "nymphs" – visually evoking the female's most intimate secrets, are sufficient alone to fire a man's arousal. Claude Simon, recipient of the Nobel Prize for Literature, noted that a woman was allowed to satisfy her every erotic craving in a position with her thighs splayed wide at some 90 degrees: "The legs are raised, the thighs pressed back over the hips, the knees gaining the shadows of the armpits." There is no doubt that for a male the female genitalia are the most perplexing as well as the most aston-

Christian Schad
Girlfriends, 1930
Freundinnen
Oil on canvas, 31.5 x 23 cm
Private collection

176

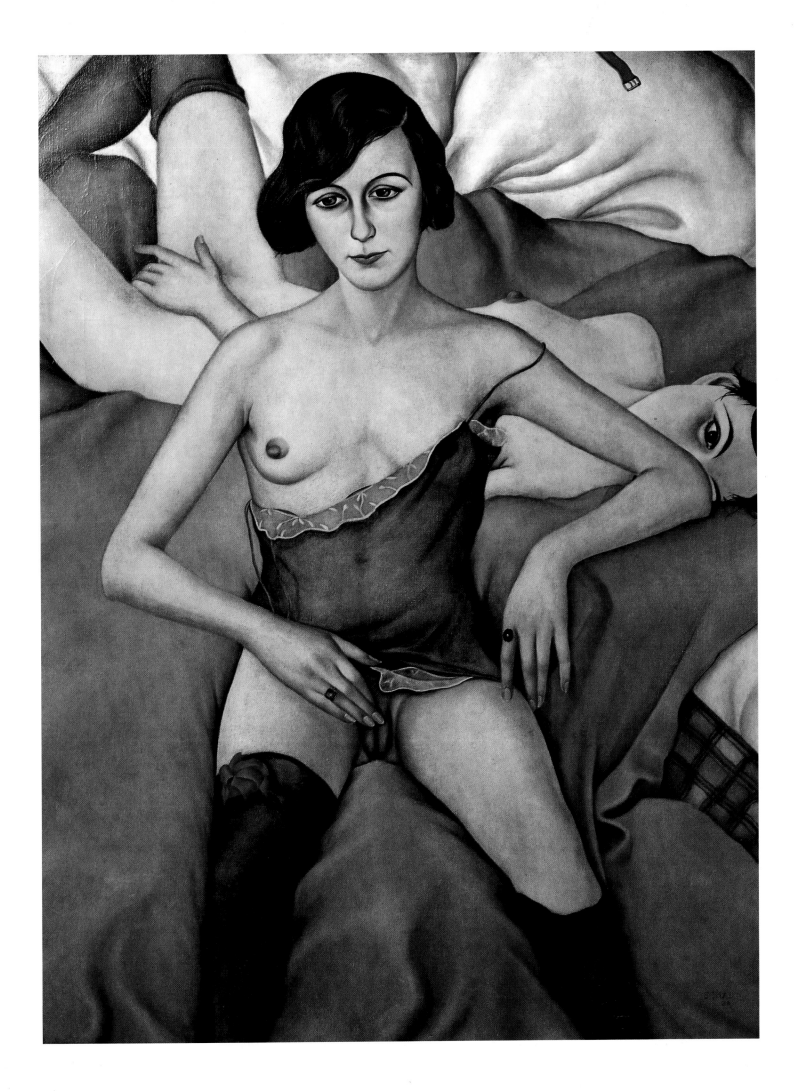

ishing secret that exists. He considers every imaginable possibility of solving this riddle, whereby he gratifies his every lust. The female genitalia portend a vast mystery, especially in comparison with the simpleton fashion his own sexual organ functions. Females find sexual pleasure by a variety of means, whereas the male has no choice – it's ejaculate or pass.

This quite possibly accounts for both the male's fundamental misunderstanding and his insatiable curiosity: he has never forgiven women for being other than himself, for being different, yet at the same time so terribly similar. And equally enraging is the ill-begotten fact that she has an autonomous subjectivity, a will of her own despite her inferior physical strength. Since the dawn of mankind, the female has been well aware of her power. In this vein Simone de Beauvoir writes with sculpturesque directness in her book "The Second Sex":

Martin Kippenberger
War Without Peace, 1990
Krieg ohne Frieden
Pencil, ball-point pen and
chalk on hotel stationery, 29.7 x 20.8 cm
Private collection

"Feminine desire is like the faint palpitation of a mussel; it stalks like a carnivorous plant; it is the swamp in which insects scuttle and children disappear; it is the absolute vortex, a breathing suction cup, the bait and the tar..."

Can fellatio and anal sex be considered as perversions? Dr. Gellmann ranks these practices as part of sexuality's classic, normal purview. Indeed, experts in this field have determined that, to the contrary, the actual perversion of sex can be observed in those people who gratify their lusts in one staid routine, who marry themselves to one technique and refuse all variation. Perversity is monogratification! It is directly comparable with cuisine: sex is an intellectual and

Robert Mapplethorpe
Marty and Veronica, 1982
Photograph
New York, © 1982 The Estate of Robert
Mapplethorpe

179

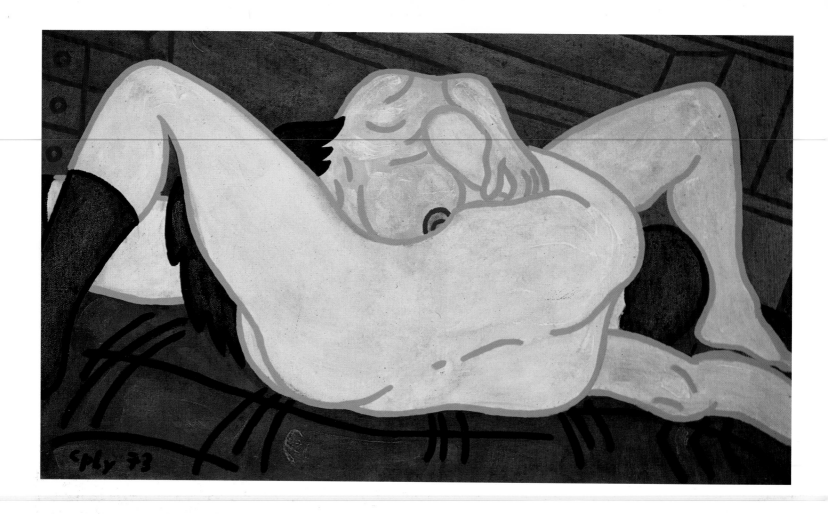

William N. Copley
The 69 Steps, 1973
Acryl on canvas, 63.5 x 106.7 cm
Collection of the artist

imaginary process which retains as goal the exquisite refinement of a function. In point of fact there is only a small difference between pornography and eroticism. Pornography is the eroticism of people of another social milieu. It is a cultural phenomenon. Pornography is always the eroticism of others.

To be accused of "pornography", as we have already witnessed, can be regarded as a warrant for fame. The final breakthrough for Baselitz arrived during the Sixties when he provoked a scandal among German society's upper echelons. In 1963, two of his graphic works were confiscated from the Michael Werner Gallery in Berlin. The first work, *Naked Man,* was loyal to its title; the second work, *Bang Goes the Big Night,* thought to be especially obscene, depicts a child with an enormous penis who is on the verge of masturbating. But what precipitated the scandal and, simultaneously, such great astonishment, was that the artist had been so bold as to employ a mode of figurative expression which dared formulate in its widest sense some social commentary. *Bang Goes the Big Night* is one of a group of paintings metaphorically portraying the theme of loneliness in a dehumanized society. These graphic works proclaim their messages in much the same manner as Dix's pornographic images, taking on the vital mission of denouncing the societal corruptions of their era.

After an art epoch in which the American school took over the role of pacemaker, continuing the tradition of examining bourgeois society, a chore it accomplished with prankish zest, it would appear that the German artists, invigorated by a different set of goals, have come to the fore at present. Hitler left behind a noxious vacuum, and it took a while before the new renaissance could take root. Movements such as Expressionism and the Blauer Reiter, which

passed from the German scene before the Nazis took political power, have been superseded by a wide palette of interesting artistic personalities. At the head of the pack stands Joseph Beuys, the former Luftwaffe pilot and the most famous German artist since Dürer. During the Seventies only Warhol was his equal in fame; only Warhol surpassed the media hype of Beuys. Warhol is a star in the American style; Beuys, a Wagnerian hero. He is Tristan from that preliminary drama called by its creator "The Death of Love". One can place the dynamism and populism of Warhol in the same room as the morbidity and shamanism of Beuys. Both men are symbols, and both represent their individual countries. For Beuys, art is work; for Warhol, business. Both are children of Duchamp, and both attempt to take his theories to their logical conclusion. In *The Silence of Marcel Duchamp is Overestimated*, Beuys takes a good look at the inventor of the ready-made, accusing Duchamp of not daring to go as far as his declarations announced, and censuring him for failing to understand his actual contribution to the tradition of art. The point Beuys makes is that Duchamp, at the moment when he could have distilled a theory from his work, instead retreated into silence. "And this theory," Beuys says, "which he could have developed, I am developing today..." Duchamp installed his found object, *Fontaine*, in a museum as a demonstration that simply by transporting an object, in this case a

Salvador Dalí
The Great Masturbator, 1929
Le grand masturbateur
Oil on canvas, 110 x 150 cm
Gift of Dalí to the Spanish government

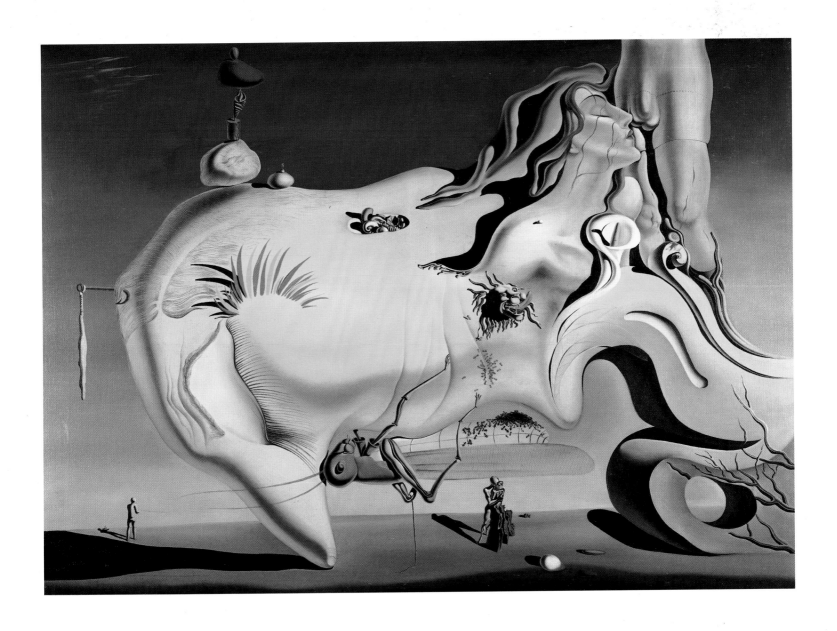

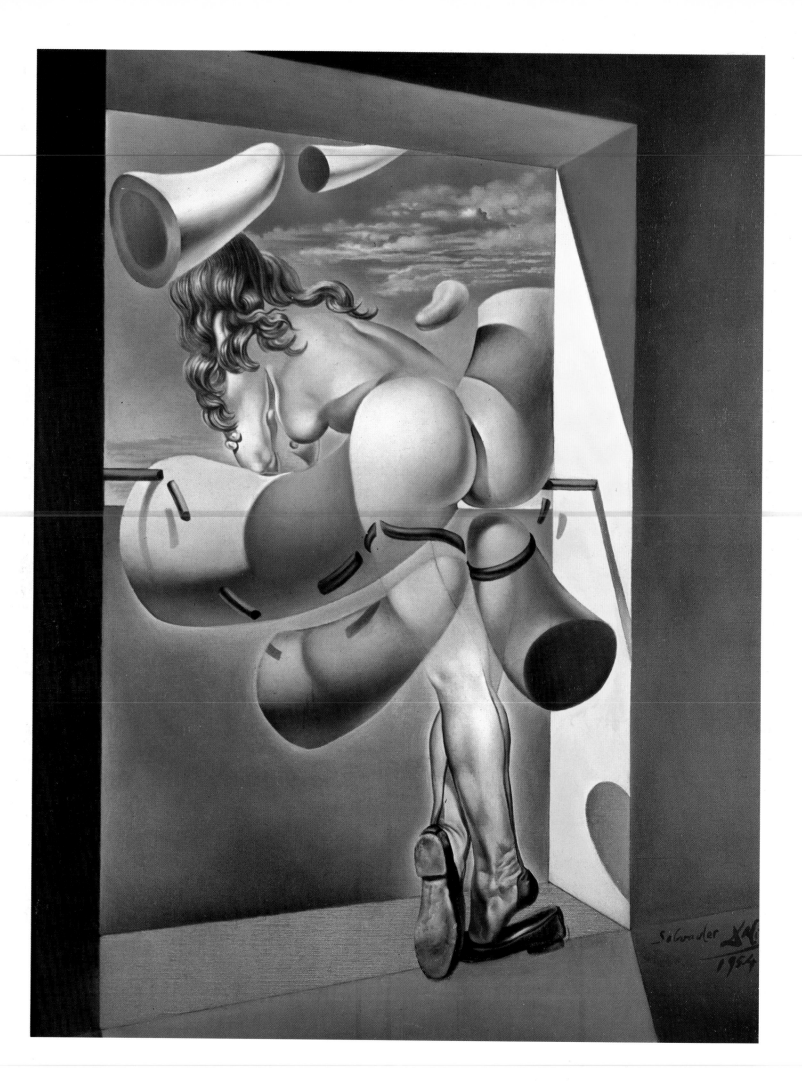

urinal, from one site to another, that object could acquire the designation of being a work of art. But this concept, Beuys continues, did not bring him to the perfectly clear and simple conclusion that every person is an artist. Quite the contrary, Duchamp stood atop a pedestal and proclaimed: Behold the fear I strike into the audience! Beuys for his part attempted to come to terms with the phenomenon of art by covering his head with gold leaf and cradling a dead rabbit in his arms. He entered into a non-stop monologue leaping in every imaginable direction: love, Eros, the environment, fat, copper, honey, the felt he used in his sculptures... racing towards the conclusion that, as opposed to Duchamp, the most essential statement to be found in his work is: "Every person is an artist. That is my contribution to art history." Another German talent towering above his contemporaries is Anselm Kiefer, an artist preoccupied with discovering his own vital identity. His investigation draws on old German mythology, alchemy, the home environment, Goethe and Hölderlin.

Surely one can find ground for comparison between *Bang Goes the Big Night*, by Baselitz, and *Sleepwalker*, a painting by the American Erich Fischl (p. 162); yet Klaus Honeff in his book "Contemporary Art" submits a point with respect to Fischl and Kiefer that is well worth considering: "What distinguishes these two

Alfred Kubin
The Promenade, circa 1903
Die Promenade
Ink and watercolour, 24.4 x 32.5 cm
Private collection

Salvador Dalí
Young Virgin Autosodomized by Her Own Chastity, 1954
Jeune vierge autosodomisée
Oil on canvas, 40.5 x 30.5 cm
Los Angeles, Playboy Collection

"Painting, like love, comes in through the eyes to flow out again through the hairs of the brush... My erotic dementia impels me to aggravate my sodomitic desires to the point of paroxysm." S. D.

Pierre Klossowski
Gulliver's Travails II., 1973
Les travaux de Gulliver II
Colour pencils, 201 x 151 cm
Milan, Private collection

artists is every bit as plain as what they have in common. Fischl provides a glimpse into the American inner life; Kiefer holds a lamp to the hidden dungeons of the German psyche." The works by the American "are powerfully steeped in sexual obsession," but, additionally, "one feels confronted with the images of modern myth. The vibrant sexuality also lends contour to the psychological breeding grounds of a host of societal neuroses which predominately flourish in the social climate of the United States." Honeff incorporates into his interpretation the viewpoint of Donald Kuspit, who discovers within American New Realism and its sprawling family of derivatives a perverse tenor that functions wherever a longing for direct perception is viewed as an offence against cultural expectations, a process which proceeds in a fascinatingly morbid manner: through the arrestation at the voyeuristic level a fetish preoccupation is erected. According to Kuspit's explication, perception here becomes a per-

verse activity tethered to a perverse object – reality; but this perversion is no-where divulged, remains implicit, unspoken, present only by implication. And to this Klaus Honeff adds: "Fischl's perspective is predominately that of the young boy or stranger. This is what lends his images such an astonishing – even shocking – insistence and urgency." These are prosaic images of everyday America, average America, the America of sexual hostility and television vapidity which Edward Hopper captured in paint from a perspective that appears to peep through a pair of binoculars from a window at the round bottom of a woman undressing across the street (p. 171). The male figure in Fischl's *Bad Boy* is none other than the hero of Mike Nichols' film "The Graduate", a young man become voyeur who hungrily devours the coup de théâtre of a mature woman pulling on her nylons.

German artists are solely interested, Baselitz once remarked, in what goes on beneath the earth. His sources of inspiration are the dead, ashes, urns, trolls. Baselitz unequivocally rejects American Pop Art as well as his gifted contemporary Anselm Kiefer, whose work for his tastes draws too greatly upon recent German history and is marked by nationalism. German art, Baselitz explains, as

George Grosz
With Two Women
Mit zwei Frauen
Watercolour, 51.5 x 69.2 cm
The Hague, Collection P.B. van Voorst van Beest

Yves Klein
Anthropometries: ANT 130, 1960
Anthropométrie: ANT 130
Body imprint with pigment and synthetic
resin on paper on canvas, 194 x 127 cm
Cologne, Museum Ludwig

*"The form of the human body, its lines, its colour be-
tween life and death, fail to interest me; for me what
is exclusively important is the climate of sensibility; it
counts. The flesh . . .! Certainly, the entire body is
made of flesh, but the actual material – that is, the
rump, the thighs. Precisely here is the actual universe
to be found, the hidden creation."* Y. K.

opposed to the art scene in France, is entirely untroubled by the image's dec-
orative presence – it doesn't care whatsoever about the elegance of composition,
but instead is wholly preoccupied with unleashing raw, aggressive power. A
sexual organ is a sexual organ and not a flower! German painting is never
conventional, but at the same time it never allows itself to become an easy
pleasure. From Dürer and Cranach to Otto Dix and Schwitters, the body is
generally represented as a tormented frontal nude; with Baselitz such figuration
can boast an unbroken German lineage that dates back some five hundred
years... "We never hesitate to express ourselves," Baselitz says, "to reveal what

Jeff Wall
The Destroyed Room, 1978
Cibachrome, 159 x 234 cm
New York, Courtesy Marian
Goodman Gallery

Eugène Delacroix
The Death of Sardanapal, 1827
La mort de Sardanapale
Oil on canvas, 392 x 496 cm
Paris, Musée du Louvre

takes place in our souls and bodies." All the same, Baselitz, exactly like Kiefer, has often been compared to the Expressionists of the twenties. Baselitz fervently denies any such affinity, allowing that he does indeed handle the brush with marked aggressivity but maintaining that this technique is more a German idiosyncrasy than anything exclusively typical of the Expressionists.

Suffering, debasement and torture are circuitous methods to attain ecstasy, but are by no means less viable than coitus or masturbation. As we have already witnessed, Eros and Thanatos are joined at the hips. Eugène Delacroix was a master of this genre, and it was he who achieved the apotheosis of cruelty in his painting *The Death of Sardanapal* (p. 187). According to legend, once rebel forces stormed the palace of this Assyrian king, forcing him to contemplate his own defeat, "Sardanapal, lying well above the proceedings upon an imposing bed bearing the appearance of a funeral pyre, orders his eunuchs and his palace

Andy Warhol
Sex Parts, 1978
Silkscreen on paper, each 79 x 59 cm
New York, © 1992 Andy Warhol Foundation
for the Visual Arts / ARS

"Love and sex can go together and sex and unlove can go together and love and unsex can go together. But personal love and personal sex is bad." A.W.

guards to put to death his wives, his pages, yes even his horses and his favourite dogs, for no object which has gratified his desires dare survive him." The female is, then – by the same token as a horse or a dog – an object. The diagonal rhythm, the motion of the line, the powerful glow of the colours, the profound sensuousness radiated by this painting, make it one of the most important masterworks of the 19th century. But the hypocritical public, the same rabble which cries "Death!" at executions, is injured in its sensibilities: the woman stabbed by the dagger at the foot of the king's bed writhes with an expression of such acute physical and emotional suffering that the painting was too wantonly

Salome
Fuck II, 1977
Egg tempera on cotton, 180 x 180 cm
Private collection

189

voluptuous for its era. The critics showered Delacroix with malicious reviews. He was immediately relieved of his every state commission.

The unbridled swells of the romantic Delacroix seem to make a response to the rich curves of the limbs of the classicist Ingres. These slave women, the sex objects of the Assyrian King Sardanapal, are women of flesh and blood very much aware of their physical situation. They play with their condition as if it were a tuneful instrument. Provoked by terror and physical harrowment, they resonate with sexual desire. As their deaths draw near, as the king's henchmen carry out their bloody orders, these women appear enveloped by that same sensual rapture which only hours before had been prompted by the stirrings of tenderness. Here death and desire trade intimate broadsides. Delacroix applies a veneer of madness to this orgy of figures, a state of intoxication that ends in ecstasy, as well as in the twitching throes of terror. The women surrounding the catafalque, King Sardanapal's royal bed, evoke in their tableau the billowing of flames. De Sade would have applauded this spectacle: a lone man possessed of enough power to surround himself with agony and death. King Sardanapal derives his final, sensuous pleasure from ruling over a mountain of naked flesh, mortally wounded bodies emptying into cries and screams. He is surrounded by a diabolical majesty: the machinations of total annihilation. His self-destruction stands at the centre of this inferno; he gives himself over to death in a manner commensurate with his persuasions and place in life, namely one on

Max Beckmann
Afternoon, 1946
Oil on canvas, 89.5 x 133.5 cm
Dortmund, Museum am Ostwall

"Cold anger rules in my soul. Will man then never escape from this eternal, repugnant vegetative corporeality? Nothing is left but to protest! To shower with boundless antipathy the lewd bait which always persuades us back to the curb of life. Then when we, half-dehydrated, attempt to quench our thirsts, the ridiculing laughter of the gods rings forth." M. B.

Nayland Blake
Restraint No. 6, 1989
Steel and leather
New York, Courtesy Matthew Marks Gallery

which he is proceeded by the splendour of an orgiastic ritual of murder. The masses have always been excited by mortal sacrifices, be it to honour gods, kings or sovereigns.

What Delacroix here openly displays is something others reserve for their private spheres, boldly availing themselves of entire panoplies of torture equipment. There are plenty of people wandering around who become aroused by being placed in chains. The icy contact of the metal galvanizes an immediate erection. With convulsive shudders the awaited deliverance finally arrives. The masochist fettered by chains begs for a rain of blows; the exhibitionist made immobile wants to suffer devouring glances; and the fetishist has no need for a partner whatsoever. From the penetration objects of Bellmer to the handcuffs of Blake, which await their next victim; from the woman of Klossowski, who allows herself to be chained so that she might be raped more excellently, to

Otto Dix
Dedicated to Sadists, circa 1922
Sadisten gewidmet
Watercolour and pen, 49.5 x 39.9 cm
London, Christie's Colour Library

"I am completely convinced that it is not desire but the idea of evil that arouses us ." Marquis de Sade

Man Ray
The Enigma of Isidore Ducasse, 1920/71
Photograph
Milan, Vera and Arturo Schwarz Collection

Schlichter's female armed with a whip – one can say in all honesty that artists have given shape to every possibility of the sadomasochistic canon; no magazine of similar compulsion can outdo art.

Dolls like Kokoschka's *Wanda*, or the famous "Venus in Fur" by Sacher-Masoch, transform themselves – exactly as does the female character in Otto Dix's *Metropolis* (p. 69) – into giant, primal sex organs challenging their chance devotees with infernal demands, stipulating that they beg for their floggings. Sadomasochists often treasure leather, and find it propitious to celebrate their rituals in groups. Clad in leather, with an arsenal of torture equipment at hand, they play master and slave, discovering a means to destroy the monotony of the everyday in their mutual intoxication with military paraphernalia and such leather items as boots and belts. And once they have suitably regenerated, they go out, climb onto their motorcycles and roar off. Hercules, Achilles, Lancelot, Marlon Brando, Rambo and Mad Max are their favourite heroes, their idols. For aficionados of those shoes with exaggerated heels there exist, especially in the United States, "High Heel Clubs". Lindner, Allen Jones and Klapheck are intimate initiates of this predilection. In speciality magazines catering to these fetishists one comes across seductive photos of females who sit, kneel, lie

supine or stretch their legs high into the air – and always wearing a pair of high heels, those shoes which they seem to worship like supernumerary sexual organs.

At the end of this catalogue exploring the fantasy desires of artists and the various forms of erotic expression in art, the time has perhaps arrived to entertain the question of whether it is possible to discover a phenomenology of eroticism in the sphere of so-called abstract art. Do the works of Tapies or Mondrian contain elements overflowing with sensuality? One can of course proceed in a jocular vein and – returning again to that formulation of Adolf Loos, in which a horizontal line represents a prostrate woman, and the vertical line her penetration by the male – arrive at the conclusion that the geometrical constructions of Mondrian are sexual orgies of a most forceful nature. In the French encyclopaedia of art, the "Encyclopédie universelle de l'art", there is an entry entitled "Sexuality and Eroticism", which submits: "The disintegration of the natural forms and the abstraction of representation, since the beginning of our century, have occasioned as consequence in the figurative arts the disappearance of all erotic expression, even in those works in which certain formal qualities manifest a decided similarity with particular anatomical organs, or invoke the play of various sexual functions. The artwork as artefact, in so far as it might be said to exist, is transmitted by lines, volumes and colours, qualities that hinder the viewer from perceiving any tangible aspect of that reality which these artworks tendentiously decline to represent."

Allen Jones
Hatstand, 1969
Painted fibreglass, leather, hair, height: 190.05 cm
Aachen, Ludwig Forum für internationale Kunst

Hans Bellmer
Unica, 1958
Photograph, 6 x 6 cm
Private collection

"After the unfading memory which remains with us from a certain photographic image, a man, in order to transfigure his victim, had wound a steel wire tautly and in blind, criss-crossed patterns across thighs, shoulders, breasts, back and stomach, to create bloated cushions of flesh, irregular spherical triangles, lewd wrinkles and lips, engendering in unspeakable places multitudes of breasts never before seen." H. B.

193

Sexual drives and wish fantasies do very much occupy a place in abstract art. "The history of the symbol," writes a student of Jung, "establishes that any item which can be taken into regard can also be assigned a symbolic value, and this applies to objects of nature as well as to those made by the human hand and even includes abstract forms. For the entire cosmos exists as a potential symbol." In 1917 Hans Arp explained: "I finally simplified these forms ever further, uniting their essence in the movements of ovals, to symbolise the metamorphosis and becoming of the body." Arp pointed the way here for the rich offspring of erotic work to be found in non-representational works. Such painterly elements as curves, rondures and swells, even when they work as completely abstract, can of course be charged with erotic significance. The sculptor Henry Moore once remarked that what interested him most about the mountains was their grottoes.

In the razor slits of Fontana's canvasses one might discern the female vulva, might even distinguish evidence of a rape. A similar effect proceeds from Hartung's straight-lined white rift between dark groves. The male quality of ice cream and the female quality of the hamburger in the work of Claes Oldenburg seem to require no explication. And one might see in the canvasses of Pollock the upshot of a grandiose ejaculation (p. 167). As Wilhelm Reich puts it in his "Theory of the Orgasm", action painting is first and foremost an orgiastic act, is the propensity to uninhibitedly allow oneself release into the biological flow.

Editors' Afterword

Specifically erotic representations are part of the ouvre of almost every artist. Often these works, which are usually relegated to the intimate format of the sketch, are cautiously warded away in private collections, at first by the artists, who refrain from bringing them out into the art market, and then by collectors or estate administrators who draw back from publication. Yet today it is by no means simple to replicate or even locate works of an explicitly erotic nature. Quite commonly, such expressions are considered aberrations on the part of the artist, productions that might imperil the artist's reputation. This standpoint again and again negatively influenced the selection of illustrations in the book before you: the right to reproduce numerous erotic works was refused. This volume, appearing under the title "Twentieth-Century Erotic Art", cannot pretend to be a complete anthology: not only is the wealth of material all too vast, but in view of these difficulties, such an intention is hardly realistic.

In this place it should also be expressly mentioned that a selection of erotic illustrations can only be accomplished with regard to purely subjective criteria. Everyone has his or her own obsessions and preferences, passions determined not by societal convention but by personal experience. The editors of this book are well aware of this fact. They have allowed themselves to be seduced by eroticism in art, declaring as their goal an examination of the artwork's sensual effects. This viewpoint need not always coincide with the intentions of the various artists presented in these pages.

The illustrations of works by prominent 20th-century artists are meant to sensitize the viewer to the various formal expressions of erotic art. This spectrum ranges from the manic compulsions of a Hans Bellmer to the floral sublimations of Georgia O'Keeffe, from the Surrealist daydreams of an André Masson to the orgiastic performances of Hermann Nitsch. This century's erotic expressions are every bit as diverse and nuanced as the body of art proper. In the final analysis, everything comes down to the projection of the viewer. The viewer decides whether a particular representation is erotic or not. It's all in what one sees.

Inspired by this nexus, this volume is consummately dedicated to its theme. And so the first chapter renders the excitement of the as yet veiled, the beginning of every erotic experience. After performing a careful disrobing, these pages procede step by step from a consideration of the various erogenous zones to the act of copulation with its wealth of lustful games and variations. The accompanying text by Gilles Néret carefully negotiates its theme in the form of an essay. Through diverse references and passages culled from literature and philosophy, Néret adeptly establishes an intellectual background supremely suited to conveying an understanding of the erotic art of this century. The commentary is not some systematic compilation, but a subjective – and completely personal – interpretation.

Bibliography

Literature:

Bailey, David: The Naked Eye, Great Photographs of the Nude, London 1987

Battaille, Georges: Les armes d'eros, Pauvert Editeur, Paris n.d.

Borel, France: Le Modèle ou l'artiste séduit, Geneva 1990

Boullet, Jean: La Belle et la Bête, Paris 1958

Fuchs, Eduard: Geschichte der erotischen Kunst, Munich 1926, vol. 3

Gerke, Claudia/Schmidt, Uwe: Mein heimliches Auge, Das Jahrbuch der Erotik V, Tübingen 1990

Hofmann, Werner (ed.): Eva und die Zukunft, Das Bild der Frau seit der französischen Revolution, Exhibition catalogue Hamburger Kunsthalle, Hamburg 1986

Kahmen, Volker: Erotik in der Kunst, Aspekte der Kunst der Gegenwart, Tübingen 1971

Klinger, D.M.: Erotische Kunst in Europa, Vom Mittelalter bis zur Gründerzeit, Nuremberg 1986

–, Erotische Kunst in Europa, Vom Jugendstil zum Art Deco, Nuremberg 1986

Krauss, Rosalind/Livingston Jane: L'Amour Fou, Photography & Surrealism, New York 1985

Kronhausen, Phyllis and Eberhard: The Complete Book of Erotic Art, New York 1987

Langner, Laurence: L'importance d'être vêtu, Paris 1959

Lo Duca, J.M.: Histoire de l'erotisme, Paris 1969

–, Psychopathia Sexualis im Comic-Strip nach Krafft-Ebing, Das aufklärende Sachbuch, Paris 1984

Lucie-Smith, Eduard: Eroticism in Western Art, London 1972

Macchi, Gulio: L'Amore, Dall'Olimpio all'alcova, Milan 1992

Marnhac, Anne de: Femmes au bain – les métamorphoses de la beauté, Paris 1986

Melville, Robert: Erotic Art of the West, London 1973

Nackt in der Kunst, Exhibition catalogue Sprengel Museum, Hannover, 1984

Néret, Gilles: L'Erotisme en peinture, Paris 1990

Smedt, Marc de: Das Kamasutra, Erotische Miniaturen aus Indien, Freiburg-Geneva 1980/1984

Smith, Bradley: Erotic Art of the Masters, The 18th, 19th and 20th Centuries, New York n.d.

Villeneuve, Roland: Le Musée de Supplices, Paris 1968

–, Fétichisme et Amour, Paris 1968

–, Le Musée de Bestialité, Paris 1968

Willemsen, Roger: Das Tier mit den zwei Rücken, Erotika, Cologne 1990

Zwang, Gérard: Le Sexe de la femme, Paris 1979

Monographs:

Arman
A Retrospective: exhibition catalogue Museum of Fine Arts, Houston 1991

Bacon, Francis
David Sylvester: Interviews with Francis Bacon 1962–1979, Oxford 1979

Francis Bacon, Meine Bilder, Munich 1983

Wieland Schmied: Francis Bacon, Vier Studien zu einem Porträt, Berlin 1985

Exhibition catalogue Staatsgalerie Stuttgart, Nationalgalerie Berlin, Stuttgart/Berlin 1986

Balthus
Sabine Rewald: Balthus, Exhibition catalogue Metropolitan Museum of Art, New York n.d.

Giovanni Carandente: Balthus, Drawings and Watercolors, New York 1983

Jean Leymarie: Balthus, New York 1982

Dieter Bachmann (ed.): Balthus, Ein Unbehagen in der Moderne, Sonderausgabe du, Zeitschrift der Kultur, no. 9, September 1992

Baselitz, Georg
Exhibition catalogue, Kunsthaus Zürich, Städtische Kunsthalle, Zurich/Düsseldorf 1990

Bayros, Franz von
Das gesamte Werk, Gala Verlag, Hamburg 1971

Beardsley, Aubrey Vincent
Zeichnungen, Wiesbaden 1987

Beckmann, Max
Retrospektive 1884–1984, Exhibition catalogue et al. Bayerische Staatsgemäldesammlung und Haus der Kunst, Munich 1984

Bellmer, Hans
H.B. Denoël: Les dessins de Hans Bellmer, Paris 1966

Sarane Alexandrian: Hans Bellmer, Berlin 1971

André Pierye de Mandiargues: Le Trésor cruel de Hans Bellmer, Paris 1979

Photographien, Munich 1984

Anatomie der Lust, Exhibition catalogue Graphisches Kabinett im Westend, Frankfurt am Main 1991

Beuys, Joseph
Beuys vor Beuys, Frühe Arbeiten aus der Sammlung van der Grinten, Exhibition catalogue et al. Hamburger Kunsthalle, Akademie der Künste der DDR, Cologne 1987

Bonnard, Pierre
Jean Clair (ed.): Pierre Bonnard, Exhibition catalogue Palazzo Reale Milano, Milan 1989

Exhibition catalogue Kunsthaus Zürich, Zurich 1984

Botticelli, Sandro
Herbert P. Horne: Botticelli, Painter of Florence, New Jersey 1980

Bourgeois, Louise
Exhibition catalogue The Museum of Modern Art, New York 1982/83

Drawings, Exhibition catalogue Robert Miller Gallery, New York, Galerie Lelong, Paris 1988

Exhibition catalogue Frankfurter Kunstverein Steinernes Haus am Römerberg, Frankfurt am Main 1990

Brancusi, Constantin
Friedrich Teja Bach: Constantin Brancusi, Metamorphosen plastischer Form, Cologne 1987

Brauner, Victor
Exhibition catalogue Museé National d'Art Moderne, Paris 1972

Bronzino
Andrea Emiliani: Il Bronzino, Busto Arsizio, 1961

Broodthaers, Marcel
Exhibition catalogue Walker Art Center, Minneapolis 1989

Œuvre 1963–1975: Isy Brachot Editeur, Paris/Brussels 1990

Brus, Günter
Handzeichnungen, Verlag Gebr. König, Cologne/New York 1971

Caravaggio
Roberto Longhi: Caravaggio, Dresden 1968

de Chirico, Giorgio
De Chirico nel centenario della nastica, Exhibition catalogue Museo Correr Venezia, Venice 1989

Christo
Surrounded Islands, Cologne 1984

Clemente, Francesco
Rainer Crone (ed.): Pastelle 1973–1983, Munich 1984

Cocteau, Jean
Exhibition catalogue Kunsthalle Baden-Baden, Cologne 1989

Copley, William N.
Exhibition catalogue Stedelijk Museum, Amsterdam 1966

Notes on a Project for a Dictionary of Ridiculous Images, Verlag Gebr. König, Cologne/New York 1972

Exhibition catalogue Badischer Kunstverein, Karlsruhe 1981

Corinth, Lovis
Zdenek, Felix (ed.): Lovis Corinth, 1858–1925, Cologne 1985

Courbet, Gustave
Michael Fried: Corbet's Realism, London 1990

Dalí, Salvador
Retrospektive 1920–1980, Gemälde, Zeichnungen Grafiken, Objekte, Filme, Schriften, Munich 1980

Descharnes/Néret: Salvador Dalí, Benedikt Taschen, Cologne 1990

Delacroix, Eugène
Exhibition catalogue Kunsthaus Zürich, Städelsches Kunstinstitut und Städtische Galerie, Frankfurt am Main, Cologne 1989

Delvaux, Paul
Barbara Emerson: Delvaux, Antwerp 1985
Dix, Otto
Exhibition catalogue Museum Villa Stuck,
 Munich 1985
Fritz Löffler: Otto Dix, Leben und Werk,
 Wiesbaden 1989
Eva Karcher: Otto Dix, "I'll either be famous –
 or infamous", Benedikt Taschen, Cologne
 1989
van Dongen, Kees
Exhibition catalogue Museum Boymans-van
 Beuningen, Rotterdam 1989/90
Dubuffet, Jean
Retrospektive, Exhibition catalogue et al.
 Akademie der Künste Berlin, Berlin
 1980
Andreas Franzke: Dubuffet, Cologne 1990
Exhibition catalogue Kunsthalle Schirn,
 Frankfurt am Main 1990/91
Duchamp, Marcel
Michael Gibson: Duchamp Dada, Paris 1991
Dürer, Albrecht
Friedrich Piel: Albrecht Dürer, Aquarelle und
 Zeichnungen, Cologne 1983
Ernst, Max
Retrospektive1979, Exhibition catalogue Haus
 der Kunst München, Nationalgalerie Berlin,
 Munich 1979
Retrospektive zum 100. Geburtstag, Exhibition
 catalogue et al. Staatsgalerie Stuttgart, Kunst-
 sammlung Nordrhein-Westfalen, Munich
 1991
Export, Valie
Anita Prammer: Valie Export, Eine multi-
 mediale Künstlerin, Vienna 1988
Fautrier, Jean
Yves Peyre: Fautrier ou les outrages de
 l'impossible, Paris 1990
Fetting, Rainer
Exhibition catalogue Museum Folkwang
 Essen, Kunsthalle Basel, Essen 1986
Fischl, Eric
David Whitney (ed.): Eric Fischl, New York
 1988
Fischli/Weiß
Stiller Nachmittag: Exhibition catalogue
 Kunsthalle Basel, Basel 1988
Gauguin, Paul
Marla Prather/Charles F. Stuckey: Gauguin,
 A Retrospective, New York 1987
Isabelle Cahn: Gauguin, Den Haag 1991
Ingo F. Walther: Gauguin, The Primitive
 Sophisticate, Benedikt Taschen,
 Cologne 1988
Gilbert & George
The complete pictures 1971–1975, Munich
 1986
Gober, Robert
Exhibition catalogue Museum Boymans-van
 Beuningen, Kunsthalle Bern, Rotterdam
 1990
Exhibition catalogue Galerie Nationale de Jeu
 de Paume, Paris 1991

Gossaert, Jan
Jan Gossaert genaamd Mabuse, Exhibition
 catalogue Museum Boymans-van Beu-
 ningen, Rotterdam 1965
Grosz, George
Serge Sabarsky: Die Berliner Jahre, Salzburg
 1986
Exhibition catalogue Van Voorst van Beest
 Gallery, The Hague, 1990
George Grosz: Ecce Homo, Frankfurt am
 Main 1973
Helnwein, Gottfried
Andreas Mäckler: G. Helnwein, Benedikt
 Taschen, Cologne 1992
Hesse, Eva
Bill Barrette: Eva Hesse, Sculptures, New York
 1989
Hockney, David
A Retrospective, Exhibition catalogue Los
 Angeles County Museum of Art, Los
 Angeles 1988
Hopper, Edward
Gemälde und Zeichnungen: Exhibition
 catalogue Kunsthalle Düsseldorf, Munich
 1980
Hubbuch, Karl
Helmut Goettle et al (ed.): Karl Hubbuch
 1891-1979, Exhibition catalogue Badischer
 Kunstverein, Karlsruhe 1981
Ingres, Jean-Auguste-Dominique
Robert Rosenblum: Ingres, London 1969
Jones, Allen
Sheer Magic, London 1973
Kahlo, Frida
Andrea Kettenmann: Frida Kahlo, Pain and
 Passion, Benedikt Taschen, Cologne 1992
Kelley, Mike
Exhibition catalogue Kunsthalle Basel, Portikus
 Frankfurt, Institute of Contemporary Art,
 London 1991
Kippenberger, Martin
Angelika Muthesius: Martin Kippenberger,
 Benedikt Taschen, Cologne 1991
Kirchner, Ernst Ludwig
Exhibition catalogue et al: Kunsthalle Köln,
 Cologne 1980
Klapheck, Konrad
Werner Hofmann: Konrad Klapheck, Retro-
 spektive 1955–1985, Munich 1985
Klauke, Jürgen
Andreas Vowinkel/Evelyn Weiss (eds.): Jürgen
 Klauke, Eine Ewigkeit, ein Lächeln,
 Cologne 1986
Klein, Yves
A Retrosepctive, Exhibition catalogue Institute
 for the Arts, Rice University, Houston
 1992
Pierre Restany: Yves Klein, Munich 1982
Klimt, Gustav
Alice Strobel: Gustav Klimt, Zeichnungen und
 Gemälde, Salzburg 1988
Klossowski, Pierre
Exhibition catalogue Centre National des Arts
 Plastique, Paris 1990

Kokoschka, Oskar
Exhibition catalogue Kunsthaus Zürich,
 Geneva 1986
Klaus Albrecht (ed.): Oskar Kokoschka,
 Munich 1991
de Kooning, Willem
Harald Rosenberg: De Kooning, New York
 1973
Koons, Jeff
Angelika Muthesius (ed.): Jeff Koons, Benedikt
 Taschen, Cologne 1992
Kubin, Alfred
Exhibition catalogue Kunstmuseum Winter-
 thur, Winterthur 1986
Lichtenstein, Roy
Ernst A.: Busche: Roy Lichtenstein, Das
 Frühwerk, 1942–1960, Berlin 1988
Janis Hendrickson: Roy Lichtenstein, Benedikt
 Taschen, Cologne 1988
Lindner, Richard
Hilton Kramer: Richard Lindner,
 Frankfurt am Main/Berlin/Vienna 1975
Magritte, René
Jacques Meuris: René Magritte, Paris 1988
Sarah Whitfield (ed.): Exhibition catalogue
 The South Bank Centre, London 1992
Maillol, Aristide
Hans Albert Peters (ed.): Exhibition catalogue
 Staatliche Kunsthalle Baden-Baden,
 Baden-Baden 1978
Manzoni, Piero
Germano Celant: Piero Manzoni, Catalogo
 Generale, Milan 1975
Mapplethorpe, Robert
Richard Marschell (ed.): Exhibition catalogue
 Whitney Museum of American Art, New
 York 1988
Some Woman, Munich 1989
Flowers, Munich 1990
Masson, André
Drawings, London 1972
Matisse, Henri
Ernst-Gerhard Güse (ed.): Henri Matisse,
 Zeichnungen und Skulpturen, Munich 1991
Gilles Néret: Matisse, Paris 1991
Matta
Wieland Schmied (ed.): Exhibition catalogue
 Kunsthalle der Hypo Kulturstiftung
 München 1991, Kunstverein Wien 1992,
 Munich 1991
Miró, Joan
Exhibition catalogue Kunsthaus Zürich,
 Städtische Sammlung Düsseldorf, Bern 1986
Janis Mink, Joan Miró, Benedikt Taschen,
 Cologne 1993
Modigliani, Amedeo
Exhibition catalogue Musée d'Art Moderne
 de la Ville Paris, Paris 1981
Mueller, Otto
Lothar Günther Buchheim: Otto Müller,
 Leben und Werk, Feldafing 1963
Munch, Edvard
Exhibition catalogue Museum Folkwang
 Essen, Kunsthaus Zürich, Essen 1987

Ulrich Bischoff: Edvard Munch, Benedikt
 Taschen, Cologne 1989

Nauman, Bruce
Skulpturen und Installationen, Exhibition
 catalogue Museum für Gegenwartskunst,
 Bern, Cologne 1990

Newton, Helmut
Portraits, Munich 1987
White Women, Munich 1988

Oelze, Richard
Renate Damsch-Wiehager: Ein alter Meister
 der Moderne, Lucerne 1989

O'Keeffe, Georgia
Jack Cowart/Juan Hilton: Georgia O'Keeffe,
 Art and Letters, New York 1987
Nicholas Callaway: One Hundred Flowers,
 New York 1989

Oldenburg, Claes
Germano Celant: A Bottle of Notes and some
 Voyages, Claes Oldenburg, Coosje v.
 Bruggen, New York 1988

Oppenheim, Meret
Retrospective, Exhibition catalogue Institute
 of Contemporary Art, London 1990

Pearlstein, Philip
The Complete Paintings, 1983

Pechstein, Max
Exhibition catalogue Kunstverein Braun-
 schweig, Brunswick 1981

Picabia, Francis
Exhibition catalogue Städtische Kunsthalle
 Düsseldorf, Kunsthaus Zürich 1983/84,
 Cologne 1984

Picasso, Pablo
Late Picasso, Paintings, Sculptures, Drawings,
 Prints 1953–1972, Exhibition catalogue The
 Tate Gallery, London 1988
Carsten Peter Warncke/Ingo F. Walther:
 Pablo Picasso, 1881–1973, Benedikt
 Taschen, Cologne 1992, 2 vols.

Pollock, Jackson
Ellen G. Landau: Jackson Pollock, New York
 1989

Rainer, Arnulf
Körpersprache, Munich 1980

Ramos, Mel
Exhibition catalogue, Darmstadt 1975

Ray, Man
Arturo Schwarz: Man Ray, Munich 1980
Man Ray: Selbstporträt, Eine illustrierte
 Autobiographie, Munich 1983

Rembrandt
Sämtliche Radierungen in Originalgröße,
 Stuttgart/Zurich 1986

Richter, Gerhard
Jürgen Harten: Bilder 1962–1985, Cologne
 1986

Rivers, Larry
Sam Hunter: Larry Rivers, New York 1989

Rodin, Auguste
Zeichnungen und Aquarelle, Exhibition
 catalogue Landesmuseum für Kunst und
 Kulturgeschichte, Münster, Museum Villa
 Stuck, Munich, Stuttgart 1984

Sculptures and Drawings, Exhibition catalogue
 Arts Council of Great Britain, London
 1986/87

Salle, David
Exhibition catalogue Mary Boone Gallery,
 Galerie Michael Werner, Cologne, New
 York 1985

Salome
Exhibition catalogue Galerie Thomas, Munich
 1984

Schad, Christian
Editions Panderma, Basel 1972

Schadow, Johann Gottfried
Götz Eckerhardt: Johann Gottfried Schadow,
 Der Bildhauer, Leipzig 1990

Schiele, Egon
Jane Kallir: Egon Schiele, The Complete
 Works, New York 1989
Richard Steiner: Egon Schiele, 1890–1918,
 The Midnight Soul of the Artist, Benedikt
 Taschen, Cologne 1991

Sherman, Cindy
Cindy Shermann: 3rd expanded edition,
 Munich 1987
History Portraits, Munich 1991

Tom of Finland
Retrospective I, Los Angeles 1988
Retrospective II, Los Angeles 1991
Burkhard Riemschneider (ed.), Tom of Fin-
 land, Benedikt Taschen, Cologne 1992

Velázquez, Diego
Exhibition catalogue Museo del Prado,
 Madrid 1990

Veronese, Paolo
Exhibition catalogue National Gallery
 Cambridge, Washington 1988

da Vinci, Leonardo
Kenneth Clark: The Drawings of Leonardo
 Da Vinci in the Collection of Her Majesty
 the Queen at Windsor Castle, London
 1969, 3 vols.

Wall, Jeff
Exhibition catalogue Westfälischer Kunstverein,
 Münster 1988
Transparencies, Rizzoli, New York 1986

Warhol, Andy
Rainer Crone: Andy Warhol, Die frühen
 Werke, Stuttgart 1987
Kynaston McShine: Andy Warhol, Retrospek-
 tive, Munich 1989

Wols
Bilder, Aquarelle, Zeichnungen, Photo-
 graphien, Druckgrafik, Exhibition catalogue
 Kunsthaus Zürich, Kunstsammlung Nord-
 rhein-Westfalen, Düsseldorf/Zurich 1989

Credits

The publishers would like to thank the follow-
ing museums, archives and photographers for
the granted reproduction rights and for their
generous assistance in helping make this book
possible. In addition to the personalities and in-
stitutions already cited in the illustration titles
we wish to mention:

Photo: Courtesy of the artist: 146; Artothek,
Peissenberg: 96, 160; Klaus Baum: 24; Galerie
Beyeler, Basel: 23; Bildarchiv Preußischer Kul-
turbesitz, Berlin: 10, 73, 152; Galerie Gisela
Capitain, Cologne: 178; Christie's Colour Li-
brary, London: 191; Courtesy Paula Cooper
Gallery, New York: 59; © Photo: Descharnes &
Descharnes: 139, 154, 181, 182; Deutsche
Photothek, Dresden: 154; Roland Dreßler, Wei-
mar: 74; Graphisches Kabinett im Westend,
Frankfurt am Main: 84, 88, 100; Anthony
Haden-Guest, London: 24; Courtesy Galerie
Max Hetzler, Cologne: 37, 127; Bruno Jarret,
Paris: 55, 108; Kunstmuseum Winterthur, Win-
terthur: 183; Kunst- und Ausstellungshalle der
Bundesrepublik Deutschland, Bonn: 103; Mi-
chael de Lorenzo, Nice: 117; Les Héritiers Ma-
tisse, Paris: 45; Philippe Migeat, Paris: 109; Marl-
borough Fine Art, London: 132; Ann Münchow,
Aachen: 193; © 1992 The Museum of Modern
Art, New York: 144; Gilles Néret, Paris: 51, 58,
72, 119; Derechos reservados © Museo del
Prado, Madrid: 48; Prammer Public Relations,
Vienna: 52; Photo: R.M.N., Paris: 94, 140, 187;
Galerie Raab, Berlin: 73; Nathan Rabin, New
York: 19; Rheinisches Bildarchiv, Cologne: 34,
88, 93, 96, 101, 163, 186; Adam Rzepka, Paris:
55, 89; From "White Women" published by
Schirmer & Mosel: 97; From "Portraits" pub-
lished by Schirmer & Mosel: 98; Photo: Wil-
helm Schürmann: 106, 137; Edition Spangen-
berg, © 1989 Munich: 124; Photo: Lee Stals-
worth: 49; Courtesy Galerie St. Etienne, New
York: 121; Photo: John Tennant: 174; Wolfgang
Volz, Düsseldorf: 51; Elke Walford, Hamburg:
18, 114, 141; Peter Willi, Paris: 35

Index of names